VERROCCHIO'S
DAVID RESTORED

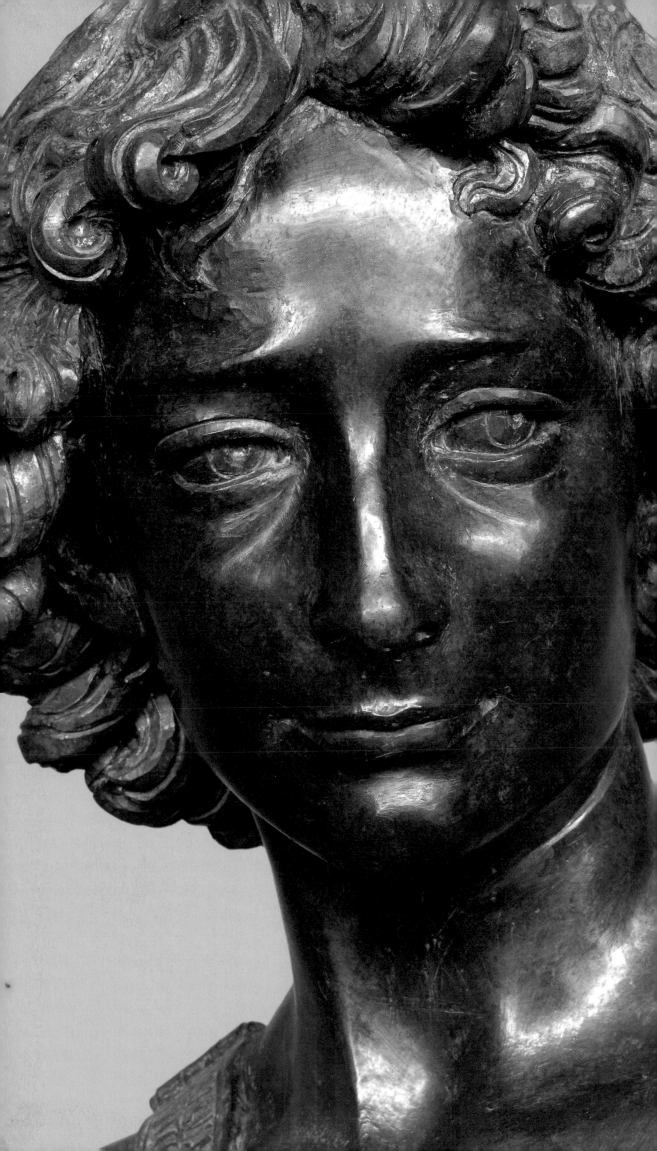

VERROCCHIO'S DAVID RESTORED

A Renaissance Bronze from the National Museum of the Bargello, Florence

Gary M. Radke, *Guest Curator*

David Alan Brown

Maria Ludovica Nicolai

John T. Paoletti

Beatrice Paolozzi Strozzi

Simone Porcinai

Salvatore Siano

Maria Grazia Vaccari

HIGH MUSEUM OF ART

ATLANTA

IN ASSOCIATION WITH

GIUNTI GRUPPO EDITORIALE

FLORENCE

Verrocchio's David Restored: A Renaissance Bronze from the National Museum of the Bargello, Florence was organized by The High Museum of Art. Generous support was provided by Worldspan, L.P.

Support for conservation was provided by Steinhauslin Bank and Progetto Città, Florence.

Additional support was provided by the Samuel H. Kress Foundation and Associazione 'Amici del Bargello'.

Verrocchio's David Restored: A Renaissance Bronze from the National Museum of the Bargello, Florence was on view at the National Museum of the Bargello, Florence, from October 7 to November 9, 2003, and from April 1, 2004; at the High Museum of Art, Atlanta, from November 22, 2003, to February 8, 2004; and at the National Gallery of Art, Washington, D.C., from February 13 to March 21, 2004.

Restoration
Project Directors: Beatrice Paolozzi Strozzi and Maria Grazia Vaccari, Museo Nazionale del Bargello, Florence
Restorers: Maria Ludovica Nicolai, assisted by Nicola Salvioli, Florence
Scientific Consulting and Testing: Salvatore Siano, I.F.A.C., C.N.R., Florence
Marcello Massi, Alfredo Aldrovandi, Simone Porcinai, Carlo Lalli, Maria Rizzi,
Opificio delle Pietre Dure e Laboratori di restauro, Florence
Pietro Moioli, Claudio Seccaroni, Attilio Tognacci, E.N.E.A., C.R., Casaccia, Rome
Umberto Casellato, Alessandro Vigato, I.C.I.S., C.N.R., Padua
Sergio Beragnoli, Expert on casting techniques, Istituto d'Arte, Pistoia
Laser Devices: El.En.Electronic Engineering S.p.a, Calenzano, Florence
Photographs: Carlo Bacherini, Maria Ludovica Nicolai, Antonio Quattrone, Florence
Transportation: Universal Express—Arterìa, Florence
Sponsors: The restorations were made possible thanks to the contribution of the Banca C. Steinhauslin, Florence, in cooperation with Progetto Città, Florence

Exhibition in Florence
Curators: Beatrice Paolozzi Strozzi and Maria Grazia Vaccari
Exhibition Layout: M. Cristina Valenti, Soprintendenza Speciale per il Polo Museale Fiorentino
Sponsor: Associazione 'Amici del Bargello'

Exhibition in Atlanta
Guest Curator: Gary M. Radke

European Edition
ISBN 88-09-03264-0

Library of Congress Cataloging-in-Publication Data
 Verrocchio's David restored : a Renaissance bronze from the National Museum of the Bargello, Florence / Gary M. Radke . . . [et al.].
 p. cm.
 Catalog of an exhibition at the High Museum of Art, Atlanta, Nov. 22, 2003–Feb. 8, 2004.
 ISBN 1-932543-00-7 (alk. paper)
 1. Verrocchio, Andrea del, 1435?–1488. David—Exhibitions. 2. Bronze sculpture, Italian—Conservation and restoration—Italy—Florence—Exhibitions. 3. Bronze sculpture, Renaissance—Conservation and restoration—Italy—Florence—Exhibitions. 4. David, King of Israel—Art—Exhibitions. 5. Sculpture—Italy—Florence—Exhibitions. 6. Museo nazionale del Bargello (Florence, Italy)—Exhibitions. I. Radke, Gary M. II. High Museum of Art.
 NB623.V5A64 2003
 730'.92—dc22 2003016123

Printed in Italy

For the High Museum of Art
Kelly Morris, Manager of Publications
Janet S. Rauscher, Associate Editor
Christin Gray, Publications Coordinator

For Giunti Editore, Florence
Ilaria Ferraris, Editor
Claudio Pescio, Editorial Manager

English Translations: Julia Hanna Weiss
Italian Translations: NTL, Florence
Technical Coordinator: Alessio Conticini
Photolithography: Fotolito Toscana, Florence
Graphics: Paola Zacchini
Picture Archives: Giunti Editore, Florence
Iconographic Research: Elisabetta Marchetti

Design and Layout: Jeff Wincapaw
Marquand Books, Inc., Seattle
www.marquand.com

ACKNOWLEDGMENTS

The Superintendent of the Florentine Museum Center and the Direction of the Museo Nazionale del Bargello wish to thank the following individuals and organizations for their cooperation: Cristina Acidini, Superintendent and Annamaria Giusti, Director of the Bronze Department of the Opificio delle Pietre Dure e Laboratori di restauro, Florence; the 'Amici del Bargello' association, and its president, Paola Barocchi; Vittorio Frescobaldi, president, and Stefano Malferrari, general manager of the Banca C. Steinhauslin, Florence; Andrea Ceccherini, chairman of the Progetto Città; Michael Shapiro, Director, and the entire staff of the High Museum of Art; Giovanni Lenza, financial manager of Florentine Museum Center; Claudio Di Benedetto and Luisa Montanari, Biblioteca degli Uffizi; the managements of the Archivio di Stato of Florence and of the Kunsthistorisches Institut in Florenz Max-Planck-Institut; the staff of the Museo Nazionale del Bargello and in particular Maria A. Giordano, Luisa Palli, Adriano Roccanti, Alessandro Robicci, and Vincenzo De Magistris. Moreover: Giovanna Alessandrini, Vanna Arrighi, Andrea Baldinotti, Anna Bellinazzi, Roberto Bellucci, Alberto Corti, Marco Fossi, Valter Giacomel, Lorenzo Macrì, Mauro Matteini, Anna Mieli, Negeen Sobhani. Special thanks to Leonardo Masotti, owner of El.En. Electronic Engineering S.p.a., who graciously provided the laser devices for the restoration and Universal Express-Arterìa, for covering the costs of moving the *David* as needed for the diagnostic tests.

The Director of the High Museum of Art in Atlanta wishes to thank Dottoressa Beatrice Paolozzi Strozzi, the gracious and ever cooperative Director of the Museo Nazionale del Bargello in Florence, as well as Maria Grazia Vaccari, Deputy Director, and Dr. Gary M. Radke, guest curator and professor of Fine Arts at Syracuse University, for their collaboration in shaping this exhibition. We are grateful to Paul Blackney, Chairman of the Atlanta Regional Arts and Cultural Leadership Alliance and former CEO of Worldspan, who was instrumental in the early stages of this project. At the High Museum of Art, thanks go to Philip Verre, Deputy Director; David Brenneman, Chief Curator and Frances B. Bunzl Family Curator of European Art; and Elizabeth Wilson, Assistant to the Deputy Director, for their efforts in supporting Professor Radke's curatorial efforts; Jody Cohen, Manager of Exhibitions, for overseeing the details surrounding the installation of the *David;* Jim Waters, Chief Preparator and Exhibitions Designer, for his imaginative design of the installation; Angela Jaeger, Head of Graphics, for her creative approach to exhibition graphics; Frances R. Francis, Registrar, and Maureen Morrisette, Associate Registrar, for their management of the demanding logistics of the safe transport of this great work of art; and Kelly Morris, Manager of Publications, and Janet Rauscher, Associate Editor, for their thoughtful editing of this publication.

CONTENTS

FOREWORD

The story of David and the giant Goliath as we read it in the Book of Samuel is one of the most engaging tales in the Bible. It is dramatic and full of suspense, like the best action film. Everything is played out in a swift, cruel scenario without frills or padding. First, there is contrast between the fair-haired adolescent and the giant in armor, then the ritual insults, and finally the slingshot and David's almost feline dash forward. The image of David standing over the body of his fallen enemy and cutting off his head concludes the sequence. Read it and you will realize that it is indeed difficult to outdo this writer.

It is easy to understand why the story of David would have pleased the Florentines. The moral and religious message transforms itself into a most effective political metaphor. David wins because he is the slingshot of the Lord, because Justice and Virtue are on his side. God put Goliath in his hands so that it would be clear to everyone that the Almighty "saveth not with the sword and the spear." Likewise, the Republic is free and strong and no enemy will ever bring it down because God extends His right hand over it, as He did over the fair head of the boy David in the Philistine camp. If the *David* was a political symbol in fifteenth-century Florence, it was also a psychological portrait of its citizens. This thought has come to me quite often in the Bargello as I looked at the three famous statues of David: the two by Donatello and Verrocchio's.

Donatello's marble *David* has something consciously heroic and almost patriotic about it. He looks as if he were sitting for a victory portrait. His left hand is on his hip, his right hand holds the slingshot. At the feet of the fighting youth is the macabre trophy, the severed head of Goliath, with the stone that caused his death still, and clearly, lodged in his forehead.

Donatello's *David* is a concentrate of taut energy, spiritual energy even more than physical. It is like a spring about to be released. The slim body is slightly bent, according to the supple model of a tradition that is still Gothic, but the face already expresses the rational morality of the Renaissance man who is aware of his destiny.

The bronze *David* by Donatello presents a different interpretation of the Bible story. David is very young and nude. Beneath his foot lies the head of his defeated enemy, resting on a laurel wreath. The adolescent warrior's pose is thoughtful, meditative. There is neither pride nor joy in his triumph. In his hand he clutches the stone and the sword, symbols of his victory. But his face, slightly lowered and shaded by an unusual, broad-brimmed hat, seems be shaded by melancholy. Is it possible to be victorious and sad at the same time? To grasp success and realize its futility? Obviously it is, if the sculptor is Donatello and we are in full fifteenth-century Florence, which is at the peak of its intellectual glory.

And now, there is Verrocchio's *David*. In some ways it is the most Florentine of all. It is a masterpiece of throbbing vitality. Rather than the moral and symbolic meanings, the artist seems fascinated by the physical and psychological immediacy of the scene. The biblical hero is a young gladiator, with muscles quivering beneath his skin, who has just defeated his enemy and now, tense and absorbed, is awaiting his well-deserved triumph. There is something boldly sporty and also cheerfully ruffian-like in this victorious boy's expression and posture.

Now we know—Ludovica Nicolai's restorations have revealed it—that the victorious boy was blonde, exactly as we read in Samuel, with gold leaf gilding on his curls and eyes. Now that the cleaning has restored the melodious patina on the shining sheath of muscles, we know that we can expect anything from a boy like this once he becomes an adult. He will leap and dance filled with the joy of the Lord, leading the procession that carries the Ark of the Covenant, and he will send the hapless Uriah, Bathsheba's husband, to his death because of passion.

Verrocchio's *David* will go to America and it will be a triumphal trip. For this we are indebted to our overseas colleagues Michael E. Shapiro, Gary M. Radke, David Alan Brown, and John T. Paoletti, and not only because the American sponsors along with our Banca Steinhauslin, Progetto Città and Associazione 'Amici del Bargello', were determined to finance the restoration. Not only for this. The loan of the statue, which would be unthinkable in other circumstances, is justified and fitting because of the extraordinary, friendly, and fruitful relationship that developed around the *David* restoration project between Italian and American scholars. The work was directed by Beatrice Paolozzi Strozzi and Maria Grazia Vaccari with great wisdom and balance, and the results—"new facts and new theories," the important historical critical, philological, and iconographic advances made possible by this alliance—are presented here in this book. Those of you who have the patience to read it will understand that it was indeed worth it all.

Antonio Paolucci
Soprintendente
per il Polo Museale fiorentino

9

PREFACE

Florence is home to many famous images of David, but none is as charming or as approachable as Verrocchio's gilt bronze. Children visiting the National Museum of the Bargello in Florence instinctively identify with Verrocchio's statue—and we trust that thousands will do the same in Atlanta and Washington.

Is it simply David's sweet smile, slightly swashbuckling pose, and jaunty boots that make him so attractive? Or is it also the manner in which Verrocchio humanizes David's archenemy, making the head of Goliath appear sad and forlorn rather than fearsome or ghoulish? Verrocchio's *David* with the head of Goliath epitomizes the seemingly limitless and yet tender potential of youth.

Today Verrocchio's *David* speaks more directly to us than he has for over four hundred years. Thanks both to a splendid restoration, which has revealed extensive gold leaf on his hair, garment, and boots, and to new scholarly research, which has clarified the figure's original placement and significance, we can experience the statue as Verrocchio intended. This exhibition offers a fresh opportunity for scholars and the general public to imagine what the work may have looked like for a short but glorious time before the Medici sold the statue to the Florentine government for display on a small column in their city hall. The figure can now be understood as in motion, not static, moving out into the future. Thus, in Verrocchio's restored *David* we newly appreciate the optimism and dynamism of the Italian Renaissance.

The High Museum of Art is honored to have collaborated on this restoration and exhibition with our generous colleagues at the National Museum of the Bargello in Florence and to share the sculpture with the National Gallery of Art in Washington, D.C. As part of our commitment to international partnerships that bring works of global significance to our community, this project has engaged an international team of scientists, conservators, art historians, and museum professionals—all intent on recovering and re-engaging the past. Through the examination and study of a single object, an entire world has opened for consideration. We trust that our visitors will enjoy learning about the city of Florence, the Medici family who commissioned this work, Andrea del Verrocchio and his workshop, and the fascinating physical processes involved in creating and restoring bronze.

Michael E. Shapiro
Nancy and Holcombe T. Green, Jr. Director
High Museum of Art

NATIONAL SPONSOR'S STATEMENT

Worldspan is honored to be the national sponsor of *Verrocchio's David Restored: A Renaissance Bronze from the National Museum of the Bargello, Florence*. The exhibition, debuting at the High Museum of Art in Atlanta, will appear at the National Gallery of Art in Washington, D.C., thereafter. It is an unrivaled privilege to bring this singular masterpiece of Renaissance sculpture to the United States. A recent state-of-the-art conservation effort will reveal *David* as originally envisioned by the artist.

Worldspan hopes that many thousands of visitors will be touched by Verrocchio's *David* and perhaps better understand the world—both past and present—as a result.

On behalf of all Worldspan employees, I invite you to join us in experiencing Verrocchio's *David* and the rich world of the Italian Renaissance in which it was conceived and shaped.

Rakesh Gangwal
Chairman, President, and Chief Executive Officer
Worldspan

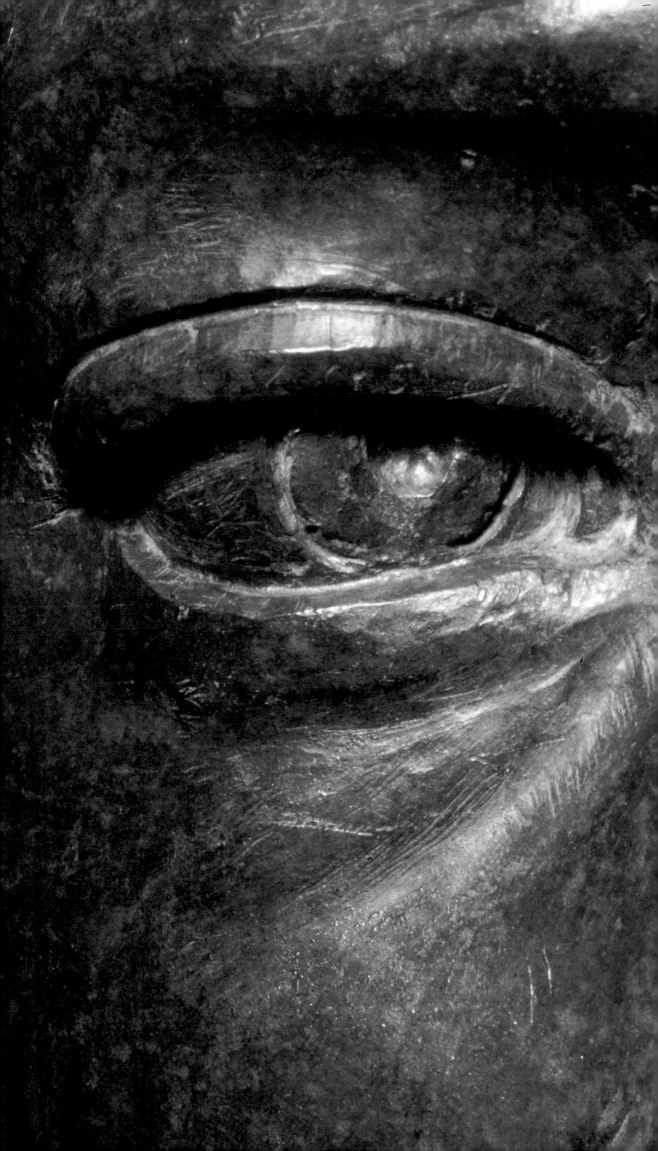

Beatrice Paolozzi Strozzi
Maria Grazia Vaccari

VERROCCHIO'S DAVID:
NEW FACTS, NEW THEORIES

Young, slender, and proud, the *David* by Andrea del Verrocchio fits the description of the future king of Israel in the Book of Samuel. The first description occurs when he is chosen among the sons of Jesse and blessed by Samuel in the name of the Lord, who said, "Look not on his countenance, or on the height of his stature: because I have refused him. . . . And Samuel said unto Jesse, Send and fetch him. . . . And he was sent and brought him in. Now he was ruddy, and withal of a beautiful countenance, and goodly to look to" (I Samuel 16: 7, 12). And then when Goliath saw David, "he disdained him: for he was but a youth, and ruddy, and fair of countenance" (I Samuel 17: 42).

The current restorations have revealed the extent to which Verrocchio followed the biblical description. He completely gilded David's blonde curls (fig. 1) and rendered the beauty of his countenance with gold around the irises, the pupils, and on the edge of the eyelids, to suggest their splendor. These features are also recalled by Dante's lines dedicated to David as the pupil of the divine Eagle: "He who shines in the middle, as the pupil, was the singer of the Holy Spirit, who bore about the ark from town to town" (*Paradise*, XX, 37–39).

The precious gilding that decorates the figure, especially the hair, is the most outstanding and astonishing result of the restorations that have recently been completed. The gilding represents not only the abundance of ornamentation that was standard in Renaissance bronzes (which scholars had long presumed to exist beneath the countless patinations),[1] but also confirms that the statue was originally meant to be placed indoors, since the gilding technique using gold leaf and animal glue yielded results that were much more fragile than the mercury amalgam traditionally used on bronzes that stood outside.[2] The lavish and refined execution, like the statue's references to biblical and poetic sources, confirms the high social strata from which the commission for the piece was issued. It would have befitted the tastes and culture of Piero de' Medici, father of Lorenzo the Magnificent, and Giuliano, who are mentioned as the owners of the statue in 1476 in the first known document mentioning the *David*.[3] The document concerns the sale of the Verrocchio bronze to the Signoria by the two Medici brothers on May 10 of that year for the price of one hundred fifty gold florins (see page 82). It also clearly indicates where the statue was to be placed inside the Palazzo Vecchio (*"penes et apud Hostium Catene,"* that is, near the entrance door—known as the Door of the Chain—to the Sala dei Gigli) and the reason the Signoria purchased it: *"pro ornamento et pulcritudine ac etiam magnificentia Palatii"* (for the decoration, and beautification, and even the magnificence of the Palace).[4]

Vasari, who saw the sculpture in its place, said that it was completed upon the artist's return from Rome and destined for the Palazzo Vecchio. Although Vasari's statement does not help us in dating the piece, since Verrocchio's Roman sojourns are the

FIGURE 1. Andrea del Verrocchio, *David*, detail of the head after restoration.

cloudiest aspects of his biography, it is still interesting because it does not mention the earlier Medici ownership. The statement also establishes a direct relationship between the statue and the Palazzo Vecchio: "Andrea then returned with money, fame, and honor to Florence, where he was commissioned to make a bronze statue of David, five feet in height, which after it was finished was placed, much to his credit, at the head of the staircase in the Palazzo della Signoria, where the chain used to be."[5]

Recent studies concur in dating the statue early in Verrocchio's career, around the time of the *Candelabrum* for the Signoria chapel that was made and paid for between 1468 and 1469.[6] It is also in the dry and taut style that Vasari called "hard and crude," which softened in the more monumental pieces from Verrocchio's mature period. Thus, the second half of the seventh decade of the century seems the most likely. Furthermore, the *David* heads the list of the fifteen works Andrea made for the Medici during the course of his life, as recorded by his brother, Tommaso Verrocchio, in January 1496.[7]

Owing to its format, this "inventory," which after the one dated 1476 is the second and last fifteenth-century document concerning the *David,* has been taken as a list of payments Andrea's brother requested (but did not specify) from the Signoria when the Medici assets were confiscated and the family's debts were paid with the proceeds of the sales. Because of the way it was drawn up, the list seems a simple balance sheet prepared on the basis of the sculptor's accounting records. Since it concerns only works done for the Medici and the amount next to each item is blank, it would seem to be a certificate attesting that all of Verrocchio's works in the family's possession were owned free and clear, having been fully and duly paid. However, the meaning of such a list at that date is quite clear. As the Signoria proceeded with the confiscation, they wanted to ascertain whether there were any outstanding claims on the Medici assets that were being seized.[8] The Signoria's 1476 payment to Lorenzo and Giuliano was entirely legitimate. As the heirs of Piero, the most likely patron, they were indeed the rightful owners.

However, given the many Medici residences, Tommaso's list is of no help in identifying the original home of the bronze. We will return to this issue, but for the time being we should take note of the exact wording with which the *David* is mentioned: *"uno davitte e la testa di ghulia"* (one David and the head of Goliath). This leads to an understanding of the work comprising (as it indeed does) two distinct parts that were cast separately. This technical feature will have many consequences for the statue's history.

In any event, the *David* stood in the Palazzo Vecchio, in the *ricetto* (a foyer or antechamber) of the Sala dei Gigli uninterruptedly from 1476 until at least the end of the following century. In fact, it was the first important artwork with which the Signoria began the restoration and redecoration of that portion of the Palazzo in the 1470s. From a political standpoint, this was the heart of the building, and shortly thereafter it was decorated with works by Benedetto da Maiano and Ghirlandaio.[9]

Recently, in his broad study dedicated to Donatello's *David* and *Judith,* Francesco Caglioti hypothesized that, for at least a few years between 1495 and 1504, Verrocchio's *David* had been moved to the courtyard of the Palazzo Vecchio, replacing Donatello's *David.*[10] His assumption is based primarily on the contemporary testimonies of Luca Landucci and Piero di Marco Parenti, which are worth quoting in full. In his *Diary* Luca Landucci mentions the transfer of the two famous Donatello sculptures from the Medici residence to the Palazzo Vecchio: "On the 9th of December 1495 a David that was in the home of Piero de' Medici was taken to the Palazzo della Signoria and placed in the middle of the

courtyard. . . . And on the 21st of December 1495, the bronze Judith that was in the home of Piero de' Medici was placed on the dais of the Palazzo della Signoria, next to the door."[11] On December 29, 1495, Piero Parenti recorded the same events in his *Storia*: "The statue of Judith with Holofernes, from the estate of Piero de' Medici, was taken from his garden and placed on the dais where it stands; similarly the column [that is] inside the palace was taken from the courtyard of his home. Only the David was changed."[12]

According to Caglioti, the events probably went like this: "On 9 December 1495 the *David* by Donatello was placed in the courtyard of the Priori [Palazzo della Signoria] on its original pedestal; by the 29th it was decided to take down the masterpiece and, leaving its beautiful 'column' in place, to replace it with another *David*, which at this point could only have been the immediately available bronze by Verrocchio."[13] However, a simpler, comparative reading of the two accounts is also possible. Specifically, Piero Parenti merely says that while the *Judith* and marble base of Donatello's *David* were taken from the Palazzo Medici to the Palazzo Vecchio together (on December 21, 1495, according to Landucci), the *David* was changed (i.e., moved) "alone" (on December 9, 1495, according to Landucci).[14] There is no documentary evidence to substantiate the hypothesis that Donatello's *David* arrived in the Palazzo Vecchio with its base on December 9. Also, it would seem entirely logical that moving a bronze monument that stands on a pedestal would be done in two phases, and that the statue would be moved first. Thus, from December 9 to 21, we can envision Donatello's *David* standing on the ground in the middle of the courtyard and then, between December 21 and 29, put back on its pedestal that in the meantime had reached the Palazzo Vecchio along with the *Judith*. According to this interpretation, the two fifteenth-century sources, Parenti and Landucci, confirm each other.[15] Moreover, this debunks the intricate and contorted hypothesis whereby the outburst of Savonarolan scruples would have persuaded the Florentine Signoria (so concerned about aesthetics and proportions) to place Verrocchio's smaller *David* atop the marble base that Desiderio da Settignano had made for Donatello's sculpture.

And there is more. According to Caglioti's hypothesis, as a consequence of this switch, Donatello's *David*, which no longer had a place, would have stood in for Verrocchio's statue in the prestigious but definitely tight space that for twenty years had barely contained Andrea's statue. The statue and column stood practically near the edge of the stairs "because the steps extend into the *ricetto* as far as the *David*, which is so close to the door of the Sala [dei Gigli] that it seems to be there more by force than anything else," as Vasari pointed out to the Duke Cosimo in 1561 when, with his new staircase, he modified the arrangement of that *ricetto*.[16] Although we lack precise details, we do know that the space was so small and crowded by the flow of people going to the Sala dei Gigli that in 1476 the Signoria was forced to order a base for Verrocchio's statue that could barely support it.[17] In conclusion, this diverse interpretation of contemporary sources leads us to exclude the hypothesis that Verrocchio's *David* ever stood in the middle of the Palazzo Vecchio courtyard. Furthermore, in 1504, when the site was being selected for Michelangelo's *David*, it was Donatello's *David*, the imperfect figure with the "bent back leg" that the Signoria Herald proposed be replaced with the marble statue by Buonarroti.[18] In addition, the restoration confirms that there is no evidence on the bronze or on the delicate gilding that Verrocchio's *David* ever stood outdoors, even for a brief period.

In any event, in Albertini's *Memoriale* from 1510 the statue is mentioned as being "at the top of the stairs," exactly where the Signoria had placed it originally and where it

15

would continue to stand for at least another fifty years.[19] It is indeed possible that it was moved—perhaps slightly—following Vasari's 1561 modifications, as we shall see further on.[20] Although a 1553 document still mentions the sculpture "at the chain in the palace,"[21] there is no precise information in the final sixteenth-century mention of the statue. In 1591 Francesco Bocchi includes it among the "beauties of the city of Florence" with the following words: "In front of the Sala dell'Oriuolo there is a bronze statue of David by the hand of Andrea Verrocchio, of ultimate beauty, endlessly praised by all the artists."[22] Bocchi's admiring words coincide with the beginning of a long period of oblivion. No written sources mention the *David* until 1677, when it reappears under the heading *Davitte* in the *Tavola delle cose più notabili* (List of Most Noteworthy Things) that Giovanni Cinelli added to a new and expanded edition of Bocchi's guide: "David . . . in bronze by Verrocchio today in the Gallery."[23]

Thus the sculpture was moved from the Palazzo Vecchio sometime between 1591 and 1677, the interval between the two editions of the book. We could, however, attempt some further clarifications. It is entirely likely that the *David* was in the Guardaroba of the Palazzo Vecchio[24] or in some Medici residence before it was taken to the Uffizi. It must have been moved there slightly prior to Cinelli's mention, when the grand ducal collections were expanded and extended into the gallery's corridors—where it was first placed—during the reign of Cosimo III, after 1670 (fig. 2).[25]

Although there is no mention of the *David* in any seventeenth-century inventory of the Guardaroba or the Palazzo Pitti,[26] we can assume that it had been removed from the Sala dei Gigli landing well before the middle of the century. This hypothesis is supported by deductive reasoning and new documentary evidence. Although it is silent with regard to the Verrocchio bronze, the 1637 *Inventario Generale* of the Palazzo Vecchio mentions "a full relief bronze head of St. John the Baptist beheaded" in the first room of the Guardaroba,[27] and the same item is listed again in the next *Inventario*, dated 1640.[28] If we envi-

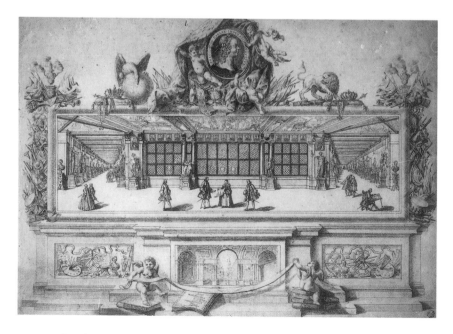

FIGURE 2. Benedetto Vicenzo De Greyss, *Perspective View of the Three Corridors in the Uffizi*, 1748, Gabinetto Disegni e Stampe (inv. n. 4492F), Uffizi, Florence.

sion the head of Goliath, already missing the stone in the forehead (as it appeared at least from the eighteenth century), it is entirely plausible that it might be mistaken for the head of John the Baptist.[29] This would mean that the *David* had already been completely "dismantled," removed from its pedestal, and placed elsewhere without the head of Goliath.[30] It was a "disfigurement" that lasted for nearly two centuries and resulted in Verrocchio's statue losing its identity until the middle of the nineteenth century.[31]

It is certain, however, that at least from 1666 on, there was only a *Bust of the Grand Duke Ferdinando I* in the *ricetto* of the Sala dei Gigli, and it was listed in the *Inventario* of that year.[32] It remained there until 1916, as we can see from the picture published by Mackowsky in 1901 (fig. 3)—somehow or other standing on the capital made for the *David* in 1476.[33]

Before proceeding with the records of the *David*'s history in the Uffizi, we should take a look at this picture and dedicate a moment to the place the statue must have occupied in the Palazzo Vecchio from 1476 until it was removed in the seventeenth century. We will also carefully examine each part of the base on which it stands today in the Bargello. The base was brought over from the Palazzo Vecchio in 1916 and is considered the fifteenth-century original.[34] From Mackowsky's photo we can identify the exact placement of the *Bust of Ferdinando* on the Landing of the Chain. It stood opposite the entrance to the Sala dei Gigli, between the door to the "Salotta"—once the access to the private apartments of the Signoria and then the duchess's sitting room—and the beginning of the final flight of stairs leading to the former kitchen (fig. 4). If this was indeed the location of the bust and base as entered in the 1666 *Inventario*, it certainly never was that of the *David*, which, as the previously mentioned sources document, stood on its base to the left of the door to

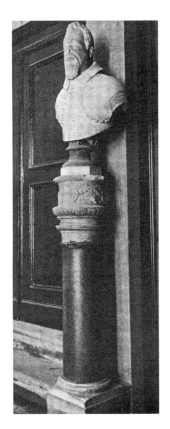

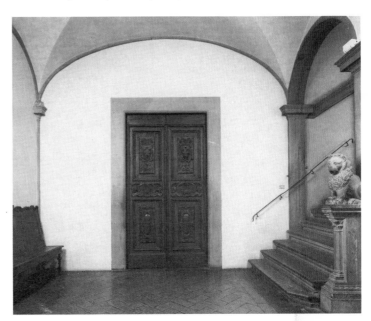

FIGURE 3. View of the Landing of the Chain in Palazzo Vecchio with *Bust of the Grand Duke Ferdinando I* (ca. 1600, School of Giambologna), 1901.

FIGURE 4. The Landing of the Chain, opposite the Sala dei Gigli, with the door to the Signoria's apartments (subsequently the Duchess's suite).

17

FIGURE 5. View of the Landing of the Chain. Entrance to the Sala dei Gigli.

the Sala dei Gigli at the top of the stairs from 1476 to at least 1561 (fig. 5). This made it necessary for anyone wanting to enter the Audience Room, coming up from the Sala dei Duecento, or from the landing of the private apartments, to pass it. The youthful hero's gaze, turned to the door of the Sala dei Gigli, where the councils met and citizens were received, would indeed have been an eloquent and highly impressive political warning.[35]

As mentioned, the arrangement of the landing had been drastically modified in 1561 in relation to the new and more convenient staircase "that clears the *ricetto* that leads to the duchess's sitting room, that from top to bottom is much more convenient, intelligent, and beautiful . . . and provides a much more gracious and convenient entrance to the large Sala dell'Oriuolo while making the *ricetto* brighter and more finely decorated than the one where the *David* stands, in addition to correcting all the errors," as Vasari stated in the detailed report he submitted to the duke along with his plans.[36] From what Vasari wrote and even more from Cosimo's reply, which expressed his fear that "this new arrangement would eat up the entire foyer that extends from the *David* to the entrance to the sitting room,"[37] we have yet another confirmation that the *David* was still in place, next to the door of the Sala dei Gigli, facing the door to Eleonora's suite. As we know, in spite of the duke's doubts, Vasari's plans were soon approved and implemented, but not without further clarifications from the architect to his lord regarding the fate of the *ricetto*.[38] The space was considerably modified with the addition of a short corridor that connects the entrance to the Sala dei Gigli with the new staircase that is much further back than the original one. Had it been left in place (but no longer at the head of the stairs), the *David* would have lost its meaning and cluttered the broader and more luminous perspective of the *ricetto* that Vasari had envisioned. Therefore, it had to be moved to the more spacious corner of the landing, to the left of the sitting room entrance and facing—rather than next to—the Door of the Chain.[39]

But for how long? We have already supposed that the statue was definitively removed in the first half of the seventeenth century and removed from the capital that may have immediately been reused for the *Bust of the Grand Duke Ferdinando I*. In the 1901 picture

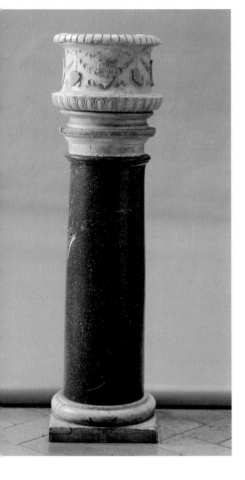

FIGURE 6. Marble pedestal and capital for Verrocchio's *David*.
FIGURE 7. Detail of the capital with the State coat of arms.

we see clearly that the column had been adapted to the purpose: it was raised with a large stone base and an additional marble block between the fifteenth-century capital and the base of the sculpture (see fig. 3). However, the seventeenth-century modification to the original *David* column was not limited to this. If we look at it carefully, the suspicion arises that much more radical changes were made.

Having determined that the capital with the coat of arms of the People and State is definitely the original that the Signoria had commissioned for Verrocchio's bronze in the Palazzo Vecchio in 1476 (fig. 7),[40] the marble support seems original and pertinent to the fifteenth-century piece. It has every appearance of being part of a column that was poorly cut and put on the fine and ancient porphyry piece that we see today (fig. 6). Taking a close look at this surviving piece of white marble that is entirely similar to the capital on top of it, we can see old scratches and deeply carved lettering that were clearly damaged by the cutting (fig. 8). Among other things, these marks reveal what was the visible part of the base when it stood on the Landing of the Chain. There, first the Signoria's guards and then Eleonora's pages stationed outside her sitting room are the prime suspects we can consider responsible for the marks on the marble.[41]

We would, therefore, suggest the possibility that throughout the time it was in the Palazzo Vecchio the *David* stood on its capital atop a white marble column (we have no idea of its height, but it was probably taller than current one)[42] that may have been damaged and considered inappropriate—in terms of style—for the bust of the grand duke. Therefore, in order to serve its new purpose, the column was cut down enough to allow attachment of the capital to the more stately antique porphyry column that had been taken from the grand ducal collection. As to when all this was done, we are tempted to date it

around the first decade of the seventeenth century, during the reign of Ferdinando I. Perhaps the severe warning and violence embodied in the fifteenth-century figure seemed inappropriate for the lavish weddings and banquets being held in the Palazzo Vecchio.[43] While awaiting new documents that shed more light on this final chapter of the history of the *David* in the Palazzo Vecchio, let us continue with its vicissitudes after it finally reached the Uffizi in the last quarter of the seventeenth century.

Notwithstanding Cinelli's explicit and precise 1677 reference, the *David* (being sculpture) was totally ignored in all the eighteenth-century Uffizi inventories. The first document to mention the statue—listing it as a "Young Mars"—was the *Inventario Generale* of 1704. The statue is entered as one of the sculptures in the "west corridor" and is described as "A modern, two-braccio high full-figure bronze on a wooden base," representing the young Mars dressed with boots and chest armor, with the hilt of the sword in his right hand and the left [hand] on his hip."[44] This means that the statue reached the Uffizi without any of the attributes that would permit an identification: the head of Goliath was still in the Guardaroba, the original sword was lost and only the hilt remained, and the statue stood on a modern wooden base. The statue's exact location in the third corridor of the Uffizi and the identification as "Mars" does not appear in the De Greyss graphics (1748.1765) or in the *Catalogo Dimostrativo* that the "custodian" Giuseppe Bianchi prepared in 1768.[45] However, one year later the new *Inventario Generale* confirmed its presence and practically repeated the description from the previous *Inventario Generale* word for word.[46]

The "incognito" *David*, sans sword and sans Goliath's head, was still in the first corridor in 1777 when Luigi Lanzi compiled the catalogue of modern bronzes to move to a new room at the end of the third corridor. He entered it among the pieces that should be moved:

FIGURE 8. Detail of scratches and graffitti on capital's support.

"Natural statue of an unknown youth, wearing a breastplate and formerly armed with a sword or dagger of which only the hilt remains."[47] In the meantime, the head of Goliath had reached the Guardaroba of the Palazzo Vecchio along with many other modern bronzes destined for the new room. Lanzi included it in his draft as: "Head of the giant Goliath with a wound in the forehead."[48] The following year, when planning the arrangement of the new Gabinetto dei Bronzi Moderni, the *David*—which not even Lanzi had recognized—was entrusted to the bronze worker Marco Corrini along with other pieces.[49] He "completed" the sculpture with an antique blade taken from the armory on October 7, 1778,[50] which is the same one it still holds today. No source, written or illustrated, gives us an idea of what the original sword looked like. It may have been a "real" blade with a tang that Verrocchio fit into the hilt. Or perhaps, and this is more likely, instead of the "dagger" that it has now, it was a curved, single-edged blade as we see in the most recurrent Davidian iconography. What is certain is that it was not much bigger than the one it has today: therefore, it was never Goliath's sword, as the Bible relates.[51]

In any event, from 1780 on, the rearmed *David* and the giant's severed head both appear in the Gabinetto dei Bronzi Moderni which—according to Lanzi—the curator Giuseppe Pelli had set up and completed. In his 1783 *Ristretto Generale,* in a brief description of the room, Pelli stated, "Youth wearing a breastplate and boots with a sword in his right hand, from the first corridor," and "on the shelf," "a bearded, anonymous head," without any further information except for the fact that it came from the Guardaroba.[52] The *Inventario Generale* of the following year allows us to pinpoint the location of both pieces: the *David* stood to the right of the entrance door, a "companion piece" to Donatello's bronze *David;* the head of Goliath was higher up, on a shelf, mounted on a yellow Siena marble base. As to the arrangement of the room, although a relationship with Donatello's sculpture was grasped, Verrocchio's bronze was still an unknown young warrior in the 1784 *Inventario;* and the Goliath head was once again "unknown," even though Lanzi's interpretation had been correct.[53] In the room that housed modern bronzes in the Uffizi, the two parts of the sculpture—still historically forgotten—were entered separately for the last time in the 1825 *Catalogo Generale.*[54]

Verrocchio's early masterpiece was finally identified between 1825 and its arrival in the Bargello around 1865. Before the middle of the century, guides had been mentioning the statue as part of the Gallery tour, on the right as visitors entered the Gabinetto dei Bronzi Moderni, where Giambologna's *Mercury* dominated the center of the room.[55] During that same period, thanks to new studies[56] and the growing popularity of fifteenth-century sculpture, Goliath's head was reattached to the *David*. Early photographs of the Bargello (fig. 9) show the two pieces together.[57] They also show some attempts at changing the position of the head which, for a while, was placed separately, to *David*'s right (fig. 10).[58] From 1916 on, when the original base with the capital finally reached the museum, the head was placed at the youth's feet and Verrocchio's bronze took on its definitive appearance (fig. 11)—the way the artist had made it in 1476 when it was decided to place it in the Palazzo Vecchio. We shall return to this shortly in the conclusion.

If at least the essential points of *David*'s history since 1476 have been determined, the early and most important portion of his history is still a mystery: the patronage, its original place, and finally the way it originally looked. With reference to the last point, scholars have long believed that the composition was modified when the Medici sold it to the Signoria, because of the limited space.[59] There is no doubt that the *David*'s dynamic pose

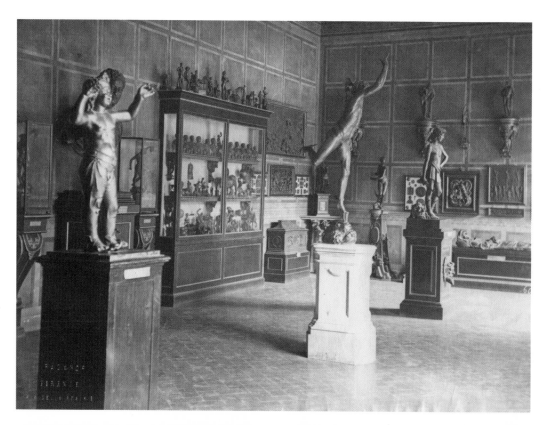

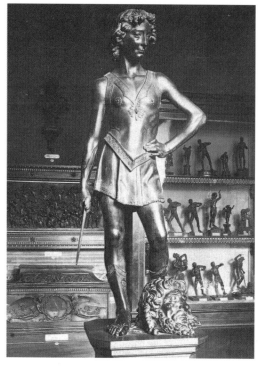

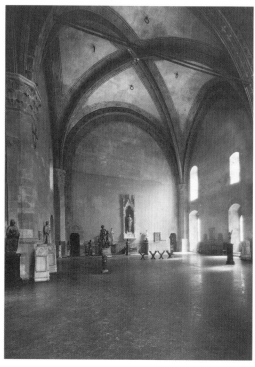

FIGURE 9. Verrocchio's *David* in National Museum of the Bargello, ca. 1880.

FIGURE 10. Verrocchio's *David* in National Museum of the Bargello, before 1916.

FIGURE 11. Verrocchio's *David* in Donatello Room of National Museum of the Bargello, ca. 1916.

NEW FACTS,
NEW THEORIES

FIGURES 12–13. Goliath, gaps in the hair.

and the liveliness of his gesture are hindered by the Goliath head that seems to impede his step and greatly detract from that illusion of motion and boldness that the artist must have conceived for the statue. On the other hand, the technique that went into the Goliath, which was made and cast separately and then mounted in the middle of the pedestal, cannot be plausibly explained given the young Verrocchio's lack of experience in "large" castings,[60] and it confirms the feeling of an adaptation imposed by new and different circumstances.

Be that as it may, the current restorations have confirmed that the giant's head was cast in relation to its exact position "embedded" between the *David*'s legs. The two gaps in the Goliath's hair—on the right and left sides of the head—were not created mechanically, as part of the finishing, but clearly show the removal of material from the wax model prior to casting (figs. 12–13). This means that Verrocchio cast the head of Goliath last and adapted it to the limited space he had available, squeezing it, as it were, between the *David*'s legs (that obviously were finished) to fit it in perfectly. Even the hole in the middle of Goliath's forehead (fig. 14) was part of the casting. The original stone, lost long ago, had been fastened into place with a pin. We cautiously hypothesized that the stone was shaped and made the way it was because it served as the head of the pin that fastened the hollow head to the pedestal. Today, this explanation seems unlikely and technically

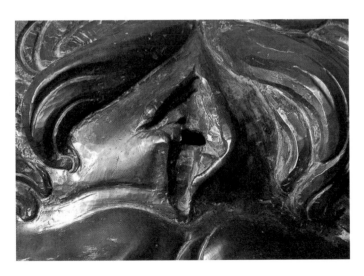

FIGURE 14. Goliath, hole in the forehead.

inappropriate, and we will suggest a reason in the final hypothesis. We believe that after the casting was complete, Verrocchio used tools to make the big hole to insert the existing pin into the middle of the base platform (fig. 15). The perimeter, in turn, was considerably reduced, allowing the statue to be fitted onto the marble capital that the Signoria had ordered for the Palazzo Vecchio (figs. 16–17). In addition to reducing the size of the figure's base and making the modifications for centering Goliath's head, moving and adapting the *David* to its new home also resulted in the mechanical removal of the block that originally included the metal core of the figure, which fastened it to the base and supported the left foot that is raised and held slightly to the rear (fig. 18).

This removal, which was done rather roughly (although the damage was not visible) created the gap beneath the statue's left foot that has erroneously been interpreted as a casting defect. It was most definitely due to the fact that the now smaller base was not an adequate static support for the figure. In fact, today the statue does not stand autonomously; it is tilted forward and to the right. The restorations have yielded other important information concerning the quality of the casting of the head and its surface finish that are clearly different from the figure of the *David*. It is most likely that the differences—which are quite obvious upon close inspection and partly attributable to the use of different tools and techniques for finishing—are the result of work by one of Verrocchio's many skilled helpers. However, taking into account all the information we have gathered to this point, we can also suggest a new hypothesis on the genesis of this sculpture.

Although we do not (and perhaps never will) know exactly how and where the Medici placed the Verrocchio bronze, it seems certain that Verrocchio's original concept of the *David* was quite different. Probably the giant's head was at his side,[61] further back and in

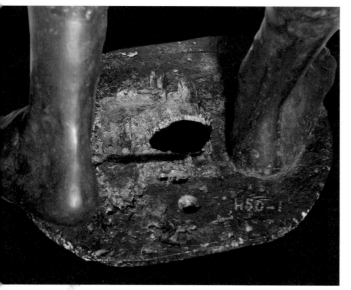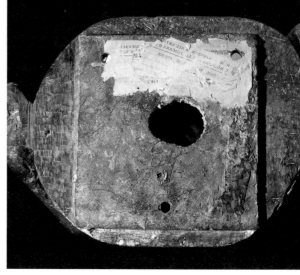

FIGURE 15. Detail of the central hole in the base of *David*.
FIGURE 16. Detail of the base of *David*, from below.

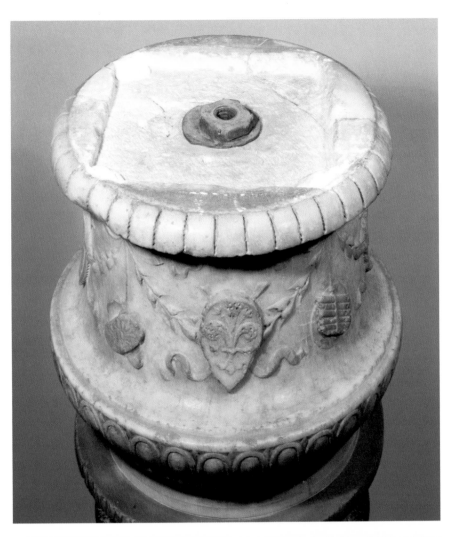

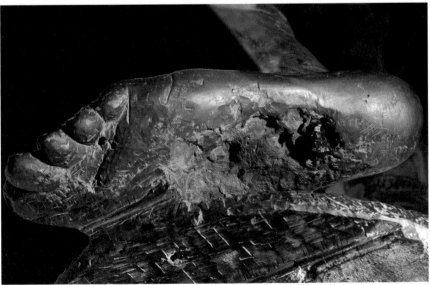

FIGURE 17. Capital of column, seen from above.
FIGURE 18. Detail of the left foot (with defect) of Verrocchio's *David*.

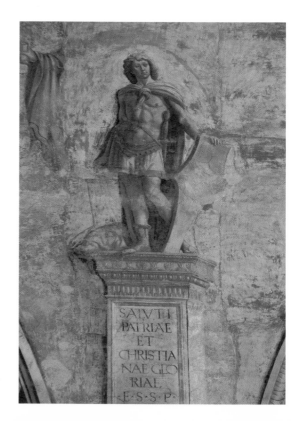

FIGURE 19. Domenico del Ghirlandaio, *David The Conqueror*, ca. 1485, Santa Trinita, Sassetti Chapel, Florence.

FIGURE 20. Sandro Botticelli, *Tragedy of Lucretia*, 1500–ca. 1504, detail, Isabella Stewart Gardner Museum, Boston.

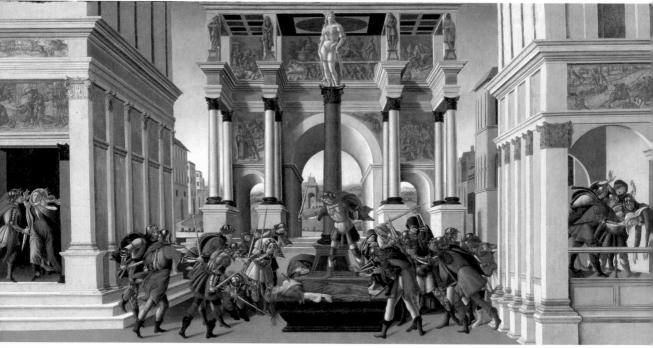

profile, more or less the way it appears in Ghirlandaio's Santa Trinita fresco (fig. 19) and other artworks from the period, such as Botticelli's *Tragedy of Lucretia* (fig. 20).[62] If this were indeed the case, we would have to think that the statue was not originally made for a pedestal and completely in-the-round viewing. The column would have had to have been enormous to support a similar display piece in a home, no matter how lavish and grandiose.[63] Suitable settings for a *David* conceived in this manner could have been a pier against a wall, as in Ghirlandaio's fresco, or even a niche in which David the conqueror and the head of his slain enemy could have formed a striking tableau that showed off the figure's dynamic features. Furthermore, a similar arrangement would have matched

FIGURE 21. Benedetto da Maiano, *Young St. John*, 1480, Sala dei Gigli, Palazzo Vecchio, Florence.

not only the traditional iconographic model that we see in paintings,[64] but also a contemporary sculpture for the Sala dei Gigli: Benedetto da Maiano's marble *Young St. John* (fig. 21), which is similar in size and was clearly inspired by Verrocchio's *David*.[65]

In any event, although its stylistic features lead us to date the *David* at the end of the 1460s, we do not know whether it was quickly completed and delivered to the Medici around that time. The death of Piero dei Medici in December 1469 and Andrea's many important commissions—he was at the peak of his career—could have postponed the final touches on the piece, which therefore would have remained in his atelier for a few years. To this we could add a lukewarm interest in this second Medici *David* on the part

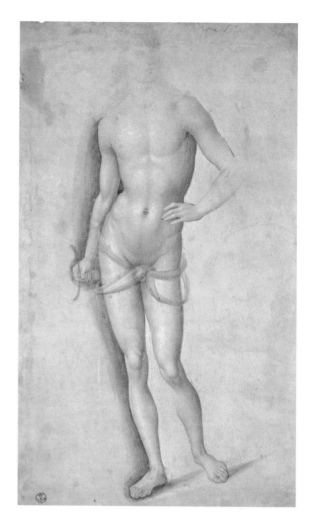

FIGURE 22. Perugino and helper (?), *Male Nude*, 1470–ca. 1480, Gabinetto Disegni e Stampe (n. 126E), Uffizi, Florence.

of both Lorenzo and Giuliano, especially in light of the political changes occurring during that decade: the 1466 foiled plot against Piero was already a memory, while the Pazzi Conspiracy (1478) that would be a determining factor in Lorenzo's future role and the future of his house had yet to be hatched. The fact remains that the original arrangement of the statue—with Goliath's head separate and on the side—must have been readily accessible to artists for long enough to inspire paintings, miniatures, and drawings, especially by Andrea's pupils, including Perugino (fig. 22) and Lorenzo di Credi (figs. 23–24).

The hypothesis is, therefore, that the completed *David* and everything that went into its making (sketches, drawings, clay and wax models, etc.) remained in Verrocchio's workshop for a long time while awaiting the move to the Medici residence, where it may have never arrived. On the larger base that allowed the figure to stand in balance, Goliath's head was probably positioned to the side of the right foot, slightly to the rear and perhaps fastened to the base by the pin concealed by the stone lodged in the forehead. However, in 1476, when the sale to the Signoria was finalized, Verrocchio had to intervene again and modify the *David* for its new setting. The perimeter of the base was reduced and the bronze head of Goliath was copied in wax from the original model (that had to have a beard and long hair spread on the ground) and then adapted to the new central position.

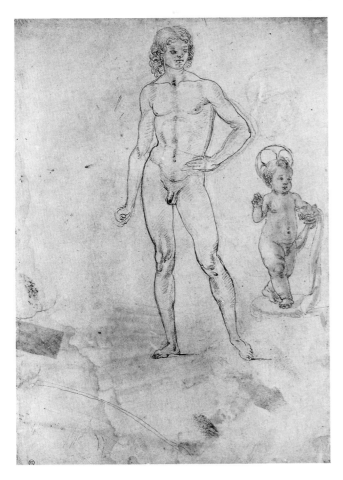

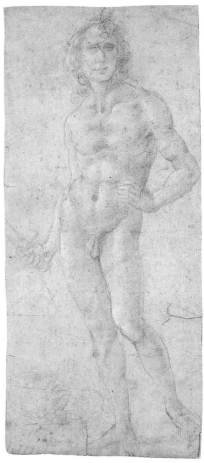

FIGURE 23. Verrocchio's Circle, *Copy from Andrea del Verrocchio's Drawing of a "Garzone" posing as David,* ca. 1470?, Cabinet des Dessins, Louvre, Paris.

FIGURE 24. Lorenzo di Credi, *Study of a Male Nude as David the Conqueror,* 1480–ca. 1490, Christ Church, Oxford.

Then it was recast using the same bronze. The stone was put into the original hole, but the inside pin, which was no longer needed to fasten the head to the base, was reduced to a mere mount for a piece that remained mobile and was soon lost. The head was now fastened via a big new hole in the middle of the base and in this way it created a center of gravity for the figure and gave it a different equilibrium.[66]

To conclude, we return to Vasari, who is perhaps more reliable than generally believed: "Andrea then returned . . . to Florence where he was commissioned to make a bronze statue of David . . . which, after it was finished, was placed . . . in the Palazzo della Signoria." It is also true that the historian is silent as to the Medici patronage and the original location of the piece, and this may be explained by the fact that it was not completed and no one ever saw Verrocchio's *David* in the Palazzo Medici.

Notes

The following abbreviations refer to manuscript collections and archives:

AGU — Archivio della Galleria degli Uffizi

ASF — Archivio di Stato di Firenze

ASSF — Archivio Storico della Soprintendenza di Firenze

1. See Andrew Butterfield, *The Sculptures of Andrea del Verrocchio* (New Haven: Yale University Press, 1997), pp. 18–19.

2. One example is Donatello's *St. Louis* (ca. 1423, Museo dell'Opera di Santa Croce, Florence). See B. Bearzi, "Considerazioni di tecnica sul San Ludo-vico e la Giuditta di Donatello," *Bollettino d'Arte* 16 (1950), pp. 119–123. This text was reprinted in L. Dolcini, ed., *Donatello e il restauro della Giuditta*, (Florence, 1988), pp. 64–66. In Verrocchio's *David* it is, above all, a particularly weak gilding that is barely glued.

3. Regarding the Medici patronage of the *David* and its implications, see John T. Paoletti's essay in this catalogue, pp. 61–81.

4. See the complete and accurate transcription in Francesco Caglioti, *Donatello e I Medici: Storia del David e della Giuditta* (Florence: L. S. Olschki Editore, 2000), p. 320; and Appendix A. The doc-ument reveals that by that date the *David* had already been delivered to the Signoria *(habiti)* and put into place in the Palazzo Vecchio *(positi);* therefore, May 1476 was the terminus ante quem for the sale.

5. Giorgio Vasari, *Lives of the Artists*, trans. George Bull (London, 1965), vol. I, p. 233; and Giorgio Vasari, *Le Vite dei più eccellenti pittori scultori ed architettori*, ed. Gaetano Milanesi (Florence: G. C. Sansoni, Editore, 1906), vol. 3, p. 360.

6. The *Candelabrum* is in the Rijksmuseum, Amster-dam. On the *Candelabrum*, see Butterfield, *Sculptures of Andrea del Verrocchio*, pp. 212–213, for the docu-ments and bibliography. The Signoria paid forty gold florins for the piece.

7. See p. 83, Appendix B.

8. As Merisalo notes: "After the seizure of all real and movable assets, and all of Piero di Lorenzo's effects, on 3 January 1497 the Officers began the exhausting task of paying the Medici debts and collecting receivables in Florence, throughout Italy and abroad, whether it was Lorenzo the Magnifi-cent's horses, the sale of products from the Medici estates, payment for artworks that Lorenzo had com-missioned or other matters." Outi Merisalo, ed., *Le Collezioni Medicee nel 1495* (Florence: Associazione Amici del Bargello/Studio per Edizioni Scelte, 1999), p. 13. See also Caglioti, *Donatello e I Medici*, pp. 325–327, specifically note 136, with the text of the docu-ment dated October 4, 1495, in which the Signoria granted Niccolò Ardinghelli permission to purchase the portrait of his mother, Lucrezia Donati, that is item seven in Tommaso's list. The amount Ardin-ghelli paid was appropriated in full by the Signoria.

9. On the decoration of the Sala dei Gigli, which was only partially completed, see Nicolai Rubinstein,

The Palazzo Vecchio 1298–1532: Government, Architec-ture and Imagery in the Civic Palace of the Florentine Republic (Oxford: Clarendon Press, 1995), specifically p. 37 ff.; Nicolai Rubinstein, "Classical Themes in Decoration of the Palazzo Vecchio in Florence," *Journal of the Warburg and Courtauld Institutes* 50 (1987), pp. 29–43; and Melinda Hegarty, "Laurentian Patronage in the Palazzo Vecchio: The Frescoes of the Sala dei Gigli," *Art Bulletin* 78 (1996), pp. 264–285. The works that were decided upon in 1469 were begun in 1472. In 1475, shortly before the *David* was placed in the *ricetto* of the Sala dei Gigli, Benedetto da Maiano had already completed the ceiling and was working on the marble door frame.

10. Caglioti, *Donatello e I Medici*, pp. 291–328.

11. Luca Landucci, *Diario fiorentino dal 1450 al 1516, continuato da un anonimo fino al 1542*, ed. I. del Badia (Florence, 1883), pp. 119, 121.

12. Piero di Marco Parenti, *Storia fiorentina*, I (1476–1478, 1492–1496), ed. A. Matucci (Florence, 1994), p. 291. The Italian *(Solo si muto il David)* may also be translated "The *David* was moved alone."

13. Caglioti, *Donatello e I Medici*, p. 311. However, see the complex story and documentary arguments in ibid., pp. 291–328.

14. This simpler interpretation offers a conceptual and linguistic explanation of the word "similarly," which in Piero Parenti's account creates a time link between the transfer of the *Judith* and the marble base of the *David*—making them contemporary. This is matched by the distinction of the statue that had been moved previously, alone.

15. The Signoria's records do not contradict—if any-thing they confirm—these conclusions. See Caglioti, *Donatello e I Medici*, pp. 300–302. In particular, Lorenzo di Giovanni Ruspoli wrote: "On 29 Decem-ber, the column of the *David* that was taken from the home of Piero di Lorenzo de' Medici was placed in the courtyard of Palazzo della Signoria." Quoted in F. L. Del Migliore, *Zibaldone istorico*, Biblioteca Nazionale Centrale, Florence, ms. Magl. XXV, 422, cited in Caglioti, *Donatello e I Medici*, p. 107.

16. See C. Frey, ed., *Il Carteggio di Giorgio Vasari* (Munich, 1923), p. 597, CCCXXXIII, *Giorgio Vasari in Firenze al duca Cosimo de' Medici in Siena*, 28 January 1561 (s. c.).

17. As Caglioti noted in *Eredità del Magnifico* (Flo-rence, 1992), pp. 11–12, there is no trace of informa-tion about a base having been made for Donatello's *David* in that place, since the base of Verrocchio's statue would have been entirely too small.

18. The famous document reads as follows: "There are two places where such a statue can stand: the first is [where] the *Judith* [stands] and the second is in the middle of the palace courtyard where the *David* is. . . . The *David* in the courtyard is an imper-fect figure because its [left] leg is bent. Therefore, I would recommend that this statue be put in either of the two places, but preferably where the *Judith* stands." On this issue and the discussion of the sources, see Caglioti, *Donatello e I Medici*, pp. 305–308, 312. The defect under the left foot of Verroc-chio's *David* will be discussed further on.

19. F. Albertini, *Memoriale di molte statue et picture sono nell'inclyta cyptà di Florentia* (Florence: Presso Antonio Tubini, 1510), c. 6r: "the bronze *David* at the top of the stairs is by Andrea Verrocchio." That is, in the corner of the landing between the top of the stairs "where the chain used to be" (Vasari) and the door to the Sala dei Gigli. See also other sixteenth-century sources such as Anonimo Gaddiano, *L'anonimo magliabechiano*, ed. A. Ficarra (Naples, 1968), p. 98; *Il libro di Antonio Billi*, ed. C. Frey (ca. 1550; reprint, Berlin, 1892), p. 47; and Raffello Borghini in *Riposo* (Florence, 1584), p. 355.

20. Butterfield, *Sculptures of Andrea del Verrocchio*, p. 204, has hypothesized that Verrocchio's statue had been moved from the chain landing between 1550 and 1568, noting that in the first edition of the *Lives* Vasari specified the site: "was placed in the ducal palace and still stands at the head of the staircase where the chain used to be." Vasari, *Lives*, ed. P. Barocchi (1550; reprint, Florence, 1966), vol. 3, p. 365. This was deleted from the 1568 edition (Vasari, *Le Vite*, ed. G. Milanesi, vol. 3, p. 360).

21. An anonymous inventory cited by Frey states that as of that date Verrocchio's bronze was not the only statue on the landing: "the bronze *David* that stands by the Chain in that palace was done by Andrea del Verrocchio. The marble figure of St. John the Baptist, at the Door of the Chain, was made by Benedetto da Maiano. The door to the audience room with a figure of the Young St. John above it, and a seated marble figure of Justice inside were all done by the hand of Benedetto da Maiano." (AGU, Misc. I, Ins. 8, c. 27r, in Frey, *Il Carteggio di Giorgio Vasari*, p. 599, note.) This is not the appropriate time to go into the identification of the second marble *St. John* that presumably stood to the right of the door of the Sala dei Gigli attributed to Benedetto da Maiano. On the relationship and political and moral significance of the figures of David and John the Baptist during the era of the Florentine Republic and with respect to the Sala dei Gigli, see Paoletti's essay in this catalogue, pp. 61–81. Among the works of Antonio del Pollaiuolo, in his *Lives* Vasari mentions a *St. John the Baptist* on the Landing of the Chain "in the palace of the Signoria of Florence, for the Porta della Catena he executed a St. John the Baptist." Vasari, *Lives*, trans. G. Bull, vol. 2, p. 75; and Vasari, *Le Vite*, ed. G. Milanesi, vol. 3, p. 293.

22. F. Bocchi, *Le bellezze della città di Fiorenza* (Florence, 1591), pp. 40–41. The Sala dei Gigli was commonly called the "Sala dell'Oriuolo" (Room of the Clock) after 1510, when the clock by Lorenzo della Volpaia was put there. See E. Allegri and A. Cecchi, *Palazzo Vecchio e I Medici: Guida Storica* (Florence, 1980), p. 395. In the Bocchi text the word *"dinanzi"* (before) could mean that as of that date the *David* no longer stood at the top of the stairs to the left of the door leading to the Sala dei Gigli but opposite it, on the far wall of the landing.

23. G. Cinelli, *Le bellezze della città di Firenze* [...] *scritte già da M. Francesco Bocchi, ed ora da M. Giovanni Cinelli Ampliate* (Florence, 1677), *Tavola delle cose più notabili*.

24. Doris Carl hypothesizes this without any documentary references. *Il David del Verrocchio*, Lo specchio del Bargello series, no. 23 (Florence, 1987), p. 7. *Guardaroba*, in current usage, is a wardrobe; literally, it means where things are kept, and in fact the immense and fully inventoried Medici *guardaroba* contained nearly everything of value, from art to tapestries, to furniture and linens.

25. As Barocchi writes regarding the modifications to the gallery during the last quarter of the seventeenth century that were met with disapproval from, among others, Cinelli: "The initial registers continued to prevail in the corridors: ancient busts and statues from Rome, Pitti and Boboli alternating with modern sculptures such as *Brutus* by Michel-angelo, *Costanza Bonarelli* by Bernini, *Laocoön* by Bandinelli. . . . The 'old' and the 'new' tried to come together in a museography that, by highlighting the most diverse contributions on both the collection and historiographic levels, was oriented towards an obvious encyclopedic approach." P. Barocchi, "La storia della Galleria degli Uffizi e la storiografia artistica," *Annali della Scuola Normale superiore di Pisa, Classe di Lettere e Filosofia* s. 3, vol. 12, 4 (1982), pp. 1440–1441.

26. During that period, Donatello's bronze *David* was moved to the Palazzo Pitti to decorate the rooms of the grand ducal apartments along with other major paintings and sculptures. In the 1637 *Inventario* of the Palazzo Pitti, it is listed as one of three sculptures above a fireplace: "The bronze *David* with the head of Goliath underfoot with scimitar in hand, approx. 1.74 meters" (ASF, Guardaroba Medicea 525, 1637, c. 20). Regarding the transfer of Donatello's *David*, see A. M. Massinelli, *Bronzetti e anticaglie dalla Guardaroba di Cosimo I* (Florence: Museo Nazionale del Bargello, 1991), pp. 25–26. As to the seventeenth-century furnishings in the Palazzo Pitti, see S. Bertelli, "Palazzo Pitti dai Medici ai Savoia," in A. Bellinazzi and A. Contini, eds., *La Corte Toscana dai Medici ai Lorena, Atti delle giornate di studio* (Florence: Archivio di Stato, 2002), pp. 11–64, appendices p. 65 ff.

27. ASF, Guardaroba Medicea 521, 1637–1638, c. 8r, 28 September 1637. It is worth noting that there is no mention of any artwork, including Donatello's marble *David*, dating from the Republic listed among the furnishings of the Sala dei Gigli as of November 21 in the *Inventario*. However, it does mention the bronze *Candelabrum* by Verrocchio that had formerly been in the Cappella dell'Udienza as "an antique bronze candlestick with leaves and on a triangular base" (c. 174).

28. ASF, Guardaroba Medicea 572, 1640, c. 1r, n. 5: "In the first room of the Guardaroba . . . a full relief head of St. John the Baptist."

29. Furthermore, there is no artwork that we know of today that fits the description.

30. The sculpture had to be separated into two parts in order to be moved: it is fastened to the base by a pin beneath Goliath's head. It is also possible that the original blade—if it still existed at the time—was removed during the move to the Guardaroba from where, we assume, the *David* was soon taken to dec-

orate some other Medici residence. The head and perhaps other attributes (the sword blade, the stone) remained there and were subsequently lost. As we shall see, the *David* turned up in the Uffizi without its original sword, and all traces of the stone that had been lodged in Goliath's forehead were lost.

31. Notwithstanding Cinelli's precise description, which apparently escaped even Lanzi, as we shall see. This also validates the hypothesis that the *David* did not come to the Uffizi directly from the Palazzo Vecchio, where tradition and artistic literature had it standing for centuries, but rather from a place totally foreign to its history following an exile that was long enough to put it into oblivion.

32. ASF, Guardaroba Medicea 746, 1666, c. 237r, in the *ricetto* of the stairs: "a marble head of the Grand Duke Ferdinando with armored torso and pedestal." In that same inventory, what we believe to be the head of Goliath is still listed in the first room of the Guardaroba along with other bronzes and described as "a full relief head of St. John the Baptist" (c. 153v), while the Verrocchio *Candelabrum* is no longer in the Sala dei Gigli but in the first room after the corridor that opens onto the Salone: "a triangular bronze candlestick with a baluster stem, with bas-relief leaves, 116 cm high" (c. 161v).

33. H. Mackowsky, *Verrocchio* (Bielefeld-Leipzig, 1901), p. 10, fig. 7.

34. See Caglioti, *Eredità del Magnifico*, pp. 10–11; and Caglioti, *Donatello e I Medici*, pp. 122–123, notes 90, 312, for an interpretation of the base and its modifications that differs from ours. On the same subject, see also Paoletti's essay in this catalogue. The white marble base that supports the porphyry column is not from the fifteenth century, but definitely a much later work.

35. On the symbolic meaning of the figure, see Paoletti's essay in this catalogue (pp. 61–81).

36. Frey, *Il Carteggio di Giorgio Vasari*, p. 598. We have already mentioned (see note 16) this long letter that Vasari wrote to Duke Cosimo in order to convince him to approve the plans, with particular emphasis on the small space in which the *David* seemed confined between the stairs and the entrance to the room. Further on in the letter he explains to the duke that if the *ricetto* was not modified "after having climbed the 25 steps to the David, it is tiring to then have to climb . . . four inside the portal within the thickness of the wall. Even though there is space and seems to make a majestic effect and has been done this way in many other places, if it is possible, I would prefer not to do it." This passage also confirms that the *David* was still there in 1561.

37. Ibid., p. 601, CCCXXXIV, 30 January 1561 [s. c.].

38. In another letter from Vasari to the duke, dated February 3, 1561 [s. c.], "the *ricetto* that we are building will, as I have again measured it, be 4.64 meters from the corner of the room." Ibid., p. 602, CCCXXXV.

39. This is noted by Bocchi and would confirm Butterfield's comment that the *David* may have been removed between 1500 and 1568 (see note 20).

40. It may have been made in Verrocchio's workshop but not by the master because "it does not follow the lines of the bronze casting with that same level of technical mastery that we would expect from a solution originally and entirely conceived by Andrea." Caglioti, *Donatello e I Medici*, p. 323.

41. Judging from the shape of one of the deeper notches on the upper edge of the molding, it seems that they used the support to sharpen their knives.

42. In this regard Paoletti hypothesizes a column of 1.44 meters for a capital with a diameter of 33 cm, like ours, corresponding to the one in the Victoria and Albert Museum. The column supporting the *David* now is 1.26 meters high. As to the possible shape of the support made for Verrocchio's bronze in 1472 (which in addition to the capital and shaft of the column must have had a carved base), see Caglioti, *Donatello e I Medici*, p. 124 ff.

43. Such as the marriage of Maria de' Medici to Henry IV of France in 1600 or the 1608 wedding of Prince Cosimo and Maria Maddalena of Austria. For the chronology of these events, see Allegri and Cecchi, *Palazzo Vecchio e I Medici*, p. 14.

44. AGU, NS. 82, 1704, *Inventario generale di tutto quanto in consegna a Gio. Francesco Bianchi Custode della Galleria di S.A.R. [. . .] dal 1794 al 1714*, p. 22 n. 225. The old Florentine unit of measure (*braccio*, which means "arm") is equivalent to fifty-eight centimeters. Thus, the statue was 116 cm high.

45. AGU, Ms. 67, *Catalogo dimostrativo [. . .]*, 1768, c. 13. See also Paola Barocchi, and Giovanna Gaeta Bertelà, "Per una storia visiva della Galleria fiorentina. Il catalogo dimostrativo di Giuseppe Bianchi del 1768." *Annali della Scuola Normale Superiore di Pisa, Classe di Lettere e Filosofia* s. 3, vol. 16, 4 (1986), pp. 1117–1230.

46. AGU, Ms. 98, 1769 *Inventario Generale di tutte le antichità, pitture, e altre preziose rarità che si conservano nella Real Galleria di S.A.R. [. . .]*, c. 46, n. 183: "An entire modern bronze figure standing on a wooden base, two *braccia* high, portraying the young Mars with boots and chest armor, with the sword hilt in his right hand, and the left on his hip." The following inventory, of 1784, lists number 3365 as the "bearded head" that matches Goliath (see note 52). The number, however, is wrong and it was not possible to identify the piece even after going through the entire inventory.

47. AGU, Ms. 106, 1777, *Sbozzo del catalogo dei bronzi moderni fatto dal Sig. Ab. Lanzi prima della mutata riordinazione*, p. 1093, 7. The piece appears again on p. 866 of the manuscript, described as "unknown hero with breastplate and sword hilt."

48. Ibid., p. 977, corresponding entry on p. 956, where it is described in the same words. It is from this description that we deduced the missing stone in Goliath's forehead.

49. See ASSF, Filza X. 1777, ins. 28 ff., for the transfer of the modern bronzes and other items to the Guardaroba of the Gallery. As to the work of Corrini, see ibid., ins. 31, 19 April 1777, *Lettera dell'abate Lanzi al Sig. Segretario de François*. Among the materials used in restoring the bronzes we find "fish

glue, vinegar spirits, rubber, ink powder, sandarac" along with "reed brushes" and "fox tails for dusting." (Ibid., Filza XI, 1778, ins. 90). It goes without saying that this information was extremely useful for the current restoration project.

50. The document, cited by B. Paolozzi Strozzi in *Il Crocifisso ligneo del Verrocchio. Letture, Artista* (1995), p. 51. note 61, is conserved in ASSF, Filza XI, 1778, ins. 90, *Nota di spese fatte da Bietro Bastianelli primo Custode [. . .] nel corso tutto dell'anno 1778,"* 7 October.

51. For an interpretation of the *David*'s weapon (which is biblically inappropriate), with reference to the probable patronage of Piero de' Medici and the anti-Medici plot of 1446, see ibid., pp. 42–44.

52. AGU, Ms. 463, I, *Ristretto generale di tutto ciò che esiste nella R. Galleria fatto nel 1783,* ins. X, Bronzi moderni, c. 69r, n. 14; c. 69v, n. 24.

53. AGU, Ms. 113, *Inventario Generale della Real Galleria di Firenze Compilato nel 1784 [. . .],* vol. II, c. 3 [immediately after Donatello's *David*]: "1° on the floor [14]. A similar [statue] of a youth with a breastplate and boots with a sword in his right hand, 116 cm high above Inv. [1769] n. 183"; "1° division above [. . .] 24. An unidentified bronze head with a yellow Siena [marble] base. Above Inv. n. 3365." On this, see the 1769 *Inventario* note 45.

54. AGU, Ms. 177, *Catalogo Generale della R. Galleria di Firenze,* 1825, classe III, tomo III, parte II, "n.2313. Giant Goliath with curly beard, parted, disorderly hair; closed eyes; deathly face due to the large wound on the forehead. Bronze head: fastened to a yellow Siena [. . .] n.2669. Unknown. A warrior, wearing a breastplate that comes to points in the back and front, decorated with a nine-petal flower. The breasts are marked by two small flowers. The edge of the upper part of the breastplate, including the armholes, is decorated with a border with unknown characters. The lower part also has a wide border, of a meander of leaves. Beneath the breastplate there is a fringed cloth, also decorated with unknown characters, that covers the body. Similar characters are visible on the tops of the boots on his feet. The rest of the body is bare. The hair is long and disheveled, his head is turned to the left and the left hand rests on his hip, in the right he holds a gladius. Bronze statue. Missing the plinth, height, greater than 121.8 cm." In this detailed description it is important to note that there is no mention of any gilding.

55. See F. Fantozzi, *Nuova guida [. . .] della città e contorni di Firenze* (Florence, 1842), p. 97: "Statua di David, di Andrea del Verrocchio."

56. Especially Bode (1882–1887) and the early monographs dedicated to Verrocchio by Semper (1877), Mackowsky (1901), Cruttwell (1904), and Reymond (1906). On Verrocchio's critical success in that period and for a complete bibliography, see D. A. Covi, "The Current State of Verrocchio Study," in Steven Bule, Alan Phipps Darr, and Fiorella Superbi

Gioffredi, eds., *Verrocchio and Late Quattrocento Italian Sculpture* (Florence: Le Lettere, 1992), pp. 7–23.

57. They were entered in the Bargello's *Inventario dei Bronzi* under nos. 450 and 451, respectively.

58. Perhaps when the molds of the statue were made, in 1876 and 1886. See *Donatello e il primo Rinascimento nei calchi della Gipsoteca* (Florence, 1995), in particular pp. 234–236. Also see the report on the restorations.

59. See Gary Radke's essay in this catalogue, pp. 35–53. It was no accident, as we have already noted, that among the various arrangements of the piece in the Bargello before it was replaced on its pedestal, the head of *Goliath* was also exhibited separately, to the *David*'s right and slightly behind the figure, almost duplicating the *David* as it appears in Ghirlandaio's freso in Santa Trinita.

60. As maintained by Butterfield, *Sculptures of Andrea del Verrocchio,* p. 27. The extraordinarily fine finishing of the *David* that is discussed in the essay on the restorations attests to Verrocchio's training as a goldsmith, a practice that was still prevalent at that time. Furthermore, this experi-ence coincides with the commissions for the large bronzes at Orsanmichele (1466) and the ball atop the cathedral dome (1468). In order to make these pieces, the artist had to have proven experience in large castings.

61. Following through with this hypothesis, it could have been on the *David*'s right, even though the figure is tilted forward, as we mentioned earlier. Goliath's head positioned in this way forms a perfect diagonal with the *David*'s left arm resting on his side and closes the composition.

62. See Radke's essay in this catalogue for a full listing.

63. Paoletti has a different opinion on this subject. See his essay in this catalogue.

64. One example is sufficient, *Uomini Illustri* by Andrea del Castagno (ca. 1450, Galleria degli Uffizi, Florence), which used to be in the Villa di Legnaia.

65. The *Young St. John* by Benedetto—who was carving the marble door of the Sala dei Gigli, where the statue would be placed when Verrocchio's *David* was brought to the Palazzo Vecchio in 1476—is approximately 1.40 meters tall (including the 15 cm base); Verrocchio's bronze is 1.26 meters tall. The marble busts of *Piero* and *Giovanni de' Medici* (made by Mino da Fiesole in 1453–1454 and 1455, respectively) stood in similar niches above the doors of the Palazzo Medici as specified in G. Gaeta Bertelà and M. Spallanzani, eds., *Inventario in morte di Lorenzo il Magnifico, 1492* (Florence, 1992), cc. 14r and 38v.

66. In fact, beneath the base we can clearly see the change and reduction of the original mount to adapt it to the marble base that was made for it (see figs. 16-17). For the technical details supporting this thesis, see the conservation report in this catalogue (pp. 97–109).

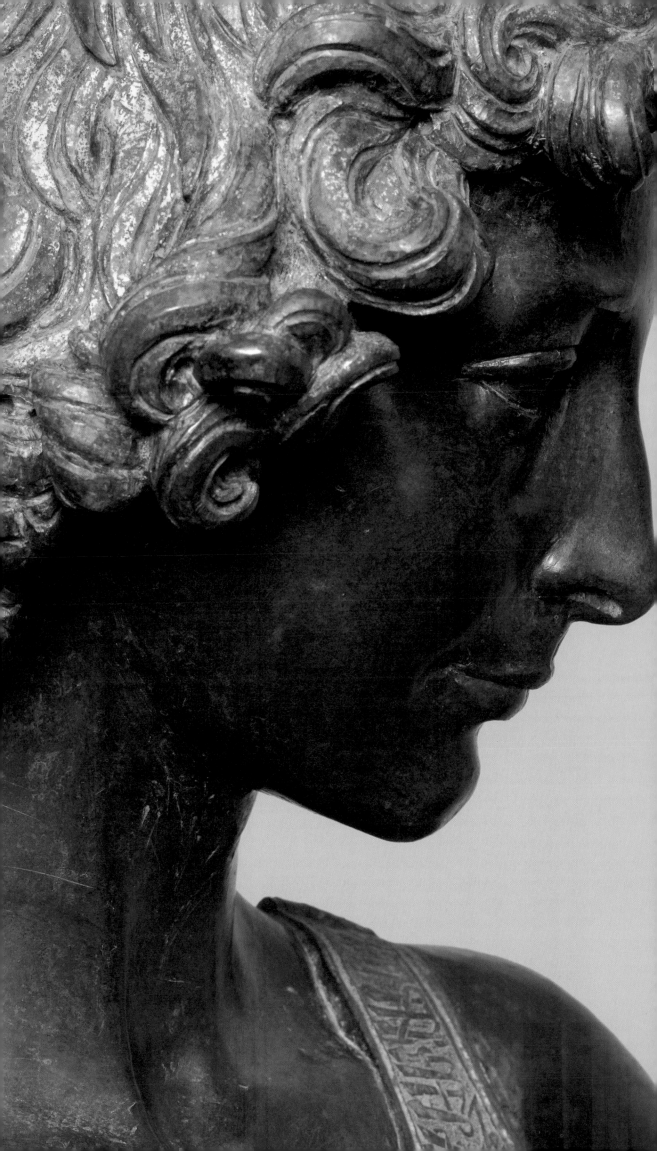

Gary M. Radke

VERROCCHIO AND THE IMAGE OF THE YOUTHFUL DAVID IN FLORENTINE ART

When Andrea del Verrocchio was commissioned to produce a bronze figure of David for the Medici family in Florence he could have turned to numerous earlier renditions for inspiration. Marble and bronze sculptures, reliefs, frescoes, panel paintings, parade decorations, wedding chests, birth trays, engravings, and manuscript illuminations all had depicted David. David's image appeared in public and private, religious and secular settings.

David fascinated the Florentines more than any other Old Testament figure, thanks in no small part to the fact that—rare among prophet figures—his life is fully recounted in the Bible.[1] He was both a great and an unlikely hero whose career saw a meteoric rise. After slaying Goliath with nothing but a slingshot and faith in God, David repeatedly defeated the menacing Philistines and firmly established the kingdom of Israel. Christians regarded him as the royal ancestor of Christ himself.

A recent study of biblical and other texts regarding David has shown that for the Florentines he personified humility, divine aid against enemies, patriotic defense, right of conquest, justice, prosperity, and civic harmony.[2] David was also an emblem of friendship because of the great love he felt for King Saul's son Jonathan. In addition, as putative author of the Book of Psalms and famed player of a soothing harp, David was associated with worship and music. Both lay devotions and formal liturgies included regular readings from the Psalms, so David's "voice" was constantly in worshippers' ears. What is more, his psalms are no pious platitudes. They range from joy to despondency, from meek acceptance of God's will to anger and vindictiveness. David was a real human being. He lusted after another man's wife (Bathsheba) and then arranged for her husband, Uriah, to be sent to a certain death. He even sired illegitimate, treacherous, and immoral children, not just the virtuous and wise Solomon. In the end, however, David redeemed himself through penitence and trust in God, a worthy model for less than perfect Florentine merchants and their families.

A recent inventory identified thousands of examples and no fewer than 245 different scenes from the life of David in medieval art across Europe.[3] Florentine depictions of David are distinctive, however, in their focus on his youth.[4] To be sure, in standard prophet cycles like the one envisioned in the late 1330s by Andrea Pisano for the bell tower of Florence Cathedral (fig. 1) David appears as a crowned and bearded ruler,[5] just as he appeared throughout the Middle Ages in jamb statues and other large individual representations on cathedral portals. Renaissance artists also portrayed David as a mature, regal musician in engravings and manuscript illuminations associated with the Psalms, often seated with his famed harp in his lap (fig. 2).[6] But beginning around 1330, nearly a decade before Andrea Pisano carved his traditional David, Taddeo Gaddi (active ca. 1328–1366) invented an alternative image that complemented, and in the fifteenth century

35

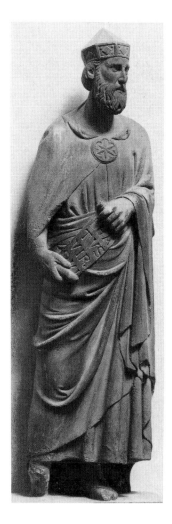

FIGURE 1. Andrea Pisano, *David*, late 1330s, marble, Museo dell'Opera del Duomo, Florence.

FIGURE 2. *Prophet David*, mid-fifteenth century, fine manner Florentine engraving, British Museum, London.

eclipsed, this representation (fig. 3). For the first time in Florentine art David was depicted as a young hero trampling Goliath.[7] Located in a fictive niche on a pier immediately to the right of the altar of the Baroncelli Chapel at Santa Croce, David appeared with all the attributes with which he would be associated for the rest of the Renaissance.[8] He is beardless and wears a youthful, short tunic, much as he had done in Byzantine art.[9] His shins are revealed and he wears leather boots. Standing triumphantly on the back of an armored Goliath, whose decapitated body is too large to appear in isolated sculptural representations, David places his right foot on the giant's back, seeming to expel blood from his severed neck. Blood drips as well from Goliath's head, which David holds by the hair in his left hand, a formulation that became popular among painters but which sculptors, for obvious structural reasons, avoided.[10] Confident but passionless, the youthful hero brandishes Goliath's large sword in his right hand; a simple slingshot hangs from his right hip.[11]

Whereas similar images of David had appeared in narrative cycles on medieval cloister capitals,[12] in reliefs around cathedral portals,[13] and in manuscript illuminations,[14] they were always part of larger cycles of his entire life. Never before had the triumphant youthful David been singled out for such prominent, monumental representation. The figure in Gaddi's frescoes contrasts markedly with a bust-length representation of David as king, paired with Solomon, on the intradose of the chapel's entrance arch. What is more, the youthful David turns toward the altar, and—more than any of the other images in the chapel—overlaps his framing colonettes, seeming about to step into the viewer's space.[15] This is a bold and insistent image, especially when compared to the other standing prophets and saints in the chapel's frescoes and stained-glass windows, nearly all of whom are bearded, wear traditional, long flowing robes, and never overlap their frames.[16]

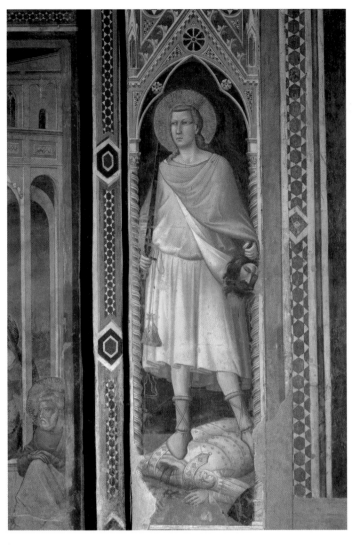

FIGURE 3. Taddeo Gaddi, *David,* ca. 1330, fresco, Baroncelli Chapel, Santa Croce, Florence.

What motivated Gaddi and his Florentine patrons the Baroncelli to make such a break with tradition? David's location just under the standing figure of his father Jesse is understandable in the context of the chapel's dedication to the Annunciate Virgin, whose lineage had Davidic roots,[17] but Gaddi's depiction of the young rather than regal David emphasizes military and political interests instead of genealogical ones. Contemporary events may provide a clue to understanding the artist's and patrons' intentions. In the period immediately prior to the decoration of the Baroncelli Chapel, Florentines were continually assaulted by the territorial ambitions of Castruccio Castracani, tyrannical lord of nearby Lucca.[18] Castruccio's rout of Florentine troops in 1325 at the infamous battle of Altopascio, combined with bankruptcies and political problems at home, led to great civic embarrassment and disillusion. In December 1325 the communal councils took the extreme step of abandoning their representative ideal and named Charles, Duke of Calabria, Lord of Florence for an unprecedented term of ten years.[19] Charles attempted to impose order, but heavy taxation and vascillating policies quickly made him unpopular.[20] Then, just as Florentines were considering an armed rebellion against Charles, both he and their archenemy Castruccio Castracani suddenly died in the fall of 1328. It was believed that God had intervened to save Florence from two tyrants in one blow.

To students of Renaissance art and history, this episode sounds strikingly familiar, for it anticipates by three-quarters of a century a famous episode in Florence's struggles to maintain its liberty against the imperialist ambitions of the Milanese tyrant Gian-

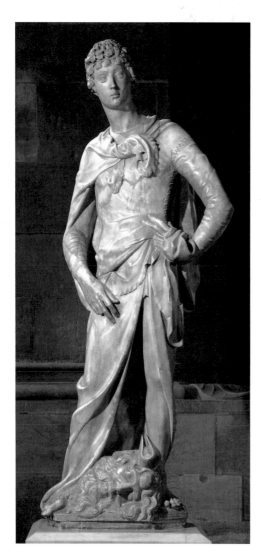 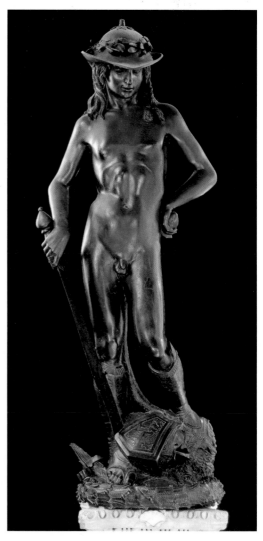

FIGURE 4. Donatello, *David*, 1408–1409, marble, National Museum of the Bargello, Florence.
FIGURE 5. Donatello, *David*, 1450s?, bronze, National Museum of the Bargello, Florence.

galeazzo Visconti, who also died suddenly as he was about to capture an overpowered Florence. Frederick Hartt argued convincingly that Donatello's marble *David* of 1408–1409 (fig. 4)—the first monumental, sculptural representation of the young David triumphant over Goliath—should be seen as part of a visual response to assaults on Florentine liberty.[21] Just as God had assisted the young David, armed only with a slingshot and his faith, so God intervened on the part of vulnerable Florence. The youthful David, who was credited with composing the triumphant Psalm "Benedictus Domini" immediately after defeating Goliath, stood as a universally recognized emblem of patriotic defense and divine aid against enemies.[22] His prominence in the Baroncelli Chapel is thus undeniably appropriate and timely, especially for the Baroncelli family, one of whose members, Bartolo Manetti Baroncelli, was buried in the chapel and had been taken prisoner at the battle of Altopascio.[23] God could be understood to have overturned the Florentines' infamous defeat.

Although not much other Davidian imagery survives from the Trecento,[24] when the Florentine guilds decided around 1390 to decorate the vaults of the communal granary and Marian shrine of Orsanmichele with images of saints, David once again appeared as

a youthful military hero. In the program created by Francesco Sacchetti,[25] he stands with other representatives of the Old Testament period of Mosaic law. However, all the other figures in this bay are older military saints who don military helmets. David, instead, is hatless and again wears a short tunic and cloak like Gaddi's figure. Guardian, hero, defender, and Marian ancestor, he occupies pride of place in this civic setting, standing in the eastern severy of the bay directly in front of the Marian tabernacle.[26] Clearly, the youthful David had captured Florentine imaginations. Indeed, when in 1408 the Opera del Duomo commissioned prophet figures for the buttresses of the cathedral, youth was again on their minds. Donatello's David was matched by Nanni di Banco's Isaiah, perhaps the only youthful representation of that prophet in the history of Florentine art.[27]

For all their civic resonance, Trecento and early Quattrocento images of David appeared in predictably ecclesiastical contexts. In 1416, however, the Signoria took the extraordinary step of expropriating Donatello's marble figure of David from the Opera del Duomo. Donatello was paid the not-insignificant sum of five florins to adapt it for display in the main meeting hall of the city council. Janson has suggested that Donatello extensively re-carved parts of the figure, perhaps removing a scroll that would have been appropriate for the figure in the original prophet cycle at the cathedral but which may have seemed awkward in its new, governmental context.[28] From this time on, the youthful David could no longer be seen as just a religious image; he was securely a civic icon. Town fathers made this clear in an inscription they added to Donatello's sculpture: "God gives aid to those who fight for the country even against the most terrible foes."[29]

Thus when the Medici commissioned Donatello to create a bronze figure of David for their family palace (fig. 5), they could have been seen as great patriots on one hand, or, on the other, as presumptuous usurpers of civic imagery.[30] No David in the history of Florentine art has produced such a prodigious and conflicting literature.[31] Proposed dating ranges from the late 1420s through the 1460s;[32] its unusual imagery has prompted numerous identifications and associations with figures other than David, including Mercury and Ganymede;[33] and its sensual, erotic character has not gone unnoticed.[34] For the purposes of this essay it is perhaps best to emphasize just how singular the work was. While it carried an inscription that once again identified David as a great civic hero ("The victor is he who defends the country; God crushed the wrath of a huge enemy; Behold a boy has defeated a great tyrant. Conquer O Citizens!"[35]), there is much that is strange about Donatello's representation. First and most obvious is its state of partial undress, rather than the total nudity of most antique sculptures and Michelangelo's later David. Instead, Donatello created a youth who wears no clothes but still dons a shepherd's hat and splendid boots. What is more, David is peculiarly united to Goliath. The giant's beard caresses David's big toe while a long feather on the back of his helmet rises suggestively up the entire length of David's inner thigh. Meditative and self-absorbed rather than confident and vigilant, Donatello's bronze David is a beautiful but disturbing object. Its exact meaning and the specific intentions of both the artist and patron are difficult to discern.

Not surprisingly, numerous statuettes and manuscript illuminations inspired by Donatello's work "correct" some of its problematic aspects. For example, in illuminating the text of some psalms composed by Giovanni di Paolo da Castro for Piero de' Medici between 1466 and 1469, Mariano del Buono depicted a clothed, hatless David standing above an unhelmeted Goliath (fig. 6).[36] He also added a slingshot to make narrative sense of the single stone that Donatello's statue holds in his left hand. In other words, Mariano

made changes to just those aspects of the sculpture that continue to strike us as odd today. Still, Mariano's reference to Donatello's work remains unmistakable, both in the figure's pose and in the words the scribe has written below it, a near verbatim reprise of the inscription on Donatello's statue. The same normalizing of Donatello's image is seen in statuettes by Donatello's student and assistant Bartolomeo Bellano (fig. 7), numerous examples of which were distributed throughout central and northern Italy.[37]

Lorenzo Ghiberti and His Influence on David Imagery

A new chapter in the history of David imagery in Florence opened in 1452 with the installation of Lorenzo Ghiberti's *Gates of Paradise* (fig. 8). In the end, it was to be Ghiberti, not Donatello, who was responsible for popularizing the story of the youthful David throughout Florentine art, especially in paintings intended for domestic settings. Ghiberti's *David* panel, the last of ten Old Testament scenes that he composed for the doors of the Florentine Baptistery, is situated at the bottom of the left valve. There, easily visible from slightly above, a small but extremely vigorous young David dominates the foreground. Framed in a slight concavity next to a pebbled streambed from which he probably chose the stones for his slingshot, David lunges forward, forcing all his weight on Goliath's substantial sword in order to decapitate the sprawling, fallen giant. Ghiberti catches David at the moment of his

FIGURE 6. Mariano del Buono, *David*, ca. 1466–1469, manuscript illumination, Biblioteca Medicea Laurenziana, plut. XIX, 27, fol. 23v–24r, Florence.

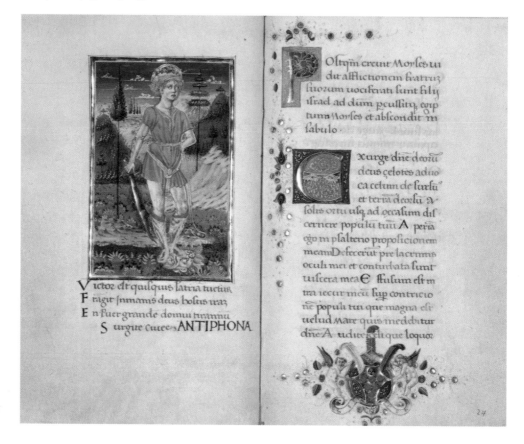

FIGURE 7. Bartolomeo Bellano, *David*, ca. 1490?, bronze, Philadelphia Museum of Art, Philadelphia.

FIGURE 8. Lorenzo Ghiberti, *David and Goliath* from *Gates of Paradise*, cast by 1436, gilt bronze, Museo dell'Opera del Duomo, Florence.

indisputable victory, not at the vulnerable moment of his approach toward Goliath with only slingshot in hand.[38] Behind and to the left of David we see the beginning of the conflict as King Saul imperiously lifts his baton to lead his troops into battle. In the middle and right portions of the relief, soldiers engage in vicious hand-to-hand combat, finally routing the Philistines. In the background dancing girls meet Saul's victorious troops, led by David with the head of Goliath in his hands, just outside the city gate of Jerusalem. The city itself—with several domed and arcaded structures, numerous towers, and even a commemorative column at the far right—seems more Rome than Jerusalem, and it is girdled by crenellated walls that distinctly recall Florence's own fortifications.

Ghiberti's focus on the decapitation and the subsequent space he devotes to David carrying and displaying Goliath's head merit notice. Historians of criminal justice in the Renaissance have noted that hanging—far more frequent than decapitation—was the most common form of capital punishment.[39] Beheading was largely reserved for the malfeasances of high officials. John of Salisbury, who wrote the most influential medieval exposition of political theory, emphasized that since a ruler is the head of a state, his head had to be severed from the state if he grossly abused his powers.[40] Thus, David's decapitation of Goliath is to be understood as a kind of tryannicide, a warning to anyone in republican Florence who might think to seize personal political authority. There was no little irony, then, that the Medici, who were often accused of tyrannical ambitions, had images of David and Judith, both tyrant slayers, in their private home. How could they be guilty of tyranny when they were so obviously and publicly allied against it?

Ghiberti provided his contemporaries with a compelling way of telling the story of David's victory over Goliath. Soon after the panel's installation, versions of the story began to appear with great regularity in prints and on *cassoni* (marriage chests) and birth plates.

41

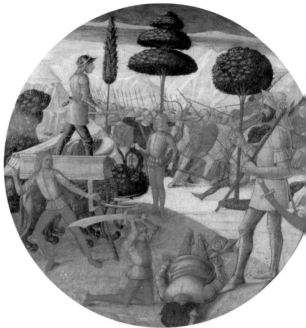

FIGURE 9. Florentine, *David and Goliath*,
ca. 1470–1490, engraving,
British Museum, London.

FIGURE 10. Florentine, *David and Goliath,* ca. 1470,
tempera on wooden panel, The Martin D'Arcy
Gallery, Loyola University, Chicago.

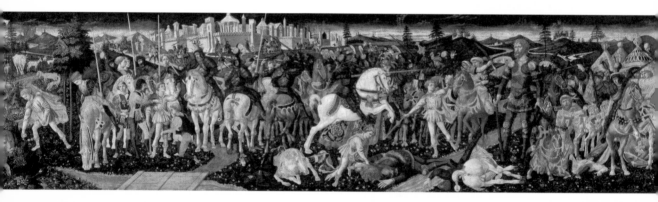

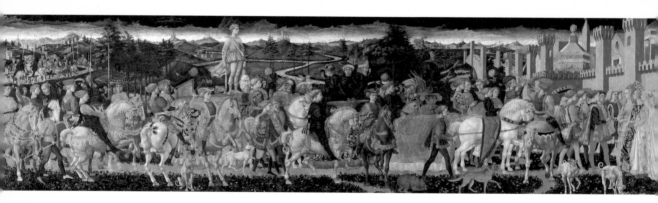

FIGURE 11. Francesco Pesellino, *David and Goliath,* 1450s,
tempera on wooden panel, National Gallery, London.

FIGURE 12. Francesco Pesellino, *Triumph of David,* 1450s,
tempera on wooden panel, National Gallery, London.

THE YOUTHFUL
DAVID IN
FLORENTINE ART

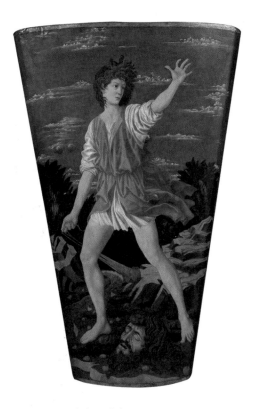

FIGURE 13. Andrea del Castagno, *The Young David with the Head of Goliath*, ca. 1450, tempera on leather and wood, National Gallery of Art, Widener Collection, Washington, D.C.

Once again they give pride of place to the decapitation rather than to the dramatic but less decisive moment of David approaching Goliath with his slingshot. By their reproductive nature, prints tended to remain closest to Ghiberti's formulation. An example from between 1470 and 1490 (fig. 9) contains most of the major elements of Ghiberti's narrative, focusing our attention on the act of decapitation.[41] Sword still high over his shoulder, David has yet to strike the final and decisive blow but the outcome is certain: the head of the stunned Goliath will soon roll. David appears at the same moment but now on his knees in the foreground of a contemporary birth plate (fig. 10). Here we also see David slinging his stone at Goliath, but that action takes place behind the featured beheading, which the artist placed on the central axis just below David's presentation of Goliath's head to Saul in the very center of the plate. The heated battle between the Israelites and the Philistines serves merely as a backdrop to David's presentation of the head. Jacqueline Musacchio has interpreted the choice of this subject for a birth salver as a wish on the part of new parents that their son would be brave and virtuous.[42] She has also raised the fascinating question of how and why this head-toting, sword-wielding David became "domesticated" in the second half of the fifteenth century.[43] Images of David became so common in this period that it is difficult to see overtly political and/or civic motives in these commissions. Instead, appropriate to their function, *cassoni* and birth plates celebrate brave and victorious youth. Indeed, David's early exploits ended with Saul granting him the hand of his daughter Michal in marriage.

Appropriately, then, the story of the young David appears numerous times on wedding chests.[44] On the front of one of the most splendidly preserved sets (figs. 11–12), Pesellino repeated the main elements of Ghiberti's formulation in an even more elaborate and slightly expanded narrative. At the far left of the first *cassone* David gathers stones, moving on at the right to be fitted with and reject Saul's armor, and then on to set his slingshot into motion against a towering Goliath. Even here, however, the decapitation is shown at the center foreground of the painting, just as in Ghiberti's panel and the birth plate. Pesellino concludes his story on the front of the second *cassone,* which is completely given over to a representation of Saul's and David's triumphal return to Jerusalem. Appropriate to the matrimonial associations of *cassoni,* handsomely garbed young men lead the procession where they, not David, are met by even more splendidly dressed young women, presumably their wives-to-be. David, instead, stands like an isolated statue atop a triumphal cart. But, unlike any of the actual statues or statuettes of the subject, David holds Goliath's large head by the hair as a trophy, much as he had done in Trecento painted representations of the subject (see fig. 3).

Andrea del Castagno's representation of David (fig. 13) from around the same time as the *cassoni* is unusual in focusing upon the stone-wielding David. Castagno's depiction,

43

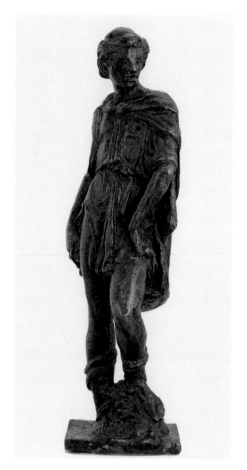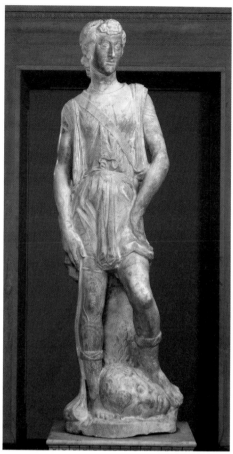

FIGURE 14. Donatello, *David*, 1460s?, bronze, National Museums, Berlin.

FIGURE 15. Bernardo Rossellino?, *David*, 1460s?, marble, National Gallery of Art, Widener Collection, Washington, D.C.

painted on a leather parade shield, includes the requisite bloody head of Goliath, stone lodged in his forehead, at the bottom center of the composition. But above Goliath's head a barefoot David, seemingly caught in the whirlwind of his own swinging slingshot, focuses his eyes and raised left hand at Goliath outside the pictorial field. This is the sort of theatrical implied narrative that is not thought to have been invented until the seventeenth century, when Gianlorenzo Bernini created his splendid marble *David* now in the Villa Borghese. Similarly, in emphasizing David's encounter with Goliath rather than the subsequent victorious moment of decapitation, Castagno anticipates Michelangelo's famous formulation. And yet the pose of Castagno's *David* is very much of his own time, recalling that of the slinging David in Pesellino's *cassone* with the outcome made clear by the head at his feet. It was Goliath's head, not David's slingshot, that viewers expected as proof of David's victory.

Very late in his life, Donatello again turned to the subject of David with a more traditional image than the nude he had produced for the Palazzo Medici. Ursula Schlegel has argued convincingly that a bronze statuette now in Berlin (fig. 14) is the relic cast of a wax model Donatello made in the 1460s.[45] Charles Seymour's further suggestion that it represents an idea formulated by Donatello for the most important David commission of that time—the "giant" commissioned in 1464 from his student, Agostino di Duccio, which eventually became Michelangelo's monumental David—merits serious consideration,[46] though the work may just as likely reflect an idea for another commission, perhaps even

for the Medici just before Verrocchio was asked to produce his image. At the very least, the reinvigoration of the prophet cycle at the Duomo in the 1460s signals a continuing interest in the image of David in this period, as does Verrocchio's commission itself. Posed much like the nude bronze *David,* but now clothed, Donatello's late *David* is more alert and vigilant, the cape and cocked head suggesting an update of his early marble *David* that stood in the Palazzo della Signoria (see fig. 4) combined with the vigilant pose and equally jaunty cloak of his St. George for Orsanmichele. The position of the hilt of the sword suggests that this David was to have held the weapon out in front of himself, as St. George originally did, rather than resting it at his side, an important shift that is reflected in a number of subsequent manuscript illuminations[47] and which had significant visual consequences for Verrocchio. Holding to tradition, however, David once again places his left foot firmly on Goliath's head, strands of the giant's beard swirling around some of the toes on David's other foot.

The only surviving large-scale reflection of Donatello's sketch model is the much altered Martelli *David,* now in Washington, D.C. (fig. 15). A detailed visual analysis by John White shows that the marble sculpture is a largely recut work that deceptively gives the impression of being unfinished.[48] According to White's reconstruction, the sixty-four-inch statue had been brought to a nearly complete state by one of Donatello's students or close followers: Agostino di Duccio and Bernardo Rossellino are the most likely candidates.[49] Closely resembling the Berlin statuette, the figure was cloaked and stocky. He held his arms close to his body and was intended to be viewed head-on from an octagonal base. This is the version Verrocchio is likely to have known when he was conceiving his bronze statue. Soon afterward, however, another sculptor—perhaps impressed with Verrocchio's extraordinarily open composition—undertook an ill-fated attempt to free the figure's arms from his body and make the composition more three-dimensional. At this point the cloak was removed, David's boots were partially transformed into sandals, and torn leggings were invented for David's right leg.[50] When these transformations failed to improve the work—indeed, they nearly ruined it—the sculpture was subjected to a third intervention in which someone willfully hacked at the surface to make it appear unfinished, probably before 1488, when the sculpture is first recorded in the Casa Martelli.

Verrocchio's Bronze David

For all of the common features of the works discussed, little in this survey of David imagery prior to the mid-1460s prepares us for Verrocchio's fresh imagining of David. Smiling, dressed in militarily inspired garb, and lifting his left foot off the ground as if in movement, Verrocchio's *David* definitively altered David imagery for the rest of the fifteenth century. To be sure, Verrocchio seized upon the aged Donatello's idea of having David hold out a sword. He looked as well at the old master's marble statue in the Palazzo della Signoria (see fig. 4), which likely inspired him to bring the fingers of David's left hand up across his waist. But Verrocchio is the first sculptor to exploit the implications of the sword's freedom and set his statue into motion. Whereas in all previous sculptures of David, even Donatello's Berlin sketch, the figure stands in iconic stasis, balancing his foot on Goliath's head and locking his toes into Goliath's beard, Verrocchio's *David* jauntily swings his left leg. The general pose is actually that of Donatello's nude bronze—weight on his right hip and arm akimbo over his bent left leg—but Verrocchio enlivens and energizes it.

For the first time in a sculptural representation of David, Verrocchio also cast the head of Goliath separate from the main figure. It was a curious thing to do if Verrocchio

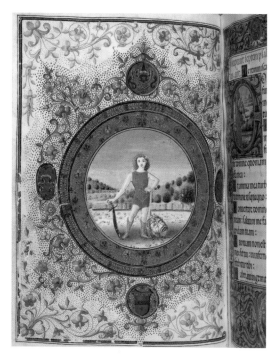
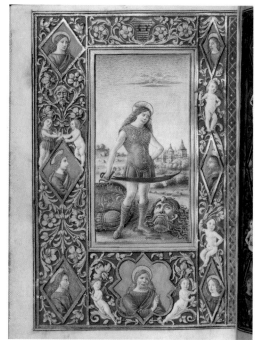

FIGURE 16. Mariano del Buono, *David*, after 1464, manuscript illumination, ms. 1722–1921, fol. 108v, Victoria and Albert Museum, London.

FIGURE 17. Attavante, *David and Goliath*, 1470s, manuscript illumination, Wil Rp 867 oct., Royal Castle, Warsaw.

originally intended to place the head in its traditional position between David's feet. In all of Donatello's compositions, Goliath's head is not just an essential iconographic attribute; it also provides a physical anchor, lessening the likelihood that the bronze or marble would crack at the figure's ankles—just as tree stumps and small allegorical figures support ancient Roman marble copies of Greek bronzes. Since Verrocchio went to unprecedented risk and trouble modeling and casting his *David* without such support at its feet, the artist may have intended originally to place Goliath's head elsewhere.[51] Verrocchio surely would not have wanted to obscure David's virtuosic pose, so reminiscent of ancient gems owned by the Medici and eerily prescient of the graceful movement of the soon-to-be discovered *Apollo Belvedere*.[52]

Manuscript illuminations help to confirm this hypothesis. A series of miniatures, all clearly derived from Verrocchio insofar as they dress David in the unprecedented military garb invented by him, show Goliath's head to David's left. The head had never been positioned this way before. As we have seen, earlier artists preferred to depict the actual moment of the decapitation,[53] show David holding Goliath's hair and dangling the head from his left hand,[54] or place Goliath's head under David's foot (see fig. 6). In the wake of Verrocchio, however, Mariano del Buono positioned David alone in a landscape with Goliath's severed head on the ground and to his left, slightly behind David's foot (fig. 16).[55] In other illuminations probably dating from the early 1470s Attavante repeated the position to the figure's left and added the giant's body (fig. 17).[56]

Further evidence that Verrocchio originally intended Goliath's head to be positioned alongside his sculpture, not between his feet, appears in representations of sculptures of David in subsequent paintings. In a panel of the *Marriage of Stratonice* (fig. 18) a statue of a vigorous, armor-clad David stands atop a vase-shaped pedestal. Once again Goliath's head appears on David's left, Goliath's chin just barely overlapping the young hero's foot. Some later images, also representing sculptures of David, move Goliath's head to the figure's right.[57] Still, the fact remains that in these representations, too, Goliath's head was displaced from between David's feet.

THE YOUTHFUL
DAVID IN
FLORENTINE ART

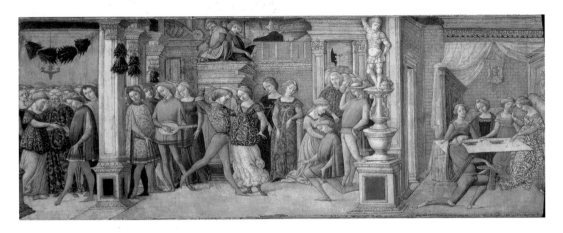

FIGURE 18. Master of Stratonice, detail of *Marriage of Stratonice,* ca. 1470, tempera on panel, The Huntington Library, Art Galleries, and Botanical Gardens, San Marino, California.

Tellingly, the only drawing that can be associated with Verrocchio's project for David, an anonymous workshop copy of a nude young man standing in the same distinctive pose, includes no head of Goliath whatsoever (see page 29, fig. 23).[58] Similarly, in a more muscular invention from the 1480s, Lorenzo di Credi, Verrocchio's student, posed David in an open stance with a swinging left foot. Almost as an afterthought he barely sketched out Goliath's head on an executioner's block to the figure's right.[59] This contrasts markedly with earlier studies, such as a series of Davids drawn in the 1450s by Maso di Finiguerra, in which David always stomps on Goliath's head.[60]

Without Goliath's head between David's feet, then, Verrocchio's original conception of the sculpture demands that we imagine the figure moving forward. The idea of David standing with the head of Goliath to his side may de-rive from images of David standing over the sprawled, decapitated body of Goliath, but his almost dance-like pose, confident demeanor, and easy movement suggest more of a contemporary festival reenactment and retelling of the story than a straightforward narrative of the biblical text.[61] Verrocchio seems to imagine a moment when David moves beyond slaying his enemies and looks out to future greatness as king and prophet.

Such imagery is fully consistent with Medicean visual politics. As John Paoletti shows in his essay in this catalogue (see page 65), the figure's commission may be associated with the Medici family's successful survival of the Pitti conspiracy in 1466. If so, Verrocchio's sculpture of David promoted the idea

47

FIGURE 19. Master of the St. John and David Statuettes, *David,* 1490?, terra-cotta, National Gallery of Art, Kress Collection, Washington, D.C.

FIGURE 20. Antonio del Pollaiuolo, *David*, ca. 1480, tempera on panel, National Museums, Berlin.

that the Medici were vigilant but undeterred by threats to their position in Florence. David retains a small sword in his right hand—a warning to future challengers—but Goliath, an earlier scourge, is left in the shadows.

Still, Verrocchio's image is not without its contradictions. This is the first sculpture of David in Florentine art to wear militarily inspired rather than civilian or shepherd's garb,[62] perhaps an allusion to St. Paul's admonition to "put on the full armor of God."[63] Indeed, artists inspired by Verrocchio's sculpture often read it as armor, as seen in manuscript illuminations, frescoes, and terra-cotta statuettes. But as is typical of so many commissions associated with the Medici, Verrocchio's imagery is actually much more subtle and understated. While David's jerkin resembles an ancient cuirass and leather skirt, it can at most be interpreted as a military undershirt and skirt. He is also incompletely armed. His costume lacks the epaulets and rolled-up sleeves of actual armor. The bones of his own ribs, not the idealized musculature of cuirass armor, push against his tight shirt. Neither does he wear greaves or a helmet. Verrocchio's *David* presumably could don armor if he needed to, but here he seems more an athlete than a soldier, a citizen not a military victor. He is alert and vigilant but not ready for nor interested in battle—a model of both Medicean restraint and rulership.

By the time Lorenzo and Giuliano de' Medici sold their *David* to the Signoria in May 1476, Verrocchio's bold conception had been blunted. As Beatrice Paolozzi Strozzi and Maria Grazia Vaccari suggest in this catalogue (see page 28), the work may never have arrived in the Palazzo Medici as Verrocchio originally intended it. With Goliath's head squeezed between his feet, David was once more the traditional fixed, civic icon guarding the republic. A commission to Domenico Ghirlandaio to depict famous defenders of republican liberty—nearly all in armor, on the walls of the Sala dei Gigli at which David stood guard—reinforced this image.

A popular series of terra-cotta statuettes (fig. 19) doubtless reflects the arrangement of the sculpture as it was displayed after 1476.[64] Also dating from around this time is a David (ca. 1480) by Antonio del Pollaiuolo (fig. 20),[65] who stands astride a Goliath head

FIGURE 21. Michelangelo, *David*, 1501–1504, marble, Galleria dell'Accademia, Florence.

clearly inspired by Verrocchio's separately cast head. Goliath's doleful eyes, exposed teeth, and undulating hair suggest that Pollaiuolo studied Verrocchio's example very closely, even if he did not arm David in Verrocchio's new manner.

In the end, Verrocchio's original idea to portray David without the head of Goliath lodged between his feet meant that Pollaiuolo's sort of representation was on the wane. Instead, Verrocchio opened the door to the possibility that David might eventually be portrayed with no Goliath head at all. In his famous giant of 1501–1504 (fig. 21), Michelangelo created just such an image. Michelangelo reclaimed and heroicized the nudity of Donatello's bronze *David* (see fig. 5), eliminating the ambiguity of Donatello's partially clothed youth. At the same time Michelangelo paid more than passing tribute to Verrocchio's experiment. Both Verrocchio's and Michelangelo's Davids eye the future. In each, blood pulsates vigorously through the veins of the statue's right arm. Each is poised to move forward. And in each we sense David coming of age, not bound by the biblical narrative to being a young boy but first becoming a confident teenager in Verrocchio's conception and then a fully mature man in Michelangelo's. Small in physical stature and deceptively sweet and pleasant, Verrocchio's *David* nonetheless marked a major shift in conceptualizing the young biblical hero. Indeed, for the entire last quarter of the fifteenth century, Verrocchio's *David* served as the preeminent and definitive expression of David in Medicean Florence, both in its original conception and as frequently viewed and admired in the Palazzo della Signoria.

49

Notes

1. 1 Sam. 16–31, 2 Sam., and 1 Chron.

2. Andrew Butterfield, "New Evidence for the Iconography of David in Quattrocento Florence," *I Tatti Studies, Essays in the Renaissance* 6 (1995), pp. 115–133.

3. *King David in the Index of Christian Art,* ed. Colum Hourihane (Princeton: Princeton University Press, 2002).

4. See the ambitious but often unnecessarily revisionist overview by Volker Herzner, "David Florentinus," *Jahrbuch der Berliner Museen* n.s. 20 (1978), pp. 43–115, and n.s. 24 (1982), pp. 63–142.

5. See Luisa Becherucci and Giulia Brunetti, *Il Museo dell'Opera del Duomo a Firenze* (Venice: Electa, 1971), vol. 1, pp. 240–241.

6. Arthur M. Hind, *Early Italian Engraving: A Critical Catalogue with Complete Reproduction of All the Prints Described* (1938; reprint, Nendeln, Liechten-stein: Kraus, 1970), part I, vol. 1, p. 166, and vol. 2, plate 224.

7. Andrew Ladis, *Taddeo Gaddi: Critical Reappraisal and Catalogue Raisonné* (Columbia, Mo.: University of Missouri Press, 1982), pp. 88–90, plates 4b-1 and 4h-1. Ladis and others have called attention to this being an early isolated representation of the young David, but none have explored the particular significance or motivation for the creation of this novel image. Julian Gardner, "The Decoration of the Baroncelli Chapel in Santa Croce," *Zeitschrift für Kunstgeschichte* 34 (1971), pp. 89–114, has demonstrated the sophistication of the program and visual organization, suggesting that it was conceived by Giotto but taken over by Gaddi.

8. Although Robert J. H. Janson-La Palme, "Taddeo Gaddi's Baroncelli Chapel: Studies in Design and Context," Ph.D. diss., Princeton University, 1975, vol. 1, p. 341, suggests that he may have worn a crown painted *al secco,* that attribute is not visible in the fresco today.

9. See in particular the splendid silver plates preserved at The Metropolitan Museum of Art, New York, which have spawned an impressively rich bibliography. They have most recently been reevaluated by Ruth E. Leader, "The David Plates Revisited: Transforming the Secular in Early Byzantium," *Art Bulletin* 82 (2000), pp. 407–427.

10. Benvenuto Cellini's famed sculpture of *Perseus* (1545–1554, Loggia dei Lanzi, Florence) finally overcame this difficulty and is justly famous for the way Perseus dangles the head of Medusa from his outstretched left arm.

11. Gaddi had originally imagined a longer slingshot. Its shadowy image is visible below the figure's skirt, while the correction stands out clearly against the figure's yellow skirt.

12. For example, on the capitals of the west gallery at St. Pierre, Moissac, ca. 1100.

13. The left pedestals of the central bay of the north facade porch at Chartres Cathedral (1220–1230) include David being anointed, David playing before Saul, David arming himself before Saul, David encountering Goliath and hurling stones, and David cutting off Goliath's head. Also, half medallions and quatrefoils appear on the right portal of the west facade of Auxerre Cathedral (1260–1270).

14. A thirteenth-century Old Testament picture book in the Pierpont Morgan Library, New York (M638, fol. 28r–29r), contains a particularly rich cycle.

15. The only other niche figure that slightly overlaps its frame is the Madonna and Child on this same level of the frescoes.

16. They include representations of Jesse (directly above David) as well as Jeremiah, Isaiah, Ezekiel, and Daniel in the frescoes over the entrance arch to the chapel. Sts. Francis, Peter, John the Baptist, Louis of Toulouse, Sylvester, John the Evangelist, and Bartholomew are featured in the stained-glass windows. As is traditional, Louis of Toulouse is shown beardless as may be Daniel, whose image is difficult to read.

17. Gardner, "Decoration of the Baroncelli Chapel," p. 103, makes this association.

18. Janson-La Palme, "Taddeo Gaddi's Baroncelli Chapel," vol. 1, p. 344, made the connection with Castruccio, incorrectly stating, however, that Castruccio was dead by the time the chapel was begun. His remains the only extensive discussion of David in the Baroncelli Chapel (vol. 1, pp. 339–345), and in a note (vol. 1, p. 511 n. 7) he mentions Verrocchio's *David* as a later version of Gaddi's creation.

Intriguingly, David may at first have been included in the iconographic program for simple genealogical reasons. An inscription in the chapel says that the structure was begun in February 1328, half a year before Charles's and Castruccio's deaths. But by the time Taddeo Gaddi reached the lowest level of his frescoes—where he was to paint the figure of David —the foreign lords had been defeated, the republic had been restored, and Florence was about to enter what one historian has called the century's "halcyon years." (Marvin B. Becker, *The Decline of the Commune,* vol. 1 of *Florence in Transition* [Baltimore: Johns Hopkins Press, 1967], p. 89). Without changing the basic scheme, Gaddi gave it a new spin and in turn formulated a type of Florentine David that was to become standard for the rest of the Renaissance and beyond.

19. Becker, *Decline of the Commune,* p. 84, notes that there was extremely little opposition to his election. Most communal officials held terms no longer than six months.

20. See *Cronica di Giovanni Villani* (1823; reprint, Rome: Multigrafica, 1980), vol. 5, pp. 144–145: "se l' duca non fosse morto, non potea guari durare, ch'è Fiorentini avrebbono fatta novità contra la sua signoria, e rubellati da lui."

21. This interpretation was first formulated in Frederick Hartt, "Art and Freedom in Quattrocento Florence," in Lucy Sandler, ed., *Essays in Memory of Karl Lehman* (New York: Institute of Fine Arts, New York University; distributed by J. J. Augustin, Locust Valley, N.Y., 1964), pp. 114–131. Although Butterfield, "New Evidence," p. 117, discounts this interpretation

because of its dependence on analogy rather than specific texts, the popularity of the youthful David in Florentine public art, his appearance at crucial moments in the city's history, and the documented appropriation by the Signoria of several sculptures of David from the Opera del Duomo and the Medici make it clear that David was not just of generic significance to the Florentine government.

22. Butterfield, "New Evidence."

23. Janson-La Palme, "Taddeo Gaddi's Baroncelli Chapel," vol. 1, p. 343. It is also interesting to note that the intradose decorations of the chapel's entrance arch include a pair of Old Testament heroines, Jael and Judith, who, like David, display the decapitated heads of their enemies. Judith has widely been recognized as another emblem of civic triumph in Renaissance Florence. Most recently see Francesco Caglioti, Donatello e I Medici: Storia del David e della Giuditta, 2 vols. (Florence: L. S. Olschki, 2000).

24. Francis Ames-Lewis, "Art History or Stilkritik? Donatello's Bronze David Reconsidered," Art History 2, no. 2 (1979), p. 141 n. 12, has recognized the influence of Gaddi's figure in an illuminated manuscript in the Biblioteca Nazionale Centrale, Florence: Esposizione del Pater Noster, cod. II. VI. 16, fol. 34v.

25. Werner Cohn, "Franco Sacchetti und das Ikonographische Programm der Gewölbemalereien von Orsanmichele," Mitteilungen des Kunsthistorischen Institutes in Florenz 8 (1958), pp. 65–77.

26. An image of the crowned, harp-playing David as psalmist appears at the center of the frieze of prophets on the back of the marble tabernacle.

27. See Mary Bergstein, The Sculpture of Nanni di Banco (Princeton: Princeton University Press, 2000), pp. 99–105.

28. H. W. Janson, The Sculpture of Donatello (Princeton: Princeton University Press, 1963), pp. 3–7.

29. "Pro patria fortiter dimicantibus etiam adversus terribilissimos hostes deus praestat auxilium," quoted in Maria Monica Donato, "Hercules and David in the Early Decoration of the Palazzo Vecchio: Manuscript Evidence," Journal of the Warburg and Courtauld Institutes 54 (1991), pp. 90–91. Prior reports of this inscription inaccurately indicated "gods" instead of "God."

30. John T. Paoletti has provided the most reliable and consistent appreciation of this aspect of Medici patronage.

31. Caglioti, Donatello e I Medici, provides the most recent and exhaustive view of the literature to date. See also Sarah Blake McHam, "Donatello's Bronze David and Judith as Metaphors of Medici Rule in Florence," Art Bulletin 83 (2001), pp. 32–47.

32. Christine M. Sperling, "Donatello's Bronze 'David' and the Demands of Medici Politics," The Burlington Magazine 134 (1992), pp. 218–224; and H. W. Janson, "La Signification politique du David en bronze de Donatello," Revue de l'Art 39 (1978), pp. 33–38, associates the statue with early conflicts in the 1420s with Visconti Milan. On the opposite end of chronological possibilities, John T. Paoletti, "The Bargello David and Public Sculpture in Fifteenth-Century Florence," in Wendy Stedman Sheard and John T. Paoletti, eds., Collaboration in Italian Renaissance Art (New Haven: Yale University Press, 1978), pp. 99–111, reminds us that the earliest documented presence of the statue in the Medici courtyard dates from descriptions of the 1469 wedding of Lorenzo de' Medici and Clarice Orsini, so the work might even have been cast posthumously.

33. Alessandro Parronchi, "Mercurio e non David," in Donatello e il potere (Bologna: Cappelli; Florence: Il portolano, 1980), pp. 101–126; and Albert Czogalla, "David und Ganymedes, Beobachtungen und Fragen zu Donatellos Bronzeplastik 'David und Goliath,'" in Festschrift für Georg Scheja zum 70. Geburtsag (Sigmaringen, Germany: Thorbecke, 1975), pp. 119–127.

34. Most recently see Adrian W. B. Randolph, "Homosocial Desire and Donatello's Bronze David," in Engaging Symbols: Gender, Politics, and Public Art in Fifteenth-Century Florence (New Haven: Yale University Press, 2002), pp. 138–192.

35. "Victor est quisquis patriam tuetur/Frangit immanis Deus hostis iras/En Puer grandem domuit tiramnum/Vincite cives." Sperling, "Donatello's Bronze 'David,'" proposed to identify the author of the inscription with Francesco Filelfo. Caglioti, Donatello e I Medici, p. 57 f, makes a more convincing case for associating it with Gentile de' Becchi.

36. Florence, Biblioteca Medicea Laurenziana, plut. XIX, 27, fol. 23v–24r. See Caglioti, Donatello e I Medici, pp. 283–289, for a discussion of this manuscript. Another image attributed to a collaborator of Mariano, the so-called Master of Riccardiano 231, Book of Hours, Stratton on the Fosse, Downside Abbey, fol. 214v, reverses David's pose and dresses him in a slightly more risqué tunic cut up on the sides to his waist. Like the statuettes and other illuminations, the work eliminates David's hat and Goliath's helmet but adds a slingshot. See Annarosa Garzelli, Miniatura fiorentina del Rinascimento, 1440–1525: Un primo censimento (Florence: Giunta regionale Toscana & La Nuova Italia Editrice, 1985), vol. 1, p. 212, and, for an illustration, vol. 2, fig. 763.

37. The finest examples are the David illustrated in fig. 7 from the Foulc Collection, now in the Philadelphia Museum of Art, and another version in the Ruxton Love Collection, The Metropolitan Museum of Art, New York, both illustrated and discussed in Alan Phipps Darr, ed., Italian Renaissance Sculpture in the Time of Donatello (Detroit: Founders Society, Detroit Institute of Arts, 1985), pp. 225–228. The Foulc David is particularly charming insofar as it includes a circular rilievo schiacciato under its base showing David tending his flocks. Variants include rather decadent third- or fourth-generation casts like a statuette in the Frick Collection illustrated in John Pope-Hennessy, The Frick Collection, An Illustrated Catalogue, III, Sculpture, Italian (New York: The Frick Collection; distributed by Princeton University Press, 1970), pp. 67–71, or fresher reconceptions like a statuette in The Metropolitan Museum of Art that John Pope-Hennessy attributed to Maso di Bartolomeo. See

John Pope-Hennessy, *Luca della Robbia* (Ithaca: Cornell University Press, 1980), pp. 264–265.

38. Sometimes represented in paintings and manuscript illuminations, this scene rarely appeared in narrative sculpture. A rare exception is Bartolomeo Bellano's bronze relief of a miniature David confronting the looming giant on a scoured plane in his David reliefs for the choir of the Santo in Padua. See *Le sculture del Santo di Padova*, ed. Giovanni Lorenzoni (Vicenza: Neri Pozza, 1984), p. 100.

39. For example, Samuel Y. Edgerton, "Images of Public Execution," in *Pictures and Punishment: Art and Criminal Prosecution during the Florentine Renaissance* (Ithaca: Cornell University Press, 1985), pp. 126–164.

40. Very helpfully summarized in McHam, "Donatello's Bronze 'David,'" pp. 40–41.

41. Arthur M. Hind, *Early Italian Engraving*, part 1, vol. 1, pp. 138–139, and vol. 2, plate 202.

42. Jacqueline Marie Musacchio, *The Art and Ritual of Childbirth in Renaissance Italy* (New Haven: Yale University Press, 1999), pp. 67–68.

43. Musacchio is preparing a book-length consideration of domestic imagery in general. Her most recent remarks on David were given in New York at the 2003 annual meeting of the College Art Association.

44. Ellen Callmann, *Apollonio di Giovanni* (Oxford: Clarendon Press, 1974), p. 39 n. 4, presents an impressive list.

45. Ursula Schlegel, "Problemi intorno al David Martelli," in *Donatello e il suo tempo: Atti dell'VIII Convegno internazionale di studi sul Rinascimento, Florence and Padua, 1966* (Florence: Istituto nazionale di studi sul Rinascimento, 1968), pp. 245–258; and Douglas Lewis in Darr, *Italian Renaissance Sculpture in the Time of Donatello*, pp. 127–128.

46. Charles Seymour, *Michelangelo's David: A Search for Identity* (Pittsburgh: University of Pittsburgh Press, 1967), pp. 35–39.

47. For example, an illumination by Bartolomeo di Domenico di Guido, *Hours of Alessandro Taddei*, ca. 1467–1476, British Library, London, ms. add. 11528, fol. 207v, discussed by Garzelli, *Miniatura fiorentina del Rinascimento*, vol. 1, p. 168.

48. White's unpublished analysis can be consulted in the curatorial files of the National Gallery of Art. Douglas Lewis gives an excellent summary in Darr, *Italian Renaissance Sculpture in the Time of Donatello*, pp. 176–178.

49. Hartt recognized strong similarities between *David*'s face and work documented to Bernardo Rossellino in the Chapel of the Cardinal of Portugal, Florence. See Frederick Hartt, "New Light on the Rossellino Family," *The Burlington Magazine* 103 (1961), pp. 387–392.

50. Douglas Lewis and Caroline Wilson Newmark have recently noted that leggings of this sort appear in Mantegna's work by the 1450s, when Donatello was active in Padua. This rustic idea could, then, have been Donatello's, though not the execution. Lewis intends to publish their observation and posit

the idea that Bartolomeo Bellano carried out the changes according to Donatello's directives but that when Donatello saw how inept they were, he, like Michelangelo in the sixteenth century, attempted to destroy the work. This would account for the hacking and "unfinished" appearance of the sculpture as we see it today.

51. First suggested by Andrew Butterfield, "Verrocchio's *David*," in Steven Bule, Alan Phipps Darr, and Fiorella Superbi Gioffredi, eds., *Verrocchio and Late Quattrocento Italian Sculpture* (Florence: Le Lettere, 1992), p. 109, fig. 64. Butterfield based his suggestion on nineteenth-century photographs showing *David* with Goliath's head placed to the figure's right. Butterfield indicated that his hypothesis needed to be confirmed by further study.

52. See Phyllis Pray Bober and Ruth Rubinstein, *Renaissance Artists & Antique Sculpture: A Handbook of Sources* (London: Harvey Miller; Oxford: Oxford University Press, 1986), pp. 71–72, 74.

53. Such imagery continued well into the 1470s and 1480s. See, for example, Garzelli, *Miniatura fiorentina del Rinascimento*, vol. 2, fig. 716.

54. Later examples include Garzelli, *Miniatura fiorentina del Rinascimento*, vol. 2, figs. 718, 843, 924, 984, and 1073. A particularly splendid example appears in Sidney Colvin, *A Florentine Picture-Chronicle by Maso Finiguerra* (1898; reprint, New York: B. Blom, 1970), plate lxxviii.

55. Roger Wieck has kindly called to my attention a similar image on panel of around 1490, now in the Tenschert Collection, illustrated in Cor Engelen, *Miroir du Moyen Age* (Leuven: Cor Engelen, 1999), p. 174.

56. A very similar representation with both the head and the body of Goliath to David's left survives in The Hermitage, St. Petersburg, ms. Basilewski 440 n. 676 (illustrated in Garzelli, *Miniatura fiorentina del Rinascimento*, vol. 2, fig. 859). A version from the 1490s for a member of the Pitti-Taddei de' Gaddi family of Florence (now New York, Pierpont Morgan Library, Ms. M. 14, fol. 104v) shows Goliath's head apparently behind and to the left of *David*, but here the head's position cannot correspond fully to Verrocchio's conception because David seems to step on the giant's mouth, a physical impossibility for the sculpture. I am very grateful to Roger Wieck for calling this image to my attention. See also a similar image from around 1480 in an Office for the Dead, illustrated in Engelen, *Miroir du Moyen Age*, p. 174, again called to my attention by Roger Wieck.

57. Domenico Ghirlandaio, figure of David over the entrance to the Sassetti Chapel, Santa Trinita, Florence, 1485; and Botticelli, sculpture of David on a tall column in his panel of *Tragedy of Lucretia*, ca. 1504?, Isabella Stewart Gardner Museum, Boston. Illustrated here at p. 26, figs. 19-20.

58. Paris, Musée du Louvre, Cabinet des Dessins, illustrated here at p. 29, fig. 23.

59. Oxford, Christ Church, 0057, illustrated and discussed in Patricia Lee Rubin and Alison Wright, *Renaissance Florence: The Art of the 1470s* (London:

National Gallery Publications Limited; distributed by Yale University Press, 1999), pp. 272–273. Here see p. 29, fig. 24.

60. See Lorenza Melli, *Maso Finiguerra: I disegni* (Florence: EDIFIR, 1995), figs. 78, 79, and 166 Florence, Gabinetto dei disegni degli Uffizi, 41 F and 42 F; and Stockholm, National Museum, NMH 72/1863).

61. Verrocchio's contemporaries and competitors explored such ideas in their work, too. See, for example, the splendidly balletic dancers by Antonio del Pollaiuolo in the frescoes of the Villa Gallina, Arcetri (after 1464), which in their ruinous state resemble ancient vase painting but probably looked quite different in their original condition. See Leopold Ettlinger, *Antonio and Piero Pollaiuolo* (Oxford: Phaidon; New York: Dutton, 1978), pp. 145–146 and plates 22–27.

62. Ames-Lewis, "Art History or *Stilkritik?*," pp. 137–155, fig. 27, reproduces a most unusual image of a standing, bearded, and armor-clad older David who may predate Verrocchio's work. The illumination (Evangelistary, f. I, Florence, Biblioteca Medicea Laurenziana, Ms. Edili 115) is attributed to Filippo di Matteo Torelli (1365–1442).

63. Eph. 6:11.

64. Well-known examples are preserved in the collections of the Victoria and Albert Museum, London; The Princeton University Art Museum; and the National Gallery of Art, Washington, D.C. (Kress Collection).

65. See Sonja Brink, "Der Berliner 'Verkündigung' and der 'David' von Pollaiuolo," *Jahrbuch der Berliner Museen*, n.s. 32 (1990), pp. 153–171, esp. 168 f.

David Alan Brown

THE PRESENCE OF THE YOUNG LEONARDO IN VERROCCHIO'S WORKSHOP

Giorgio Vasari described Leonardo da Vinci as "marvelously endowed by heaven with beauty, grace, and talent in such abundance that he leaves other men far behind." Leonardo's miraculous abilities were first displayed, according to Vasari, in the *Baptism of Christ* now in the Uffizi Gallery, Florence. The young artist's teacher, Andrea del Verrocchio, "happened to be painting a St. John baptizing Christ," Vasari said, and "for that picture Leonardo did an angel holding some garments: and although quite young he made it far better than the figures of Andrea. The latter would never afterwards touch colors, chagrined that a child should know more than he."[1] Vasari recounted this episode of jealous rivalry in order to contrast what he saw as Verrocchio's plodding efforts with Leonardo's divine gifts. Leonardo's kneeling angel from the *Baptism* (fig. 1) has likewise been contrasted with its prosaic companion by Verrocchio and seen as a kind of spiritual self-portrait of the young prodigy. And yet, since Leonardo's share in the painting most likely represents the culmination of his early work with Verrocchio, it would have to have been completed when the younger artist was in his mid-twenties, too old for the angel to represent him.

The workshop in which Verrocchio and Leonardo collaborated was not simply a context: it provided the conditions that allowed Leonardo's creativity to flourish. Primarily a sculptor in marble and bronze, Verrocchio took up painting about the time that Leonardo came to work with him. Parts of the *Baptism* and of the painting *Tobias and the Angel* (fig. 2) represent Verrocchio's achievement in this field. Attempting to translate sculpture into painting, he achieved a striking new realism, much admired by Florentine humanists and merchants. But Verrocchio was not well versed in painting. For that reason and to expand his production, he employed a stellar group of painting assistants, including Leonardo, Botticelli, Perugino, Ghirlandaio, and Lorenzo di Credi. Though less accoplished as a painter than his assistants, Verrocchio nevertheless provided them with a few exemplary models, to which the pupils responded each in his own way.

Clearly Leonardo did not burst on the scene in the form of the angel in the *Baptism*, and today there is a consensus that his early production includes the Uffizi *Annunciation*, the *Portrait of Ginevra de' Benci* in the National Gallery, Washington, D.C., a *Madonna* in Munich, and those parts of the *Baptism* that are not by his teacher. While predictably uneven and dependent on the master, Leonardo's early paintings adumbrate a precocious view of nature that he would later develop in his notebooks. In these works the young artist rejected the meticulous clarity of Verrocchio's "goldsmith aesthetic" in favor of his distinctive vision of forms dissolved in light and atmosphere. To express this vision, Leonardo adopted the newly introduced medium of oil, dabbing the wet paint with his fingers to create a "soft-focus" effect.

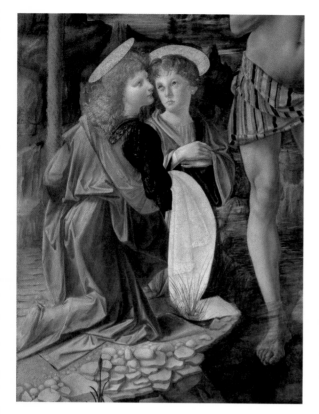
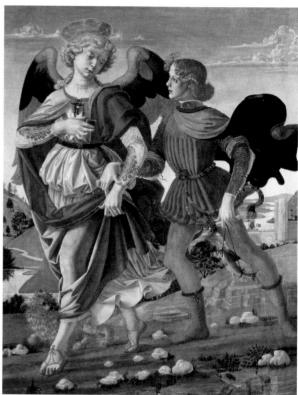

FIGURE 1. Verrocchio and Leonardo, *Baptism of Christ*, 1472–1475, tempera on panel, Uffizi Gallery, Florence.
FIGURE 2. Verrocchio and Leonardo, *Tobias and the Angel*, 1470–1480, tempera on panel, National Gallery, London.

The paintings just mentioned, together with a small number of related drawings, were completed by Leonardo in Verrocchio's workshop between 1472 and 1476, when the pupil was in his early- to mid-twenties. Despite his subsequent fame, there is almost no factual information about the young Leonardo. We know only that he was born in the hill town of Vinci, twenty miles west of Florence, on April 15, 1452, the illegitimate son of Ser Piero da Vinci and a country girl named Caterina. He was raised in the household headed by his paternal grandfather, who listed the lad in his tax return of 1457. Leonardo's father meanwhile was working as a notary, drawing up legal documents in Florence. Sometime in the late 1460s Ser Piero apprenticed his son to Verrocchio.[2] Vasari is our source for this information, and two official records indicate that Leonardo was still in Verrocchio's employ in 1476, meaning that he remained with his teacher for an uncommonly long time. Leonardo's decade-long attachment to Verrocchio argues for a special creative relationship between master and pupil, and this is borne out by their works.

Paintings like *Ginevra de' Benci* are too accomplished to be Leonardo's initial efforts. They date from the 1470s, when the young artist was emerging as an individual in Verrocchio's workshop. But if Leonardo entered the shop at the normal age for beginning an apprenticeship, around 1466, what did he produce at the outset of his career? The first painting in which Leonardo's hand can be plausibly identified is *Tobias and the Angel* (fig. 2).[3] On close examination, this unassuming little panel, often dismissed as shopwork, becomes one of the most fascinating pictures of the entire Quattrocento. It belongs to a series of similar representations of the theme, which was highly popular in Florence during the last third of the fifteenth century. To invoke the saint's protection over their offspring, merchants who sent their sons away on family business frequently commissioned pictures of the Archangel Raphael guiding young Tobias on his journey. In this

FIGURE 3. Detail from *Tobias and the Angel,* National Gallery, London.

case, Verrocchio's part of the picture may be identified in the figure of the archangel and in the landscape, which displays a lack of feeling for nature. Inexperienced as he was at portraying flora and fauna, Verrocchio seems to have turned to the young Leonardo for the extraordinarily lifelike and animated dog (fig. 3) and fish that were painted in over the landscape. A clear sign of Leonardo's participation is the dog's fluffy coat, which is strikingly similar to the long rippling hair of his angel in the *Baptism.* Carefully observing the animals and capturing their behavior, the young artist was already on the way to gaining that understanding of nature for which he was later to become famous. Leonardo's involvement in the picture also seems to have extended to the figure of Tobias, whose unruly curls and impressionistically painted sleeves indicate that he did not share the metalworker's sense of form that Verrocchio and his other pupils brought to painting.

The figures of Raphael and Tobias might be seen as ideal self-portraits of Verrocchio and his most brilliant pupil. But a better idea of Leonardo's youthful allure at this time—the beauty that seemed no less striking to contemporaries than his talents—may be gained, perhaps, from Verrocchio's *David* (fig. 4), which has been convincingly redated to the mid-1460s, when Leonardo had probably just arrived in the shop.[4] The theory that the young Leonardo served as the model for the *David* now appears, if at all, only in the popular literature on the artist. Scholars who rejected the notion did so on the basis of

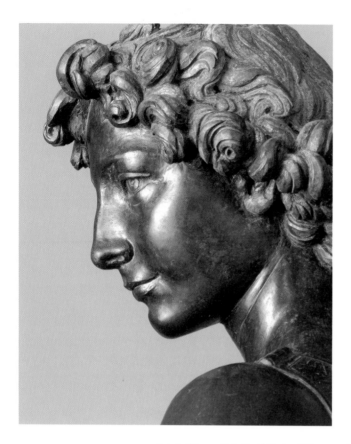
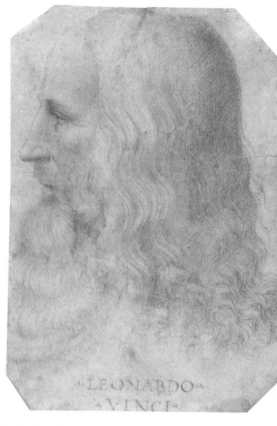

FIGURE 4. Detail of Verrocchio's *David*, National Museum of the Bargello, Florence.
FIGURE 5. Student of Leonardo, *Profile Portrait of Leonardo,* red chalk on paper, Royal Library, Windsor Castle.

the so-called *Self-Portrait* of Leonardo as an old man in the Royal Library of Turin. Leaving aside signs of age, such as wrinkles and the pattern of facial hair, the features in this famous drawing obviously differ from those of the biblical hero in Verrocchio's statue. But the Turin drawing, to judge from its style and technique, could not have been made much later than the 1490s, when Leonardo was only in his forties, so the drawing can scarcely be a self-portrait; in fact, it resembles more nearly the apostles' heads in the *Last Supper*.[5] A more accurate image of the aged Leonardo appears in a pupil's drawing of an old man's profile (fig. 5) inscribed with Leonardo's name.[6] This drawing, unlike the one in Turin, exhibits features which agree remarkably well, given the length of time separating them, with those portrayed by Verrocchio. The resemblance between the profile in the drawing and the brow, eyes, nose, and mouth of the *David* may be seen even more clearly by slightly tilting the head of the statue to an upright position corresponding to the one in the drawing. If the *David* really does represent Leonardo aged about fourteen—and apprentices commonly served as models—then this is the first glimpse we catch of him in the shop. Assuming that the same face may be recognized in both the sculpture and the drawing, despite the age difference, the larger question arises as to whether Verrocchio's whole conception of the *David*, with its tense energy and intellectual alertness, was inspired by Leonardo's presence, a question that cannot be answered here. All we can say for sure is that even in Verrocchio's shop, with such soon-to-be famous artists as Perugino and Botticelli as fellow pupils, Leonardo stood out.

Notes

1. Giorgio Vasari, *Le vite de' più eccellenti pittori, scultori, ed architettori,* ed. G. Milanesi, (Florence: Sansoni, 1879), vol. 4, p. 17, quoted in translation in David Alan Brown, *Leonardo da Vinci: Origins of a Genius* (New Haven: Yale University Press, 1998), p. 6.

2. New documentary information on Leonardo's father and teacher, which links them more closely, has recently been published by Alessandro Cecchi in "New Light on Leonardo's Florentine Patrons," in Carmen C. Bambach, ed., *Leonardo da Vinci: Master Draftsman* (New York: Metropolitan Museum of Art; distributed by Yale University Press, 2003), pp. 121–139. Cecchi's research has also revealed that the workshop where Leonardo originally assisted Verrocchio, together with the master's family dwelling in the via dell'Agnolo, was rented out beginning in 1470. At that time, the shop moved to larger premises (more suitable to producing sculpture) behind the Duomo.

3. For a full discussion of this painting see Brown, *Leonardo,* pp. 46–57.

4. For the earlier dating for the *David*—as opposed to that of about 1476, when it was sold—see Andrew Butterfield, *The Sculptures of Andrea del Verrocchio* (New Haven: Yale University Press, 1997), pp. 18–31.

5. For an argument against the traditional identification of the drawing as Leonardo, see David Alan Brown, "Leonardo's 'Head of an Old Man' in Turin: Portrait or Self-Portrait?," in *Studi di Storia dell'Arte in Onore di Mina Gregori* (Milan: Silvana, 1994), pp. 75–78. For other purported portraits or self-likenesses of Leonardo at various stages in his career, see Giorgio Nicodemi, "The Portrait of Leonardo," in *Leonardo da Vinci* (New York: Reynal, 1956), pp. 9–16.

6. About the drawing, see Martin Kemp in Kemp and Jane Roberts, *Leonardo da Vinci* (London: South Bank Centre; distributed by Yale University Press, 1989), cat. 1, pp. 46–47; and more recently Martin Clayton, *Leonardo da Vinci: The Divine and the Grotesque* (London: Royal Collection Enterprises, 2002), cat. 46, pp. 110–113.

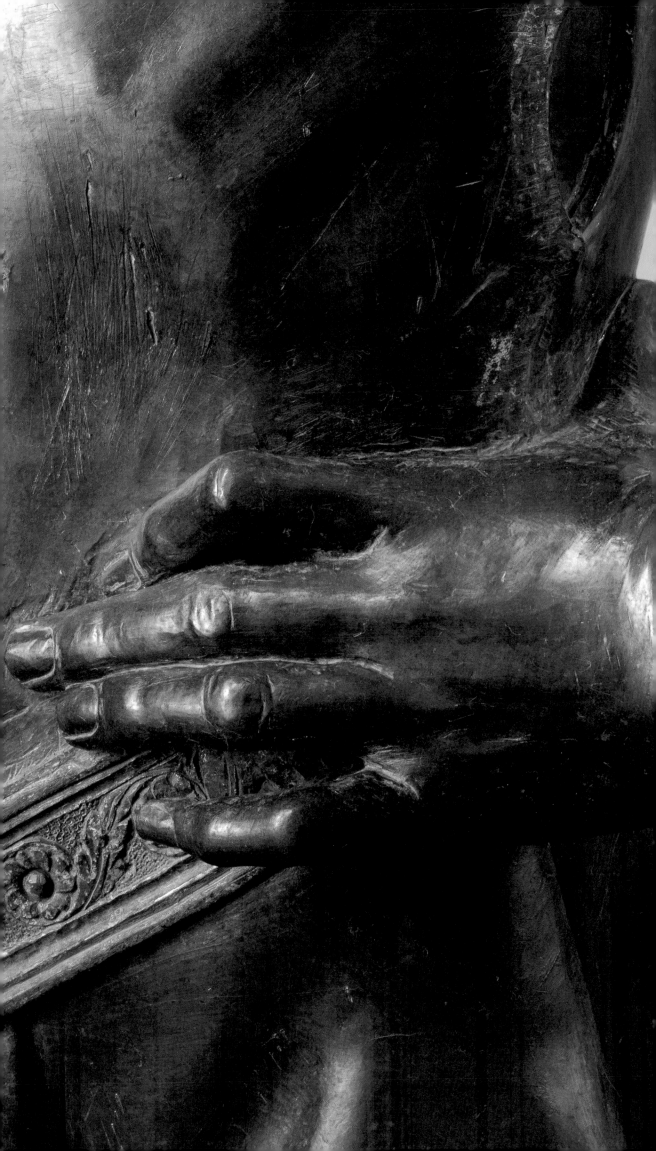

John T. Paoletti

VERROCCHIO'S DAVID, MEDICI PATRONAGE, AND CONTESTED PUBLIC SPACES

The early history of Verrocchio's *David* (fig. 1)—before its sale by Lorenzo and Giuliano de' Medici to the Priors of the city of Florence in 1476—is completely unknown. The document for the sale of the statue (Appendix A) clearly indicates that the Medici brothers owned the *David* in 1476. But if, as seems likely for stylistic reasons, the sculpture was cast in the mid- to late-1460s, they could not have commissioned it. Both men would have been in their teens at that time, Lorenzo having been born on January 1, 1449, and Giuliano on October 25, 1453. Thus, it is likely that the boys' father, Piero di Cosimo de' Medici, commissioned the *David*. The obscure origins of the statue force us to forgo factual narration of commission and execution and to seek methods of interpretation based on the historical context of the *David* if we are to have any sense of the statue's impact in Florence at the time of its creation. The physical properties of the statue itself—its medium, its pose, the figure's bodily form—are themselves suggestive of meaning. The statue's presumed original placement at the Medici Palace until 1476 and its subsequent installation at the Palazzo della Signoria, or town hall of Florence, allow us, furthermore, to propose political meanings that would have resonated from the statue during the years immediately after it was made. The *David* is richer in its historical significance than its forgotten origins would indicate.

Sometimes the obvious is a good place to start. The medium of the statue, bronze with partial gilding, is in some ways its most salient characteristic. Now that the statue has been cleaned and the gold detailing of the hair and armor are once again visible, an iconography of medium can more readily be appreciated. Verrocchio and his contemporaries knew that ancient Greek sculpture had been cast in bronze and that most of the freestanding marble sculptures now attributed to sculptors like Polykleitos are, in fact, Roman copies. Thus the bronze medium, particularly in the sensual form that it takes with the *David*, would have placed this statue within the greatest traditions of ancient sculpture. The tight-fitting cuirass that reveals the undulant surfaces of the young David's body may be a nod to classical sculpture in which gods and heroes were depicted nude, even though this youthful figure shows a decidedly adolescent body rather than the idealized mature musculature one normally thinks of in those antique statues. Nonetheless, the pose refers to similar heroic poses from classical antiquity in the placement of the legs, the turn of the torso, and the raising of the shoulder,[1] while at the same time the angular body type of the *David* suggests that Verrocchio knew another column statue from antiquity, the *Spinario* (fig. 2), then outside the Lateran Palace in Rome. The *Spinario*, like Verrocchio's *David* also a bronze statue, shows a young boy with soft features, thin arms and legs, high instep in the feet, and long hair curling at its ends.[2] Verrocchio's quotations from classical antiquity—medium, pose, body type of the *idolino*—seem to have been very rich indeed.

61

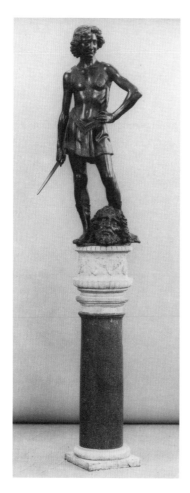

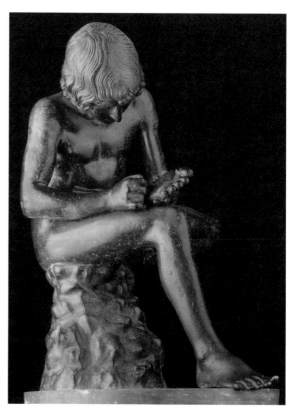

FIGURE 1. Andrea del Verrocchio, *David*, National Museum of the Bargello, Florence.

FIGURE 2. *Spinario*, first century B.C.E., Palazzo dei Conservatori, Rome.

Bronze was extremely costly and notoriously difficult to manufacture into large-scale sculpture. Not only is the casting process very complicated, but the filing, chasing, polishing, incising, patinating, and gilding of the raw cast statue are time-consuming, expensive processes. So we can be sure that whoever ordered the *David* from Verrocchio was not only interested in connecting his patronage with that of ancient collectors, but that he had the financial wherewithal to do so. In fact, bronze was so costly during the Renaissance that it was used almost exclusively for public sculpture commissioned by corporate bodies like a guild or the Church. The *David* is too small in scale, despite the fact that it is nearly life-size, to function effectively as public sculpture, leading us to believe that it must have been commissioned for a private space. Moreover, as a result of the analyses made during the current cleaning and restoration campaign, the gilding on the statue now appears to be of a kind that would not survive in an outdoor environment, suggesting that the *David* was commissioned for placement indoors, or at least for a protected location. As far as we are currently able to ascertain, the Medici were the only family in Florence that commissioned large-scale bronze sculpture for their personal spaces during the fifteenth century. By the 1460s they were the wealthiest family in the city, the first recorded owners of the *David,* and the de facto rulers of Florence despite the existence of an elaborate bureaucratic republican government.[3]

Although a youthful softness has always been evident in the *David*, the cleaning of the statue during 2002 and 2003 has heightened the silkiness of the flesh and its pliable tactility. Francis Ames-Lewis has suggested that the intense study of Neoplatonic philosophy sponsored by Cosimo de' Medici and carried out by tutors to Lorenzo and Giuliano, his grandchildren, would have made images with the sleekness of Verrocchio's *David* sym-

pathetic to members of the Medici household.[4] Even at a simple narrative level, *David*'s comeliness would have been understandable, indeed appropriate, given the biblical account of his handsomeness in the Book of Samuel and his apparent physical attractiveness to Jonathan, Saul's son. So the sensuality of the figure could be read as integral to the figure's meaning both by scholars of Neoplatonic philosophy and by those who read the Bible carefully.

Verrocchio's figure of the young David is not the whole statue, however. The bronze figure is now supported by a porphyry columnar pedestal with a marble capital. This base, decorated with perfunctory carving of the coats of arms of the Commune and the People of Florence (fig. 3), may have been made rather hastily for the statue when it was placed in the Palazzo della Signoria in 1476.[5] The very imprecise fit of the round capital to the slightly oval shape of the statue's bronze base suggests an opportunistic joining of the two, which left the part of the base beneath David's right foot overhanging the capital. Since we know that other bronze statues in the Medici Palace at this time—such as Donatello's bronze *David* and his *Judith and Holofernes* (fig. 4)—were placed on columns, we might assume that Verrocchio's *David* was from the beginning also intended to rise from a column support, although suggestions made by Beatrice Paolozzi Strozzi, Maria Grazia Vaccari, and Gary Radke in this catalogue about the placement of the head of

FIGURE 3. Column support for Verrocchio's *David*, detail showing arms of the State.

FIGURE 4. Donatello, *Judith and Holofernes*, 1455–1460, Palazzo della Signoria, Florence.

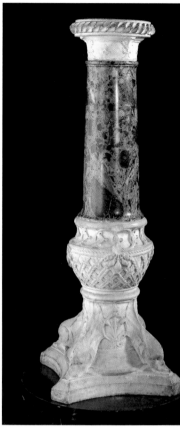

FIGURE 5. Joannes Stradanus, *Mercato Vecchio*, 1585–1587, fresco, Palazzo Vecchio, Sala del Gualdrada, Florence.
FIGURE 6. *Column*, ca. 1465–1471(?), white and green marble, Victoria and Albert Museum, London.

Goliath leave open the possibility of some more substantial base for the statue. Virtually any pedestal would imply that the statue was originally freestanding—that is, not placed close against a wall—and meant to be seen from a variety of viewpoints, much as Michelangelo's later *David*, placed on a large pier before the Palazzo della Signoria, could be seen from a variety of directions. As a column statue, Verrocchio's *David* would have carried with it special meaning derived from similar column statues in classical antiquity, a specific iconographic type of public sculpture still in use in Florence during the fifteenth century, one that appears frequently in domestic paintings of the period (page 47, fig. 18). The column statue in antiquity refers to victory or triumph, appropriate for the subject of David and Goliath and their story of freedom triumphing over tyranny or of virtue overcoming vice.[6] A major civic image, the statue of *Dovizia*, or Abundance, made by Donatello (ca. 1429–1430), stood on a tall column in the Mercato Vecchio during the time that Verrocchio lived in Florence and broadcast the benefits of the city to its population (fig. 5).[7] Wherever Verrocchio's *David* stood in the Medici environs, as long it was atop a column —or even atop a squared pier as in Ghirlandiao's frescoed *David* on the outer wall of the Sassetti Chapel in Santa Trinita—it carried with it the idea of civic virtue and political order, like the *Dovizia*. This would certainly have been an appropriate message for the Palazzo della Signoria, but a much more complicated one for the home of private citizens like the Medici.

Were the *David* originally raised atop a column, what might that support have looked like? Certainly, the current installation of the *David* atop its column in the Bargello gives some indication of how one might have seen the statue. Another column, now in the Victoria and Albert Museum and bereft of any surmounting figure (fig. 6), may provide an even clearer indication of the *David*'s original appearance. This column is composed of a

green *verde antica* marble shaft with a white marble base and capital.[8] The interest of this column for Verrocchio's *David* lies in the similarities of their measurements. The recent cleaning of the *David* has allowed accurate measurements of the bronze disk that forms its base to be made; it measures 32 × 26.5 cm. It is possible to argue that an original round base (c. 32 cm. in diameter) was cut down slightly to give it the present oval shape. But since *David*'s toes curve down over the edge of the base, it is impossible to argue that the base could ever have been any larger than c. 32 cm. in diameter on any axis if it were to fit on the round column on which it was placed in 1476 (page 19, fig. 6).

The diameter of the column capital in the Victoria and Albert Museum measures 33 cm. Despite the problems inherent in suggesting that this column originally formed the pedestal for Verrocchio's *David*—chief among them being the heraldic devices differing from those of Lorenzo or Giuliano de' Medici that decorate it—the coincidence of measurements make this link a tantalizing possibility.[9] Were this column the original support, its height of 4 feet 9⅜ inches would give a fair idea of how the *David* was originally seen. Atop such a column, the most direct image that a viewer would have seen would have been the severed head of Goliath, a subtle message for anyone not supportive of the Medici regime.[10]

The messages that the formal elements of the *David* convey are amplified if we consider the statue within the Florentine context of its time. If we are correct that details of the style of the statue place it in the later years of the 1460s, then its creation occurred at a critical time in the history of Medici control over Florence as well as at a fascinating but ill-defined moment in the history of sculpture at the Cathedral in Florence. In the late summer of 1466, Piero de' Medici (1416–1469) faced a political coup by opposition forces in the government. When Piero took over the responsibilities for his family, its business, and its position in the city at the time of his father's death in 1464, Medici political opponents, led by members of the Pitti family, thought that without his father's astute leadership and direction Piero would be vulnerable to being toppled, especially given the crippling effects of his gout. They had not counted on Piero's careful training by Cosimo in affairs of state and the shrewdness of his political acumen. Piero got wind of the plot and foiled it in August. Coup leaders were exiled by state decree on September 11, leaving the Medici in a stronger position than ever.[11] Clearly the times demanded stronger subliminal images of power for the family. Verrocchio's *David* would have provided that message while at the same time disguising the family's poltical control with the seductiveness of the sculpture's polish and elegance.

If we are to project a Medici sculptural response to the crisis of 1466 in the form of Verrocchio's *David*, then another commission needs to be brought into the argument. In 1463 Agostino di Antonio di Duccio was commissioned to make a colossal terra-cotta sculpture to be placed on one of the exterior tribune buttresses of the Cathedral. His effort was so successful that he was commissioned in the following year to make a marble companion for the terra-cotta, which by then may already have been placed on the exterior of the Cathedral (fig. 7). Rather than the four blocks of marble he was told to quarry for the colossal figure, Agostino returned from Carrara having ordered one gigantic block of marble measuring eighteen feet in length. Agostino was released from his contract and paid for work already done in December 1466, shortly after the marble block had finally arrived in Florence and just four months after the failed coup. Since we know that the block of marble was identified as a David when it was given to Michelangelo to complete in 1501, it is tempting to believe that Agostino originally had been commissioned for

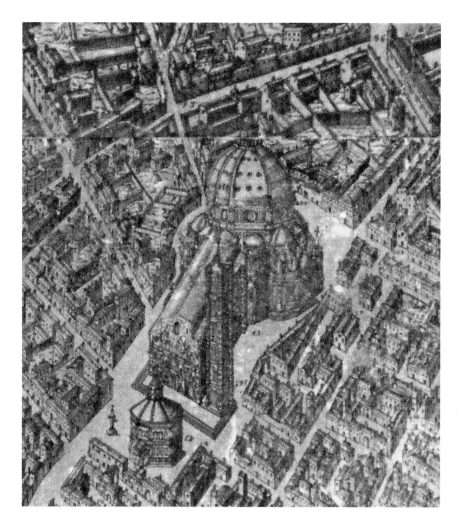

FIGURE 7. Stefano Bonsignori, *Bird's-eye view of the city of Florence* (detail), 1584, etching, Museo di Firenze com'era, Florence.

a David as well.[12] If that was the case, then the appearance of David within a Medici context in the 1460s seems telling. The relationship between the form and style of Verrocchio's *David* and the model that Agostino was using for his marble statue—a model still in existence in the Cathedral workshops in 1501—can never be known with certainty. But the similarlity in pose of both Donatello's *David* in the Medici Palace courtyard (page 38, fig. 5) and Verrocchio's figure suggests that the model for the colossal figure may well lie behind their formal congruence.[13]

The aborting of Agostino's buttress sculpture in December 1466 may be seen, as Charles Seymour suggests, as a result of the death of the elderly Donatello in the same month, and thus as an indication that it was really the older sculptor and not Agostino who was the genius behind the project. On the other hand, even if Agostino had been acting as the hands for Donatello, who had conceptualized the statue, this master/student relationship would not explain why Agostino was not allowed to continue the project, since the model for its final form already existed. At any rate, the result of the termination of Agostino's contract was that the iconography of David—a powerful one for traditional concepts of the Republic that the Medici were undermining—was temporarily forestalled from the decorative program of one of the most important public sites in the city.

Yet, at approximately the same time that Agostino's commission was rescinded, Piero apparently added the Verrocchio bronze *David* to the decorative program of his palace, where it joined Donatello's bronze *David*. Donatello's bronze hero is of uncertain date but

MEDICI
PATRONAGE
AND PUBLIC
SPACES

documented in 1469 standing on a now-lost column at the center of the main courtyard of the palace, where it could be seen clearly from the street when the main portal of the palace was open. Thus, shortly after the Medici Palace was inhabited sometime in the late 1450s, its decorative program—initially, it seems, overseen by Piero—incorporated Davidian imagery, atypical for private homes, that was freighted with civic meaning.[14] In fact, even after Lorenzo and Giuliano had sold Verrocchio's *David* to the Priors in 1476, the Medici retained Donatello's image of this civic hero, visually tying their palace to the Palazzo della Signoria. The confiscation of Donatello's *David* from the Medici Palace by the Signoria in 1495, a year after the Medici had been exiled, gives clear evidence not only of the statue's perceived function as a civic icon but also of a public perception that the Medici had appropriated state imagery for their own use, and had thereby essentially transformed the Medici Palace into a civic space through its decorative program.[15]

Paolo Uccello's battle scenes, with the *Battle of San Romano* (fig. 8), now known to have been purchased (or appropriated) by Lorenzo for his quarters in the palace rather than commissioned by a member of the Medici family, are another example. Historical battle scenes such as these typically appeared in the main council rooms of town halls to record the military triumphs of the state (fig. 9).[16] Placed in the Medici Palace, Uccello's battle paintings confused civic and domestic imagery. They, too, were confiscated by the state in 1495. A large freestanding marble statue of St. John the Baptist, the patron saint of Florence, was also part of the interior of the Medici Palace, although we do not know when it was placed there before it was first recorded in an inventory of 1492. Large marble sculptures were very rarely owned by citizen families, perhaps for the simple reason that the interior spaces of late medieval and early Renaissance urban palaces were modest in size and would not have accommodated them easily. The Medici Palace, on the other hand, set a new standard of magnificence in terms of size as well as ornament for the city. The interior of the building contained imagery both religious and secular that, like Verrocchio's *David,* connected the family to the ritual and political life of the city, equating their environment with that of the state.

FIGURE 8. Paolo Uccello, *Battle of San Romano*, 1454–1457, Uffizi Gallery, Florence.

FIGURE 9. Sala del Mappamondo, Siena, Palazzo Pubblico, showing Lippo Vanni's *Victory of the Sienese Troops at the Val di Chiana in 1363,* ca. 1364, and *Victory of the Sienese Troops over the Florentines at Poggio Imperiale, 1379,* 1480, by Giovanni di Cristofano and Francesco d'Andrea.

In Verrocchio's sculpture, as in Donatello's, David is (following the biblical account) portrayed as an adolescent. Yet another image in the palace brings this issue of youth more clearly into focus. On the walls of the chapel at the heart of the palace is a fresco cycle painted by Benozzo Gozzoli that shows the procession of the Magi moving around the small room to honor the Christ Child. The fresco of the youngest magus (fig. 10) shows him clothed in white, astride a white horse, at the head of a retinue of figures headed by none other than Piero de' Medici, followed by artificially and hierarchically ordered ranks of figures including Galeazzo Maria Sforza and Sigismondo Malatesta, as well as the youthful Lorenzo and Giuliano de' Medici. The young king, by far the youngest representation of this figure in fifteenth-century art, is normally read as a second—allegorical— representation of Lorenzo, who was about ten years old when the fresco was painted. In 1459 Lorenzo himself had been the leader of a chivalric procession capping a week of celebrations in honor of Pius II and Galeazzo Maria Sforza staged by the Medici. Lorenzo was groomed from birth to be a statesman/ruler rather than a banker, and the youthful images in the Medici Palace of a biblical military hero who grew to rule a nation and of the youthful magus may have been *exempla,* of a civic and of a religious nature, for the growing boy. The implied connection of the youthful David to Lorenzo continued at least early into the decade of the sale of Verrocchio's *David* to the Priors when, as Andrew Butterfield has noted, Pietro Collazio dedicated his poem *De duello Davidis et Goliae (On the Duel of David and Goliath)* to Lorenzo.[17] Of more significance to Verrocchio's *David* is another text noted by Butterfield, Bartolomeo Platina's *De optimo cive (On the Finest Citizen),* dedicated to Lorenzo in 1474. Ostensibly a conversational instruction by Cosimo to his grandson Lorenzo, the text portrays David as a model of devotional propriety in a time of war and of clemency in a time of civic sedition. Lorenzo apparently did not take this last lesson to heart since he savagely punished the conspirators who assassinated his brother and attempted to kill him in 1478. Bernardo Bandini de' Baroncelli, extradited from Constantinople in 1479 at Lorenzo's request, was defenestrated from the Palazzo del Capitano di Giustizia (now the Bargello, where Verrocchio's *David* is housed), his hang-

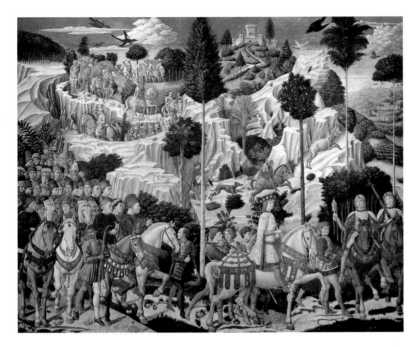
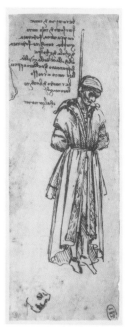

FIGURE 10. Benozzo Gozzoli, *Procession of the Youngest Magus*, ca. 1459, fresco, Medici Palace, Florence.
FIGURE 11. Leonardo da Vinci, *Bernardo Bandini de' Baroncelli*, December 28, 1479, drawing, Museé Bonnat, Bayonne.

ing and partially nude corpse carefully drawn by none other than Leonardo da Vinci, Verrocchio's best-known student (fig. 11). Lorenzo's retribution notwithstanding, two years before Lorenzo and Giuliano sold the *David* to the Priors, Platina had depicted the virtues of the youthful David as appropriate models for his patron, by then the ruler of Florence in all but name. Clearly linking the older, kingly David to Lorenzo would have been tantamount to admitting Lorenzo's rulership and would thus have been both improper and unwise. Associating Lorenzo with a heroic shepherd, on the other hand, avoided impropriety while still casting Lorenzo as a future leader.

Verrocchio and the Medici

It is safe to say that by the time of Donatello's death in December 1466, Verrocchio was poised to serve as house sculptor for the Medici family, then headed by Piero di Cosimo de' Medici. The extent of Verrocchio's work for this family from the mid-1460s until his death in 1488 is amply indicated by a list made in January 1496 by Tommaso del Verrocchio, the artist's brother (Appendix B). The list appears to be an account of work commissioned by the Medici from the Verrocchio shop; specific amounts "owed" are not indicated, leading to two possible interpretations: either Verrocchio had been paid in full and this document functioned as a formal release of Lorenzo's estate from any claims,[18] or Verrocchio's perpetually poor brother was planning an opportunistic move to assert claims on the estate, since the Signoria had established a commission to settle financial claims against the Medici in 1495, a year after the political coup that had led to their exile.[19] Perhaps Tommaso—also in litigation with his brother's artistic heir and major beneficiary, Lorenzo di Credi—thought that with anti-Medici sentiment running so high in Florence and with numerous claims against Medici property being settled in favor of the claimants he would be able to bring charges against the Medici that would bring him additional income. It is not hard to imagine that some of the commissions listed by Tommaso, particularly the later ones, went unpaid or were only partially paid as Lorenzo's personal finances declined; Lorenzo de' Medici was, after all, notoriously irregular in his financial

69

affairs.[20] Whatever Tommaso's reasons for making his list, there is no known record of any response from the state commission.

The named commissions give a good indication of the range of Verrocchio's work for the Medici family and point out the wide variety of work that an artist's shop might be engaged in: from major bronze figural sculptures and the imposing tombs of Cosimo and of Piero and Giovanni in San Lorenzo that were so important in keeping the memory of Medici leadership alive to death masks to painted banners. Regardless of the success of the shop, powerful patrons were not to be denied, even if they requested something that to modern eyes would seem perfunctory, like a death mask. And even in the most successful shops, the master needed to keep an even flow of trade, which meant producing work at different levels of the economic scale.

In addition to the *David* and the other works listed in the 1492 inventory of the Medici Palace and Tommaso del Verrocchio's list of his brother's work for the Medici, Giorgio Vasari's life of the artist (first published in 1550) indicates a number of other sculptures that Verrocchio provided for the family. Apparently Lorenzo commissioned Verrocchio to make two bronze reliefs of ancient Greek military rulers, one of Alexander the Great and one of Darius. Lorenzo subsequently sent these reliefs to Matthias Corvinus of Hungary as a diplomatic gift. Although the originals seem to have been lost, there are a number of marble and terra-cotta reliefs that are most likely copies from the originals (fig. 12). As with other diplomatic gifts, there is a double edge to the imagery. Alexander may refer to Matthias, a king and military figure. On the other hand, Alexander controlled the entire Mediterranean basin and had extended his empire to India by the time he was in his early twenties, just as Lorenzo took over his father's role as paterfamilias and as unspoken ruler of the city at the age of twenty.

After the Pazzi Conspiracy in 1478 that ended his brother's life and in which he was wounded, Lorenzo commissioned three votive images of himself. Although Tommaso records a number of unspecified heads in his list, Vasari indicates that these votive images—essentially full-scale dolls, each composed of an armature of wax head, hands, and feet that were then clothed in Lorenzo's own clothes—were made by a wax-worker named Orsino.[21] Although it does not appear that Verrocchio had anything to do with these votive images then popular in Florence, according to Vasari he invented the process that made replication of human facial features possible.[22] Such heads do resonate with the rows of Medici partisans and diplomatic allegiances that Gozzoli had included in his frescoes for the Medici Chapel (see fig. 10), where the power brokers of Florence were arranged in a manner that allowed little doubt about who the most important figure was. More to the point, heads such as those recorded by Tommaso would have been seen in the Medici Palace together with Mino da Fiesole's portraits of Piero (fig. 13) and his brother Giovanni that mark the beginning of full-scale portrait busts in the Renaissance.

But Tommaso's list does not tell the whole story of Verrocchio's dealings with the Medici nor why it was important for the family to have such close and continuing relations with the sculptor. The relationship between artist and patron was obviously mutually beneficial. Not only did Verrocchio make sculpture, paintings, masks, and banners for the Medici as personal commissions, he also garnered a number of other important commissions—such as the *Doubting Thomas* for Or San Michele—because of the building committees on which members of the family sat. The Medici, on the other hand, knew that when Verrocchio was working on a project that was important to them for political reasons, they could feel secure that he would understand the outcome that they wished.

FIGURE 12. Verrocchio Circle, *Alexander,* marble, National Gallery of Art, Washington, D.C.

FIGURE 13. Mino da Fiesole, *Piero de' Medici,* 1453, marble, National Museum of the Bargello, Florence.

Verrocchio's *David* in the Palazzo della Signoria

The sale of the bronze *David* to the Signoria in 1476 provides a provocative example of how the Medici used works of art not only to decorate their palace and villas but to insert themselves into the most important political and ecclesiastical spaces of the city, most of which were meant to be free of the influence of any individual or family. When Lorenzo and Giuliano, together, sold the *David* to the Signoria, they were acting as earlier generations of their family had, by submerging their individual personalities into a corporate or family gift.[23] Legally the *David* most likely belonged jointly to the two brothers, since family estates in Florence were divided equally among surviving male heirs. Thus the sale of the *David* by both brothers to the Signoria is not surprising. Legal matters notwithstanding, we might also imagine that Lorenzo, by 1476 the de facto ruler of a city that styled itself as a republic, veiled his intentions behind the sale by making it a family matter. But as is so often the case in Medici artistic matters, a simple interpretation does not quite catch the subliminal politics of Medici actions. The price of 150 florins, while a considerable sum of money, would not have approximated the cost of Verrocchio's *David*.[24] Thus the sale of the bronze sculpture to the Priors may be read as both a sale and a gift. The dual nature of the transfer of the *David* to the Palazzo della Signoria carries important implications for Lorenzo's motives. Because the notion of reciprocity is embedded in the gift-giving customs of the period, Lorenzo and the Signoria would have wanted to avoid any appearance of collusion between a private citizen and elected governmental officials.

71

FIGURE 14. Plan of the second floor of the Palazzo della Signoria showing (1) the Sala dei Gigli; (2) the Sala dell'Udienza; (3) the Landing of the Chain, where Verrocchio's *David* stood; and (4) the chapel.

Indeed, the splendor of the gilt bronze sculpture would certainly have given the Medici the appearance of princes within the commune, an image that the family had for years been simultaneously cultivating and disguising. Thus, Lorenzo and Giuliano undermined any appearance of collusion by selling, not giving, the *David* to the Priors. On the other hand, were the price of the sale lower than the actual value of the statue, then, indeed, it was as much a gift as a purchase, putting the Priors in a position of debt to the Medici. That Verrocchio's *David* was placed at the entrance to the Sala dei Gigli, one of the main legislative rooms of the Florentine Signoria, as the document of the sale clearly states, is a telling reminder of the complex relationships between the Medici and the traditional governance structures of the city.

Possible reasons behind the timing of this extraordinary sale by the Medici brothers to the priors of the city emerge if we place the statue in this original physical and historical context (fig. 14).[25] The importance of the Sala dei Gigli (Room of the Lilies) and of the position of the *David* at its entrance is perhaps indicated by the name of this entrance door. Known as the Porta della Catena—the *ostium catenae* noted in the document of the sale in 1476—the door was apparently secured by some form of chain in times of danger, thus protecting the governors of the city from possible attack.[26] The chain was used to bar the door during the Pazzi Conspiracy on April 26, 1478, when Giuliano was assassinated and Lorenzo wounded in an ill-conceived plot to free the city from Medici control.

In the relatively modest space just outside the Sala dei Gigli, the statue would have functioned as a warning about the state's determination (and ability) to overcome tyranny. Verrocchio's *David* would, moreover, have been seen as a pair with the marble *David* by Donatello (page 38, fig. 4) that in 1416 had been placed just a few feet away, inside the door of the Sala dei Gigli, before a blue wall decorated with gold fleurs-de-lis (perhaps the reason for the name of the room). The background decoration of the statue was a reference to the assistance provided by Robert of Anjou, the French king of

MEDICI
PATRONAGE
AND PUBLIC
SPACES

Naples, to the Republic of Florence in the early years of the fourteenth century.[27] The decorative surround of Donatello's marble *David* must have had ironic significance in 1416, since the Florentines had just been freed from a threat of invasion by the great-grandson of Robert's brother, King Ladislaus of Naples, who died in 1414 just before his planned attack. The inscription placed on Donatello's marble statue in 1416—"God helps those who fight bravely for their country even against the most terrible enemies"—established David as a hero of the state, an appropriate symbol for Florence's constant quest for freedom from foreign domination. In selling Verrocchio's bronze *David* to the Signoria in 1476, Lorenzo and Giuliano provided a powerful symbol of this political message but also subtly usurped for themselves and the Medici family the force of Donatello's older (and, in comparison with Verrocchio's *David,* old-fashioned) marble statue inside the Sala dei Gigli. The "most terrible enemies" that David faced could, in the new context, now be read as Medici opponents.

Verrocchio's *David* may have been paired at the head of the stairs with a figure of St. John the Baptist, the patron saint of the city. Vasari records in his *Lives* that Pollaiuolo made such a figure, implying that it was still in place at the time of his writing (1568), although he unfortunately does not specify whether it was a painted or a sculpted figure. A drawing that has been connected to this putative commission shows scribblings suggestive of landscape features (fig. 15), indicating a study for a painting.[28] Pollaiuolo's drawing does show similarities in St. John's pose to that of Verrocchio's *David,* especially in the position of the body, the placement of the left hand on the hip, and the extension of the left elbow into space. Painting and sculpture would then have been paired formally in a way that would have suggested the figures' twinned roles as patrons of the city. Since Pollaiuolo's *St. John* is undocumented and lost, however, and since Vasari gives no indication of its dating, it is impossible to say very much about its temporal relationship to Verrocchio's *David.* If, however-

er, Varsari's record is correct, the painting must have been in place before Pollaiuolo left for Rome in ca. 1490. Whether in place before or after Verrocchio's *David,* Pollaiuolo's *St. John* and another statuette of the Baptist by Benedetto da Maiano over the door between the Sala dei Gigli and the Sala d'Udienza (page 27, fig. 21) inflect the meaning of the *David.* This pairing of the patron saint of the city with Verrocchio's *David* would have supported the idea that David served as an Old Testament patron guardian of Florence, just as Hercules with his club served that role as a classical image of protection, essentially making Florence the heir of all recorded history in the

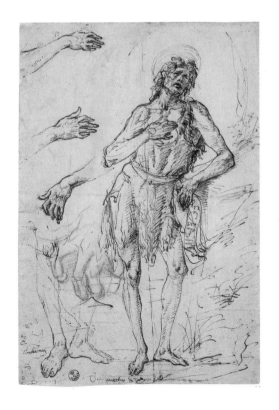

FIGURE 15. Antonio del Pollaiuolo, *St. John the Baptist,* pen and wash, Gabinetto Disegni e Stampe, Uffizi, Florence.

West. Given the presence of a large-scale marble St. John in the Medici Palace noted above, Pollaiuolo's *St. John* would also have provided yet another paralleling of imagery at the Palazzo della Signoria and the Palazzo Medici.

To broaden the Medicean implications of Verrocchio's *David* as part of the decorative program of the Palazzo della Signoria, we might simply list the images other than David and St. John that appeared both there and in the Medici Palace. A subliminal twinning of the Medici Palace with the town hall would have been suggested in images of Hercules, one apparently painted in the Sala dei Dugento on the first floor of the Palazzo della Signoria immediately beneath the Sala dei Gigli, and a set of three large-scale paintings on linen by Antonio Pollaiuolo that decorated the main *salone* of the Medici Palace.[29] Just as the chapel in the Medici Palace was decorated with a fresco cycle of the Procession of the Magi by Benozzo Gozzoli, so a painted panel of the *Adoration of the Magi* by Francesco Pesellino was placed on a landing of the main stairwell of the Palazzo della Signoria. The altarpiece by Filippo Lippi of the *Adoration of the Christ Child* also in the Medici Chapel contained figures of St. John the Baptist and a visionary St. Bernard, as did his overdoor painting in the staircase of the town hall, for which he was paid in 1447.[30] And both the Baptist and St. Bernard appear in Filippino Lippi's altarpiece of 1486 for the Council Hall, a commission that Leonardo had received in 1478 and Filippino Lippi took over in 1483, after Leonardo's departure for Milan.[31] Lippi's contract for the painting in May of that year specifies that the altarpiece was to be done in a manner that would be pleasing to Lorenzo de' Medici, clearly signifying his determining role in the project.[32] In September 1485 Lorenzo fixed the price for Filippino's altarpiece, suggesting his continued involvement in this important commission for a major civic devotional altarpiece in the town hall. It might also be pointed out that the renovation of the interior courtyard of the Palazzo della Signoria during the mid-1450s left it looking more like the courtyard of the Palazzo Medici, built beginning in 1446, than of a building begun in 1296. At the time of these renovations, Piero de' Medici was *operaio* (a member of the building committee) of the Palazzo della Signoria twice, in 1452 and again in 1454, and his brother Giovanni served as Prior in 1454 during reconstruction, indicating the possibility of their intervention in the project.[33]

This pairing of imagery in the Medici Palace and the town hall was far from coincidental. The Medici deliberately employed the images of the state to support their takeover of Florentine governance, giving themselves the appearance of rulers of the city, which, in the realpolitik of the day, they were. If the Medici were in de facto control of the politics of the city of Florence, the fact that their own home had characteristics of form and decoration similar to the town hall gave mute testament to that fact, regardless of their claim to be coequal citizens in the body politic. Lorenzo's claim that "I am not the Lord of Florence but a citizen with some authority"[34] has a definite edge to it that recognizes—as all did—his role while simultaneously denying it.

But something more than echoed images between the center of Medici life and the center of governmental action brings the gift of Verrocchio's *David* to life in the context of the Palazzo della Signoria. Melinda Hegarty has demonstrated that "the placement of Verrocchio's *David* at the entrance to the Sala dei Gigli marks the initial statement of a *renovatio* of Florentine republican symbolism, expressed in the style and taste of Lorenzo."[35] At the time of the purchase of Verrocchio's *David*, the town hall was in the midst of a major redecoration program that has traces of Medici involvement in it. Beginning in

1469 the Signoria appropriated funds for a restoration of the Sala dei Gigli, a sizable room where small councils of the city met and which served as a reception room for the adjacent Audience Hall (Sala d'Udienza).[36] Its rebuilding was in process by 1472 and its new ceiling was installed in 1475, the same year that Benedetto da Maiano carved the doorframe for the portal between the Sala dei Gigli and the Sala d'Udienza. The completion of this phase of the redecoration may have provided Lorenzo and Giuliano the incentive to sell the *David* to the Signoria in 1476, an opportune moment in the decorative projects for the Sala dei Gigli.

Commissions to fresco the Sala dei Gigli were subsequently given to Domenico Ghirlandaio, Sandro Botticelli, Piero Pollaiuolo, and Pietro Perugino in October 1482.[37] Only Ghirlandaio's were completed (fig. 16); the others seem never to have been begun. Ghirlandaio's tripartite decoration shows *St. Zenobius*, one of the patron saints of the city, flanked by his two deacons in the center of the wall, with images of Roman heroes to the left and the right. The Florentine heraldic *Marzocco*, or lion, figures prominently in the image. The civic imagery could not be more clearly and straightforwardly depicted, here tying religious and civic together with ancient Roman history, which gave Florentine politics of the time its historical, legal, and rhetorical foundations. Of the names mentioned in the documents for the commission, one in particular stands out: Lorenzo de' Medici.[38] He seems to have acted as an adviser for the project. Thus it is no surprise that the artists involved in providing frescoes for the room were those who had had or were to have important private commissions from Lorenzo. Although it might be argued that the Signoria would have been expected to consult Lorenzo on a project of this importance, given his reputed expertise in artistic matters, it is clear that Lorenzo was able to insert himself into matters as seemingly pro forma as the decoration of the town hall and to assert his

FIGURE 16. Palazzo della Signoria, Florence, Sala dei Gigli with frescoes by Domenico Ghirlandaio, 1481–1485.

FIGURE 17. Dome of the Cathedral of Florence showing the rebuilt *palla*, originally made by Verrocchio in 1471.

presence in the operations of the Palazzo della Signoria, even if he was not at the moment holding public office.

Just as Lorenzo inserted himself into the decorative programs of the Palazzo della Signoria, the center of political life in the city, he also intervened in the embellishment of the Cathedral, the center of the city's cultic life, and it appears that Verrocchio may have been one of his agents there at approximately the same time that he was making the *David*. In September 1468 Verrocchio received a commission for the *palla,* or gilt ball, to top the lantern of the cupola (to replace one commissioned the previous year that apparently failed in the casting); in June 1471 the *palla* is recorded as being in place.[39] This project, then, would have begun during the last years of Piero de' Medici's life and been completed in the first years of Lorenzo's control over Medici fortunes. Given the fact that the Medici coat of arms contained red balls (*palle*) on a gold ground and that the rallying cry of the Medici faction was "palle," this image marking the skyline of the city (fig. 17) could not have read any other way than as a reference to the Medici family, a marker of their inescapable presence floating in the air above the main altar of the building. When Alberti wrote the prologue to the Italian edition of his *Della Pittura* in 1436, he wrote that the dome of the Cathedral "cover[s] with its shadow all the Tuscan people," an image richly suggestive of Florentine political hegemony over the surrounding countryside, a metaphor—once the *palla* was in place—that would have suggested Medici control over city and *contado* as well.[40]

There are other records at the Cathedral that provide documentary evidence of Medici attempts to gain a patronage foothold there, even though recurring legislation precluded the use of the Cathedral's spaces by private families, even for funerary or commemorative reasons.[41] In 1447, for example, Piero de' Medici had provided a model for a new choir around the main altar beneath Brunelleschi's dome to the Cathedral's building committee.[42] The documents are silent about the response of the committee, and the model disappeared instantly from history. Work on the choir was taken up again in 1471 when the *operai* of the Duomo, Medici partisans Agnolo di Lorenzo della Stufa and Bartolomeo di Lodovico di Cecce da Verrazano, awarded Verrocchio a major commission for the sculpture for the exterior faces of a new choir enclosure around the main altar.[43] The commission to Verrocchio, by then deeply involved with the Medici family, was a substantial one, including sculpture in bronze or marble, yet nothing more is heard of Verrocchio's project for the choir after 1471. Its failure may be seen as a rebuke to Lorenzo, much as his father's intervention at the Cathedral had been thwarted in 1447.

The competitive tensions between the tradition of the Cathedral as a public space belonging to all the Florentines and the Medici attempts to insert their presence there are brought home with two commissions of 1476, the year that Lorenzo and Giuliano sold Verrocchio's *David* to the Florentine government. Four days before the Priors purchased the *David,* the *operai* for the Cathedral turned over Agostino's unfinished colossus from 1466, mentioned above, to Antonio Rossellino. The payment to Rossellino on January 1,

1477, was for a substantial amount, indicating that he had spent some time on the colossus that renewed a commission going back to the beginning of the century and a high moment of the republic. Also in 1476 Lorenzo instituted a design competition for the unfinished facade of the Cathedral, a project that revived a little-known earlier competition of 1464 for which Mino da Fiesole, another sculptor sometimes employed by the Medici, had produced a model. Neither project seems to have been pursued very far, however, suggesting a stand-off at the Cathedral between republican sentiment and Medici appropriation of public space.[44] Thus, Lorenzo's interventions at the Palazzo della Signoria and the sale of the *David* to the Priors must have seemed for him a particularly satisfying manifestation of Medici will in the seat of government.

Ironically, having failed to assert their presence at the main altar through some form of artistic patronage, the Medici ultimately gained control of the space in a metaphorical manner. After the Pazzi Conspiracy in April 1478, Lorenzo coined a medal that showed his bust floating prominently over the choir of the Cathedral around which is depicted the attempt on his life (fig. 18). The inscription, *SALUS PUBLICA* (public well-being), leaves no doubt that Lorenzo was the person who guaranteed the health of the city, that he had been miraculously saved from the murder attempt, and that, like Christ sacrificed on the altar, he was divinely favored. Lorenzo's psychological association with this space gave him an ongoing thaumaturgic presence at the Cathedral that would have been hard to equal in the cold stone of a sculpted choir screen.

Even a brief enumeration of the projects that Lorenzo was involved with around the time of his gift of the *David* to the Palazzo della Signoria indicates that the bronze statue —despite its extraordinary beauty and costly materials—was but one part of an overall design on Lorenzo's part to assert his presence at the Cathedral and the town hall, both as an artistic arbiter who could impose his taste on the most important public commissions of his day and as a patron whose "authority" in the arts was a stand-in for his authority in politics. What better way to suggest that than to place a figure of David, the tyrant slayer who ultimately became a king and the leader of a great nation, in the Palazzo della Signoria.

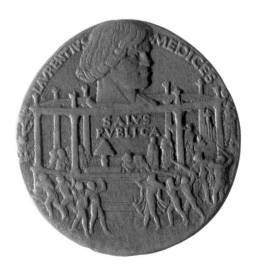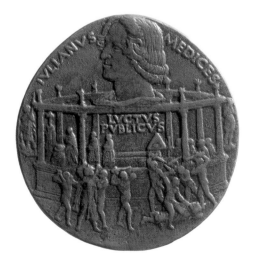

FIGURE 18. Bertoldo di Giovanni, *Medal of the Pazzi Conspiracy*, ca. 1478, bronze, obverse and reverse, National Museum of the Bargello, Florence.

Notes

I wish to thank Peta Motture, Senior Curator of Sculpture and Medieval and Renaissance Galleries of the Victoria and Albert Museum, London, for her extraordinary assistance, not only in providing information about the Medici column base in her care, but also for providing access to an article for a book still in press of which she is the editor. Her kindnesses and generosity of spirit were enormously valuable in the final stages of the writing of this essay. I also want to acknowledge with keen appreciation the helpful suggestions made by Janet Rauscher in her editing of my manuscript. It goes without saying that I am grateful to Gary Radke, the guest curator of this exhibition, for his invitation to contribute to this catalogue, for his conversation about the David, and for his ever-generous critique of my ideas.

1. For a discussion of the chiastic pose and the history of the statue, see Andrew Butterfield, The Sculptures of Andrea del Verrocchio (New Haven: Yale University Press, 1997), pp. 22–23.

2. One twelfth-century commentator thought that the youthful Spinario represented Absalom, David's son, perhaps based on the passage in 2 Sam. (14:25) where he is described as follows: "In the whole of Israel there was no man who could be praised for his beauty as much as Absalom." See Michael Camille, The Gothic Idol: Ideology and Image-Making in Medieval Art (Cambridge: Cambridge University Press, 1989), p. 87, for this reference. The connection between Absalom and the statue may derive from Absalom's perfidy and the equation of this statue with an idol, a symbol of evil.

3. In addition to bronze, the Medici consistently used porphyry in their artistic projects, a stone that virtually no other family in Florence used because of its high cost and its difficulty in carving. The stone was restricted to imperial use in ancient Rome.

4. Francis Ames-Lewis, "Art History or Stilkritik?: Donatello's Bronze David Reconsidered," Art History 2, no. 2 (1979), pp. 139–155. The appreciation for Neoplatonism in Florence was not limited to the Medici or to the group of Neoplatonist humanist writers whom they supported. Nor does a concentration of Neoplatonist study within the Medici environs preclude the interest of other families in images of sensuality, especially since some of these families were quick to follow the lead of the Medici in artistic patronage.

5. Butterfield, Sculptures of Andrea del Verrocchio, p. 20. But Francesco Caglioti, Donatello e I Medici: Storia del David e della Giuditta (Florence: Leo S. Olschki Editore, 2000), figure 104, indicates that the statue and the column were restructured in the eighteenth century (perhaps at the time that the current sword was added). Caglioti also proposes (pp. 310–328) that the Verrocchio and Donatello Davids were interchanged sometime between 1495 and 1510, ostensibly to avoid a Savonarolan backlash that might have resulted from the prominence of Donatello's suggestive David were it to have re-

mained in the main courtyard of the Palazzo della Signoria. The documents that Caglioti quotes in support of his argument are informative about the histories of the statues, but the 1504 reference to a damaged foot that he associates with the raised left foot of Verrocchio's David is not enough to settle the argument, especially since there are so many casting flaws and breaks in the Donatello David.

6. For the transformation of the column statue to an image of idolatry see Camille, The Gothic Idol.

7. For the Dovizia see David G. Wilkins, "Donatello's Lost Dovizia for the Mercato Vecchio: Wealth and Charity as Florentine Civic Virtues," Art Bulletin 65 (1983), pp. 401–423; Sarah Blake [McHam], "Donatello's Dovizia as an Image of Florentine Political Propaganda," Artibus et Historiae XIV (1986), pp. 9–28; Margaret Haines, "La colonna della Dovizia di Donatello," Rivista d'arte 37 (1984), pp. 347–359; and Adrian W. B. Randolph, "Common Wealth: Donatello's Ninfa Fiorentina," chap. 1 in Engaging Symbols: Gender, Politics, and Public Art in Fifteenth-Century Florence (New Haven: Yale University Press, 2002).

8. The base of the column is decorated at its corners with dolphins serving as feet for the column. Between each pair of dolphins is a diamond ring decorated with a single vertical feather flanked by poppy flower pods, a device that also appears around the base of the capital above. Above the base a basketwork node is also decorated with diamond rings and clusters of poppy pods. See John Pope-Hennessy and Ronald Lightbown, Catalogue of Italian Sculpture in the Victoria and Albert Museum (London: H. M. Stationery Office, 1964), p. 200, where the catalogue entry refers to earlier work by Maclagan and Longhurst that connected the poppies and feathers of the column base with Bartolomeo di Andrea de' Medici, who married Alessandra di Leonardo Bartolini-Salimbeni in the sixteenth century, a date too late for the carving of this column. Pope-Hennessy and Lightbown date the carving on the column to ca. 1470–1475 and suggest that the column might have made at the time of the 1466 wedding of Bernardo di Giovanni Rucellai to Nannina di Piero de' Medici, the sister of Lorenzo de' Medici. The basis for this assertion is the presence of the Medici diamond rings on the facade of the Rucellai Palace, a gift made by Piero to Bernardo's father Giovanni. The most recent discussion of the Bartolini-Salimbeni can be found in Michael Lingohr, Der Florentiner Palastbau der Hochrenaissance: Der Palazzo Bartolini Salimbeni in seinem historischen und architekturgeschichtlichen Kontext (Worms: Wernersche Verlagsgesellschaft, 1997), pp. 49–55, 215, where he indicates that the devices pairing the Medici diamond ring and the Bartolini-Salimbeni poppy pods refer to the 1465 marriage of Bartolomeo di Lionardo di Bartolomeo Bartolini and Marietta di Giovanni d'Antonio de' Medici. Marietta died in 1471, childless. With Marietta's death the Bartolini-Salimbeni may have been willing to part with the column since their formal marriage alliance with the Medici had come to an end. Nonetheless, the family continued to maintain close ties with the Medici into the sixteenth century. Caglioti, Donatello e I Medici,

pp. 124–125, note 96, noted that the devices on the column and those on the facade of the Palazzo Rucellai are not the same, and, following Lingohr, associated the column with Bartolomeo Bartolini and Marietta de' Medici.

Mario Scalini has recently reconsidered the column and I wish to thank him for allowing me to see his conclusions prior to their publication. In "Original Settings of Nonreligious Bronzes in the Renaissance," in Peta Motture, ed., *Large Bronzes in the Renaissance,* Studies in the History of Art, vol. 64 (Washington, D.C.: National Gallery of Art, 2003), pp. 31–55, Scalini returns to the Pope-Hennessy/ Lightbown position that the devices refer to the Rucellai-Medici wedding of 1466.

9. Mario Scalini has convincingly argued that this column functioned as the base for a fountain that was topped by the puzzling bronze *Atys* now in the Bargello; see his *L'arte italiana del bronzo 1000–1700: toreutica monumentale dall'Alto Medioevo al Barocco* (Busto Arsizio: Bramante editrice, 1988), pp. 74–78. Clearly my suggestion of a relationship between the column in the Victoria and Albert Museum is very tentative. But even reading the column as having been originally made for Bernardo Strozzi or Bartolomeo Bartolini Salimbeni does not preclude its having come into Lorenzo's possession. It can be noted that on at least one other occasion Lorenzo the Magnificent seems to have appropriated (perhaps in the form of an unwilling "gift") works of art from the Bartolini-Salimbeni family. The Battle Paintings by Paolo Uccello that decorated Lorenzo's main room in the Medici Palace and that were confiscated by the Signoria in 1495 for placement in the Palazzo della Signoria originally belonged to Lionardo di Bartolomeo Bartolini Salimbeni and were subsequently owned by two of his sons, Damiano and Andrea; see Caglioti, *Donatello e I Medici*, pp. 265–281, for this argument and for information about the family. Thus members of the Bartolini-Salimbeni family seem to have been tied to Lorenzo in ways that made them subject to his will. As for Bernardo Rucellai's possible original ownership of the column, it is useful to remember that in 1471 Bernardo Rucellai traveled with Lorenzo and Leon Battista Alberti to Rome, where, together, they studied Roman antiquities.

10. This height differentiates Florentine column statues—other than the *Dovizia*—from their antique forebears, which were placed on very tall columns, comparable to the two monuments representing the victorious figures of the military St. Theodore and the Lion of St. Mark in the Piazzetta San Marco in Venice. Despite the reduced height of Florentine column statues like Donatello's *David* and his *Judith and Holofernes* and Verrocchio's *David,* the Renaissance meaning of the sculptural type parallels that of classical antiquity.

11. The best studies of this anti-Medici plot are still those of Guido Pampaloni: "Il giuramento pubblico in Palazzo Vecchio a Firenze e un patto giurato degli antimedicei (Maggio 1466)," *Bulletino senese di storia patria* ser. 3, 23 (1964), pp. 212–238; "Fermenti di riforme democratiche nella Firenze medicea del

Quattrocento," *Archivio storico italiano* 119 (1961), pp. 11–62; and "Fermenti di riforme democratiche nelle consulte della Republic Fiorentina," *Archivio storico italiano* 119 (1961), pp. 241–281. For the most recent study of this plot in 1466 see Margery A. Ganz, "Perceived Insults and Their Consequences: Acciaiuoli, Neroni, and Medici Relationships in the 1460s," in *Society and Individual in Renaissance Florence,* ed. William J. Connell (Berkeley: University of California Press, 2002), pp. 155–172.

12. The project for decorating the Cathedral buttresses goes back to 1408 when Nanni di Banco was given the commission for an Isaiah and Donatello for a David. Neither of these statues was placed on the buttress, since each was too small. Donatello had completed a terra-cotta Joshua by 1410 when it was on the north buttress of the Cathedral, where it remained until the eighteenth century. For the most complete detailing of this history from 1408 to 1504 and for related documents see Charles Seymour, *Michelangelo's David: A Search for Identity* (Pittsburgh: University of Pittsburgh Press, 1967). I am finishing a book on Michelangelo's *David* that will reconsider this material; it is tentatively titled *Clothing Michelangelo's David.*

13. This suggestion is made somewhat tentatively since there is no secure evidence for the dating of Donatello's *David.* All we know currently is that it is first documented in a description of the wedding of Lorenzo the Magnificent and Clarice Orsini in 1469. I first indicated my belief that this statue is connected with the Cathedral commission of 1463–1466 in an essay that has been all but ignored (perhaps kindly) by my colleagues because it proposed a post-mortem casting of the statue by someone in Donatello's shop, a suggestion that of course flies in the face of the artist/masterwork approach to history. Mario Scalini, *L'arte italiana del bronzo,* figures 288–290, is the only other writer I know to suggest a date around 1466 (the year of Donatello's death) and the assistance of another sculptor (Bertoldo) for this sculpture.

14. For the decoration of the Palazzo Medici see my "Familiar Objects: Sculptural Types in the Collections of the Early Medici," in Sarah Blake McHam, ed., *Looking at Italian Renaissance Sculpture* (Cambridge: Cambridge University Press, 1998), pp. 79– 110. The major source for information about the interior of the Medici Palace is the inventory made of its contents at the time of Lorenzo's death in 1492, now known through a copy of 1512 commissioned by Lorenzo di Piero de' Medici; see Marco Spallanzani and Giovanna Gaeta Bertelà, eds., *Libro d'inventario dei beni di Lorenzo il Magnifico* (Florence: Associazione Amici del Bargello/Studio per Edizioni Scelte, 1992).

15. This statement is predicated on a late dating of Donatello's *David* and on Piero having been its commissioner. The dating of this sculpture is one of the most vexed in the history of Renaissance art (see Caglioti, *Donatello e I Medici*), and this is not the place to review the conflicting literature on the subject. Had the statue been commissioned by Cosimo, Piero's father, and dated earlier in the century, the

point I am making about the civic nature of Davidian imagery in the Medici Palace would still stand.

16. For the document indicating that these paintings were previously owned by Andrea and Damiano di Lionardo de' Bartolini see Outi Merisalo, ed., *Le Collezioni Medicee nel 1495: Deliberazioni degli ufficiali dei ribelli* (Florence: Associazione Amici del Bargello/Studio per edizioni Scelte, 1999), p. 56; and Caglioti, *Donatello e I Medici*, p. 267, with a discussion of Lorenzo's appropriation of these paintings.

17. Andrew Butterfield, "New Evidence for the Iconography of David in Quattrocento Florence," *I Tatti Studies* 6 (1995), pp. 115–133. Butterfield's discussion of the Davidian models of rulership based on Psalm 144 (*Benedictus Dominus*) is a useful corrective measure against loose readings of David iconography in connection with Florentine republicanism, but his comments pertain to David as ruler and not necessarily to the youthful David.

18. Caglioti, *Donatello e I Medici*, pp. 326–327.

19. For the records of the 1495 commission see Merisalo, *Le Collezioni Medicee*.

20. It should be noted that in Verrocchio's will of June 25, 1488, the sculptor made specific mention of monies still owed to him by the Mercanzia for his *Christ and Doubting Thomas*. Presumably had the Medici also had outstanding debts to Verrocchio, these also would have been mentioned in the will, leading one to agree with Caglioti that this list was a formality. It should also be noted, however, that a document of December 24, 1487, concerning payments to Verrocchio for the *Christ and Doubting Thomas* mentions that Tommaso was "in extrema miseria"; so, despite the fact that Verrocchio had left him housing property in Florence and the residue of the payments for the *Christ and Doubting Thomas* as dowries for his daughters, Tommaso may still have felt the need to make financial claims on Verrocchio's estate, even though the blanks for the sums presumably owed seem to indicate that any outstanding debts that the Medici might have owed Verrocchio were cleared when the sculptor moved to Venice to work on the Colleoni Monument. For whatever reason Tommaso drew up his list, it is helpful as an opening into Verrocchio's work for the Medici. For the documents see Giovanni Gaye, *Carteggio inedito d'artisti dei secoli XIV. XV. XVI* (1839; reprint, Turin: Bottega d'Erasmo, 1968), vol. 1, pp. 367–370. See also Caglioti, *Donatello e I Medici*, p. 325, note 132, who believes that Tommaso was following the lead of Ghirlandaio and Michelangelo in having works restored to them; but there is a difference between recuperation of work and payments, and Caglioti does not mention that Tommaso left the payments due blank.

21. Giorgio Vasari, *Le Vite dei più eccellenti pittori scultori ed architettori*, ed. Gaetano Milanesi (Florence: G. C. Sansoni, Editore, 1906), vol. 3, p. 374; see also Julius von Schlosser, "Geschichte der Porträtbildnerei in Wachs," *Jahrbuch der kunsthistorischen Sammlungen der allerhöchsten Kaiserhauses* XXIX, 3 (1911), pp. 171–258; and Gino Masi, "La ceroplastica in Firenze nei secoli XV–XVI e la famiglia Benintendi," *Rivista d'arte* IX (1916), pp. 134–143.

22. Vasari's contention is difficult to believe since the techniques for making life and death masks are described in Cennino Cennini's *Craftsman's Handbook* a half-century before Verrocchio's birth.

23. See my "Fraternal Piety and Family Power: The Artistic Patronage of Cosimo and Lorenzo dei Medici," in Francis Ames-Lewis, ed., *Cosimo 'il Vecchio' de' Medici, 1389–1464* (Oxford: Clarendon Press, 1992), pp. 195–219.

24. Verrocchio's *Christ and St. Thomas* for Or San Michele was valued at 800 florins; despite the larger size of the figures, the difference between 400 florins for one and 150 florins for the *David* is significant.

25. We don't know exactly what the imprecise terms ("next to," "near") of the document mean, and thus we cannot say with any degree of certainty where Verrocchio's *David* was placed on the stair landing in 1476. The plan of the building indicates a limited number of possibilities for the placement of the bronze figure. The former window—blocked up at the time of the addition to the building to the east—would have lit the figure to advantage and may suggest a placement of the statue in front of it or to the left of the door into the Sala dei Gigli, where it would also have been lit by light coming from the window.

26. Nicolai Rubinstein, *The Palazzo Vecchio 1298–1532: Government, Architecture, and Imagery in the Civic Palace of the Florentine Republic* (Oxford: Clarendon Press, 1995), pp. 37–38. It may be useful here to remember that Verrocchio provided a type of chain or linked barrier (or portcullis) for the Medici in his bronze interlace for the tomb of Piero and Giovanni dei Medici in San Lorenzo. This elaborate interlace separates the Old Sacristy from the Medici Chapel in the transept of the church, while at the same time allowing (visual) communication between them.

27. Ibid., p. 55. The south wall of the doorway is still decorated with gold fleurs-de-lis on a blue ground.

28. Vasari, *Le Vite*, vol. III, p. 293. See also Leopold D. Ettlinger, *Antonio and Piero Pollaiuolo* (Oxford: Phaidon, 1978), p. 164. The Vasari text is tantalizing insofar as it pairs this figure of the Baptist in the town hall and Pollaiuolo's representations of Hercules for the Medici Palace: "In the Palace of the Signoria of Florence, at the Porta della Catena, he made a St. John the Baptist; and in the house of the Medici he painted for the elder Lorenzo three figures of Hercules in three pictures, each five braccia in height." For this translation see Giorgio Vasari, *Lives of the Most Eminent Painters, Sculptors, and Architects*, trans. Gaston Du C. de Vere, ed. Kenneth Clark (New York: Harry N. Abrams, 1979), vol. I, p. 663.

29. Rubinstein, *Palazzo Vecchio*, p. 55.

30. Ibid., p. 57.

31. Ibid., p. 57.

32. Gaetano Milanesi, "Documenti inediti risguardanti Leonardo da Vinci," *Archivio storico italiano* ser. III, 16 (1872), p. 228n.; and Giovanni Poggi, "Note su Filippino Lippi," *Rivista d'arte* 6 (1909), pp. 307–308.

33. Marvin Tractenburg, "Archaeology, Merriment, and Murder: The First Cortile of the Palazzo Vecchio and Its Transformations in the Late Florentine Republic," *Art Bulletin* 71 (1989), pp. 565–609.

34. "Io non sono signore di Firenze ma cittadino con qualche auctorità." Lorenzo made this statement on November 26, 1481, in a letter to Pierfilippo Pandolfini; see Lorenzo de' Medici, *Lettere* (Florence: Giunti Barbèra, 1977), vol. 6, p. 100.

35. See Melinda Hegarty, "Laurentian Patronage in the Palazzo Vecchio: The Frescoes of the Sala dei Gigli," *Art Bulletin* 78 (1996), pp. 264–285.

36. For the Sala dei Gigli see Rubinstein, *Palazzo Vecchio*, pp. 102–103.

37. See Hegarty, "Laurentian Patronage," for a discussion of these projects and pp. 283–284 for the documents of the commissions.

38. See Hegarty, "Laurentian Patronage"; and Blake Wilson, "Music and Merchants: The *Laudesi* Companies in Early Renaissance Florence," *Renaissance and Reformation* n.s. XIII, no. 1 (1989): pp. 151–171.

39. The single attempt to focus on Verrocchio's commission for the *palla* of the cupola is Dario A. Covi, "Verrocchio and the *Palla* of the Duomo," in Moshe Barasch and Lucy Freeman Sandler, eds., *Art, the Ape of Nature: Studies in Honor of H. W. Janson* (New York: Harry N. Abrams; Englewood Cliffs, N.J.: Prentice Hall, 1981), pp. 151–169. Covi's study includes transcripts of the documents relating to the commission. It should be noted that the *palla* was destroyed by lightning in 1601 and that the ball currently atop the lantern is a rebuilding of Verrocchio's original. Unfortunately Covi published only the new documents that he had found rather than a complete presentation of the documentary sources, so one must see also Günter Passavant, *Andrea del Verrocchio als Maler* (Düsseldorf: Verlag L. Schwann, 1959), documents XIII–XV; and Cesare Guasti, *La cupola del Duomo di Firenze* (Florence: Barbèra, Bianchi e comp., 1857), pp. 161–168, docs. 373–379.

40. Leon Battista Alberti, *On Painting*, trans. and ed. John R. Spencer (New Haven: Yale University Press, 1964), p. 40. For the metaphorical sense of shadow as it applies to visual forms in late antiquity and the early Christian period, in the work of Cennino Cennini and in Alberti, see Jack M. Greenstein, *Mantegna and Painting as Historical Narrative* (Chicago: University of Chicago Press, 1992), p. 41. Greenstein shows that "shadow" was used to "emphasize the disparity between the literal and spiritual senses," between "*historia and figura*," and what Cennini called "things not seen." As long as Florence may have controlled its dependent states and as quietly paternalistic as its domination may have been, that shadow of control over "the entire Tuscan countryside" expresses a clear political reality. For the cosmic meaning of the dome in connection with the shadow cast by the sun see Giulio Carlo Argan, "Il significato della cupola," in *Filippo Brunelleschi: la sua opera e il suo tempo* (Florence: Centro Di, 1980), vol. 1, pp. 11–16. We don't believe that the shadow of the dome should be read—or should only be read—as a "wonderfully benevolent metaphor"; see Suzanne B. Butters, "The Duomo Perceived and the Duomo Remembered: Sixteenth-Century Descriptions of Santa Maria del Fiore," in Timothy Verdon and Annalisa Innocenti, eds., *La Cattedrale come spazio sacro: Saggi sul Duomo di Firenze* (Florence: Edizioni Firenze, 2001), pp. 457–501. Butters refers to the possible connection of the dome to the wonders of the ancient world suggested by Christine Smith, *Architecture in the Culture of Early Humanism: Ethics, Aesthetics, and Eloquence 1400–1470* (Oxford: Oxford University Press, 1992), p. 45.

41. The document for Verrocchio's commission can be found in Giovanni Poggi, *Il Duomo di Firenze* (1909; reprint, ed. Margaret Haines, Florence: Edizioni Medicea, 1988), vol. II, p. 243. The Medici interest in asserting their presence in the Duomo goes well back into the fourteenth century; see my "Medici Funerary Tomb Monuments in the Duomo of Florence during the Fourteenth Century: Strategies of Self-Presentation," forthcoming.

42. Poggi, *Il Duomo*, vol. I, no. 1194. For Medici interventions at the Duomo and for Piero's patronage at major pilgrimage sites in the city see my "' . . . ha fatto Piero con voluntà del padre . . . ' Piero de' Medici and Corporate Commissions of Art," in Andreas Beyer and Bruce Boucher, eds., *Piero de' Medici 'Il Gottoso' (1416–1469): Kunst im Dienste der Mediceer/Art in the Service of the Medici* (Berlin: Akademie Verlag, 1993), pp. 317–339.

43. Poggi, *Il Duomo*, vol. I, no. 1206.

44. Lorenzo's participation in commissions at the Cathedral in the mid-1470s should be seen in light of the fact that Rinaldo Orsini, archbishop of Florence from 1474 to 1503, gave authority over the fabric of the structure to Lorenzo. Orsini was a relative of Lorenzo's wife, Clarice Orsini, whom Lorenzo had married in 1469.

10 May 1476

The aforementioned Operai [Andrea de' Pazzi, Antonio Martelli, Piero Minerbetti], having come together in the Palazzo Pubblico of Florence for the carrying out of their duties, as is customary and in pursuit of their duties, that is to say: they decided and deliberated that Girolamo di Antonio de' Martelli, their treasurer, should, from whatever funds of their office coming to his hand, give and pay Lorenzo and Giuliano di Piero di Cosimo de' Medici 150 florins, so much for the price in the account of the David held by them and then placed near the Porta della Catena [leading to the Sala dei Gigli] for the decoration and beautification and even the magnificence of the palace.

This document was first published Giovanni Gaye and is now conveniently transcribed by Andrew Butterfield, *The Sculptures of Andrea del Verrocchio* (New Haven: Yale University Press, 1997), p. 204; the original document is in the Archivio di Stato, Florence, Archivi della repubblica, Operai di Palazzo, I, fol. 8r. (The translation is by John Paoletti.)

By Tommaso del Verrocchio. + On the twenty-seventh day of January, 1496. The heirs of Lorenzo de' Medici owe the following sums for work that appears below:

1. For a [bronze] David and the head of Goliath .florins

2. For the red nude [the restored porphyry Marysas; now in the Uffizi]florins

For the Medici villa in Careggi

3. For the bronze baby with three heads of bronze and four lion's masks of marble .florins

4. For a marble fountain figure .florins

5. For a historiated relief with several figures .florins

6. For the attachment of all the heads that are [set] above the exits from the courtyard in [the palace] in Florence .florins

7. For a [painted] panel of the head of Lucrezia Donati [ca. 1468?]florins

8. For the standard [parade banner made] for the Tournament of Lorenzo [1468; lost] .florins

9. For [the figure of] a lady in relief [sic] that was placed on [Lorenzo's] helmet [for the tournament; lost] .florins

10. For the painting of a standard with a figure of a young spirit [sic] for the Tournament of Giuliano [Lorenzo's brother; held in the Piazza S. Croce in 1475; lost] .florins

11. For the tomb of Cosimo at the foot of the High Altar of San Lorenzo . . .florins

12. For the tomb of Piero and Giovanni de' Medici [in San Lorenzo]florins

13. For the cutting of 80 letters, inscribed in the serpentine [marble] of two roundels in the said tomb .florins

14. For 20 masks taken from nature [life and/or death masks]florins

15. For the ceremonial [armor?] of the Duke Galeazzo [Sforza]florins

The translation of this document is taken from Charles Seymour, Jr., *The Sculpture of Verrocchio* (Greenwich, Conn.: New York Graphic Society, 1971), p. 175; the original document is in the Archivio della Galleria degli Uffizi, Miscellanee Manoscritte, P.I., fol. 3.

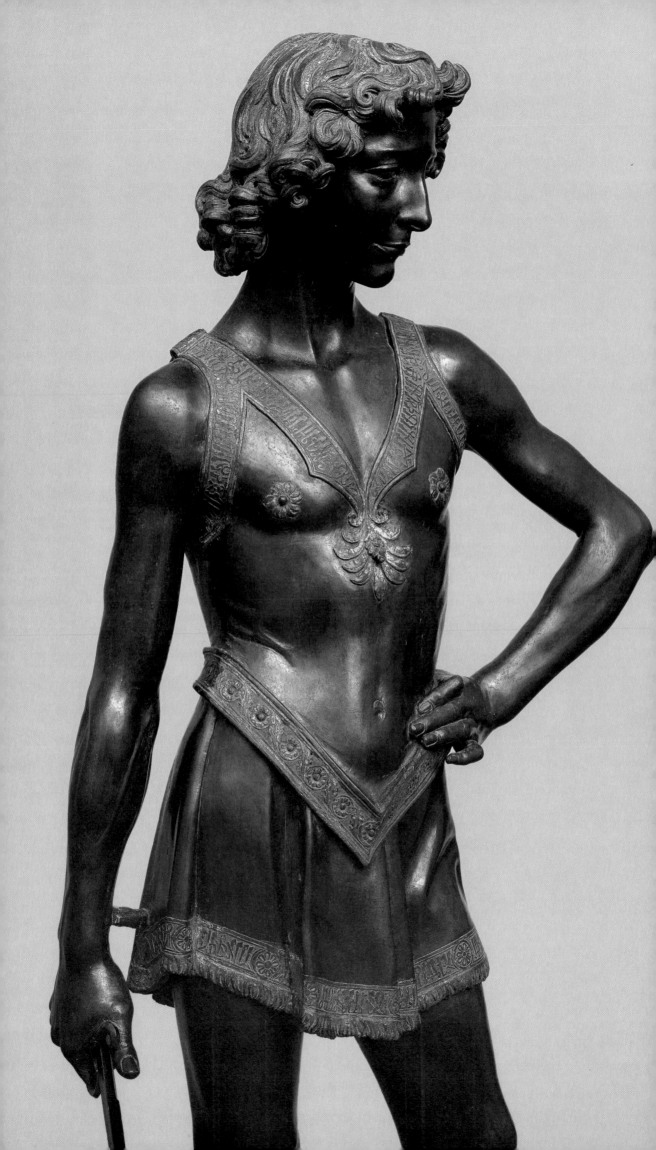

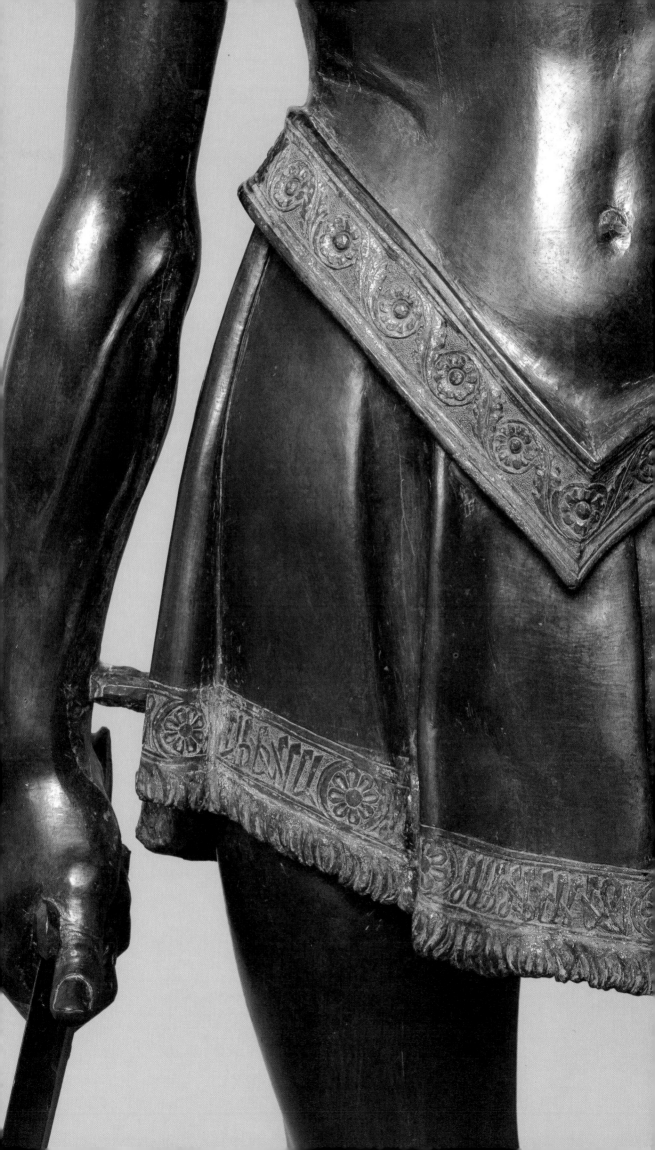

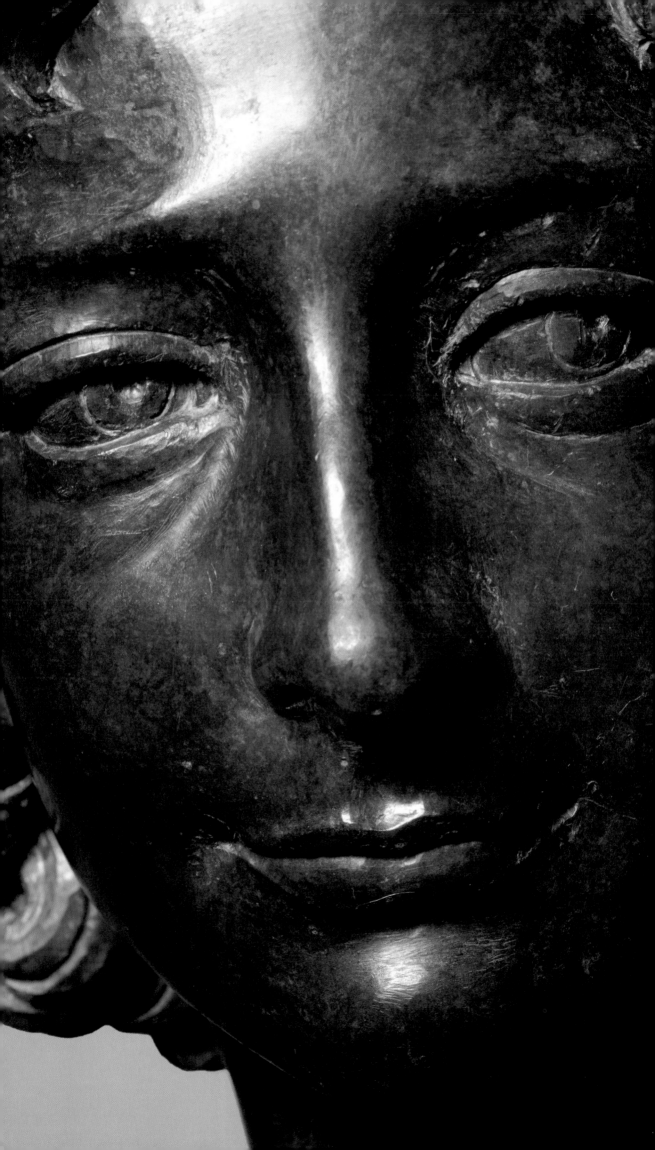

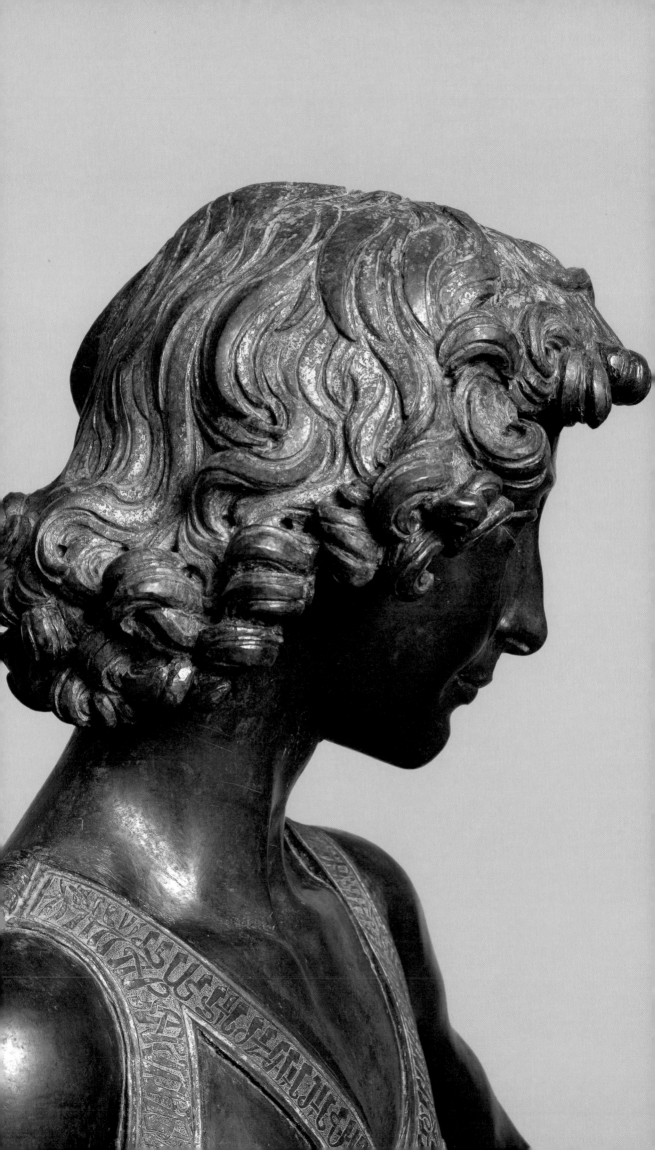

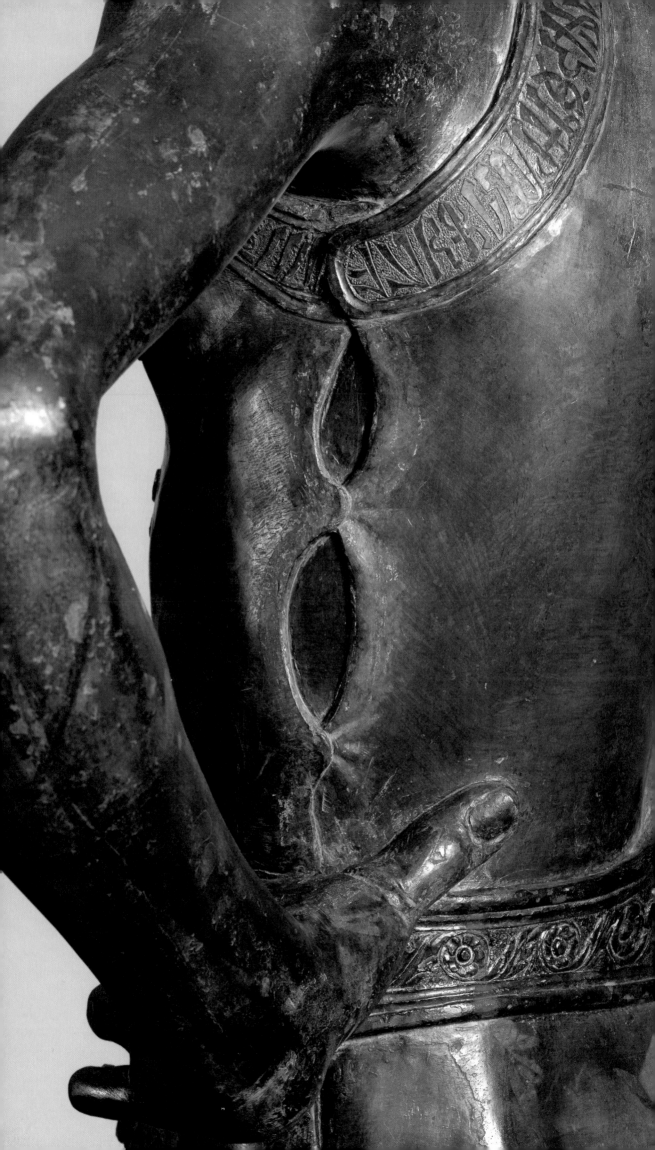

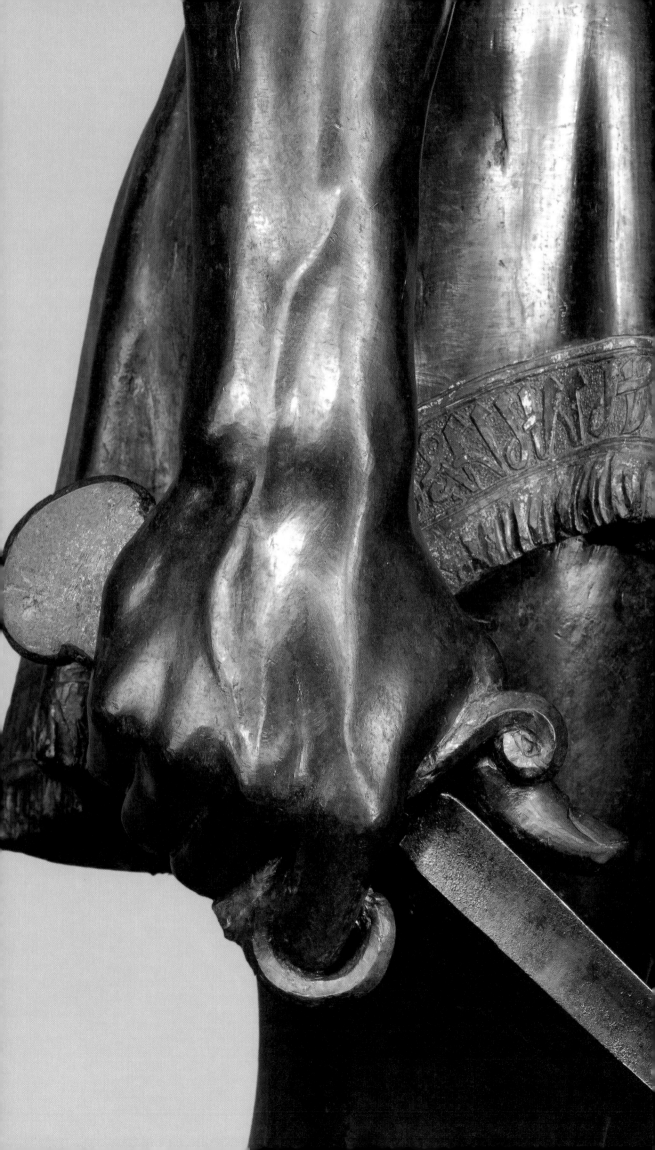

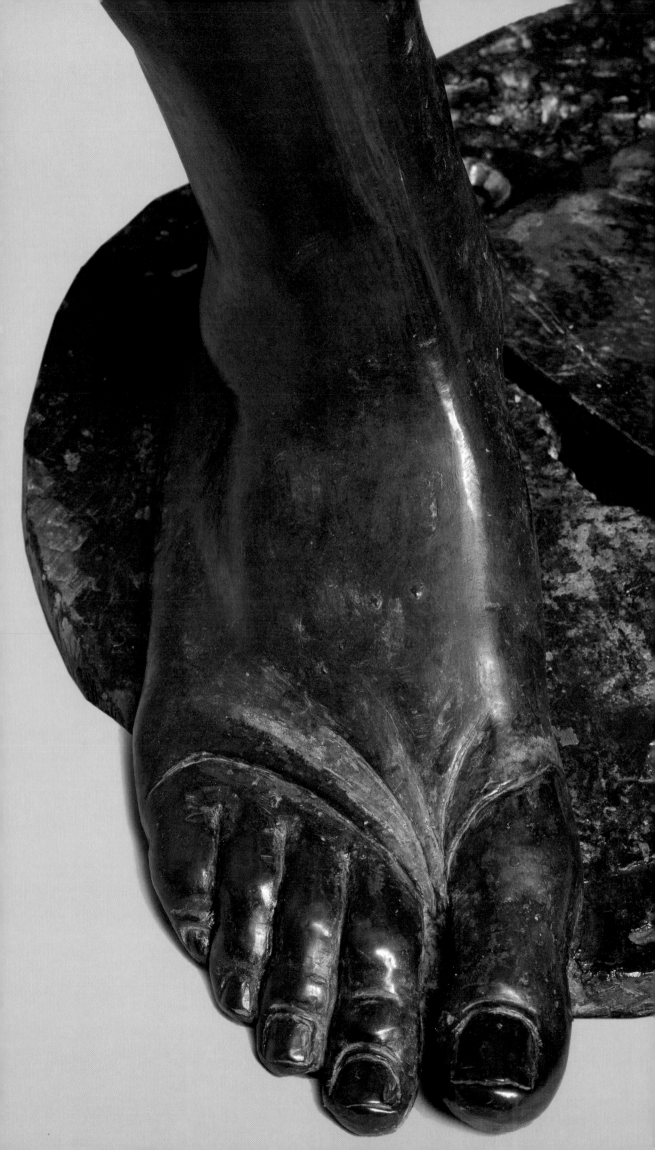

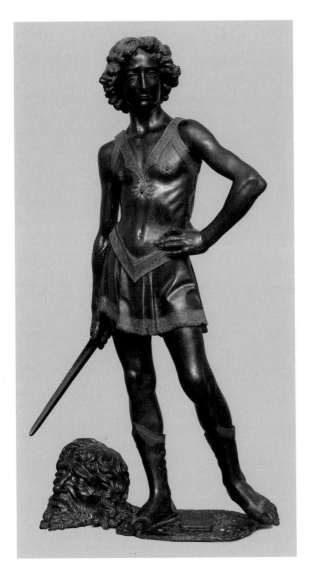
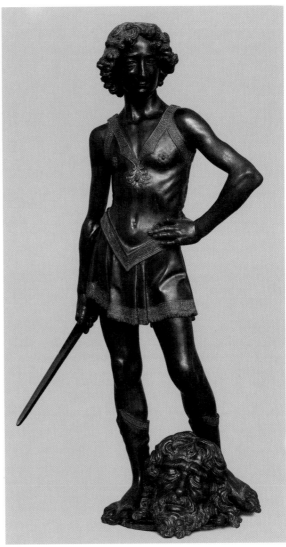

Most likely placement of Goliath's head in original configuration for the Palazzo Medici (left), before 1476. *David* as it looks today (right), adapted for its place in the Palazzo Vecchio in 1476. Head of Goliath (below).

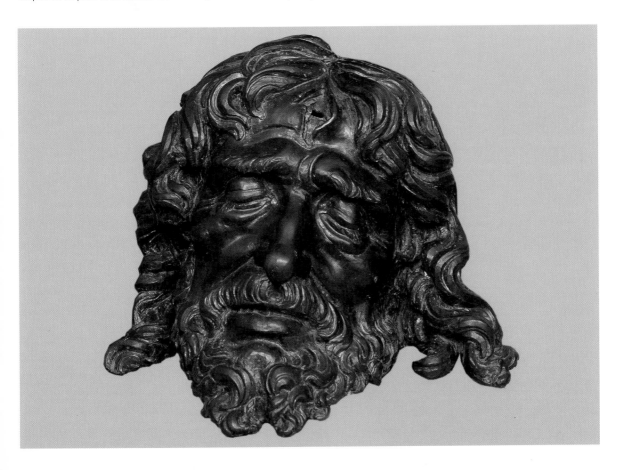

Beatrice Paolozzi Strozzi
Maria Grazia Vaccari

THE RESTORATION:
METHODOLOGICAL BASIS

In recent decades, many experiences with Renaissance masterpieces—the *Gates of Paradise* by Ghiberti, *Judith* by Donatello, the *Christ and St. Thomas* by Verrocchio, *Perseus* by Cellini, *Neptune* by Giambologna—have led to the development of a specific working approach, based in sound science and theory, to the problems related to the conservation of bronze statuary standing outdoors.[1] However, the restoration of indoor bronzes, which present much more limited problems, does not have as many references.

This category comprises the sculptures that decorate old palaces. The sculptures still fulfill their original functions within a decorative program or a more clearly iconographic program of dynastic glorification, like the sculptures (altars and tombs) in churches where, in many cases, the artworks are still tied to their original purpose or at least maintain some suggestions of it. However, sculptures in museums are certainly more significant in number—be they small bronzes or the larger and more diversified range of statuary, part of which reached museums directly from the collections of princes and patrons and part in later years through the intermediations of antiques dealers and collectors. The conservation history of these items is unknown, and when the archives do not contain information about treatments and interventions, observations and in-depth studies can help in reconstructing the sculptures' physical history and guide us in restorations.

Even the little knowledge we do have about the original appearance of Renaissance bronzes derives primarily from the fact that since they are protected, museum sculptures rarely have severe conservation problems. Therefore, opportunities for in-depth investigations of the technical aspects and physical history that are normally part of a restoration are fewer than those offered by bronze sculptures that stand outside.

When the casting of a bronze was completed, the artist had to eliminate surface irregularities by polishing and adding the final touches with the skillful use of special metal tools. Then, he could create a chromatic finish. There were several "recipes" for creating artificial patinations that modified the pure color of the bronze, enhancing it, as it were, and at the same time protecting the metal matrix from contact with the air.

Renaissance sources starting with Pomponius Gauricus[2] (the first to offer specific information on this aspect of making bronzes) report a variety of techniques that, in the final analysis, led to the artist's freedom in the field of taste and general culture that could direct his choices. In spite of this, however, there are those who maintain that the most common method of finishing statues during the Renaissance was to apply a black paint to the bronze, and the example they give is Donatello's *David,* which has a black varnish that is anything but original.[3]

The restoration of Verrocchio's *David* offers us an opportunity to approach a topic that is almost ignored except in the brief summaries that are published after some restorations.[4] Furthermore, it allows us to establish a series of reference points for the issues inherent to the aesthetic recovery of "indoor" bronzes. It is clear that the limits of our restoration work are the general guidelines set forth in the *Carta del Restauro.*[5] For bronze

sculptures, in addition to respecting the material and finishes, it calls for maintaining the "noble patinas" (malachite, atacamite, etc.) with the understanding that they are the result of the natural modifications in the materials of the alloy (corrosion products). When dealing with "indoor" bronzes, these natural alterations generally do not occur. Instead, what we see quite frequently are deliberate modifications related by necessity to maintenance requirements and triggered by changing tastes or needs related to keeping the piece in a collection or exhibiting it in a museum. Patinations fall into this context; they make changes in the appearance created by the artist by being applied over the original finish no matter what the piece's condition may be. When they are the result of previous interventions, the decision to remove them or not must be based on a critical and technical assessment of the state of the original materials and a consideration of the weight attributed to past modifications in its overall history.[6]

In the case of the *David*, the decision to remove all the additional patinations was not based purely on conservation criteria. It consisted of a cleaning procedure in order to recover the aesthetic and expressive attributes as well as to acquire information concerning the technical processes and the actual, physical history of one of the greatest masterpieces of Renaissance sculpture.

With the help of the most modern methods and the support of scientific tests we believe that these objectives have indeed been achieved. We also believe that today the *David* is much more similar to the way it looked when Verrocchio put down his tools while maintaining the signs that time has left on its "skin." The statue's state of conservation confirms that it never stood outdoors and this is documented in the essay on its history in this catalogue (see page 13). As for the statue itself, there is little documentary evidence of its conservation history. The first is a document from 1778 that relates the addition of a sword blade taken from the Medici armory. The document concludes with a list of materials that the bronze-worker Corrini used for the restorations he did to set up the "Gabinetto dei bronzi moderni" in the Uffizi.[7] These include some that can be identified as having been used for the patination on the *David* with the dual goal of harmonizing the colors of the figure and the replacement sword and to give it the same chromatic tones of all the heterogeneous modern bronzes of varying provenance displayed in the Gallery.

A less distracted and superficial observation of the bronze sculptures in the Museo Nazionale del Bargello, which were formerly in the Uffizi, allows us to note that they are characterized by a very dark, almost black patina, like the one on the *David*.

The chemical analysis of the patinations on Verrocchio's bronze revealed an oil-base with a black pigment (charcoal or lampblack). Both stratigraphic analysis and direct observation allow us to affirm that there were many coats (five have been identified). Not all were intact and were characterized by gaps and wear, which made the surface look as if it were marred by incrustations under which it was difficult, if not impossible, to see the details of the fine workmanship on the body and the careful chasing of the ornamental details.

Although there is no information about specific treatments, the archival sources concerning the late-nineteenth-century casts made from the statue give us much useful insight into the *David*'s many "experiences." Following a huge request for casts from Germany, on November 4, 1874, the Ministry of Education approved the making of a cast of the *David* as well as of other bronze and marble masterpieces.[8] Two years later, a report on the damages that making the casts had caused on the Bargello sculptures showed

Verrocchio's *David* at the top of the list. There were scratches on the armor, patina missing from the tips of the toes on the right foot (which had definitely been rubbed off), and a different tone of patina that was darker than that on Goliath's head.[9]

These documents have enabled us to acquire at least a few certainties that were of use in the restorations.[10] The most recent patinations, on the big toe of the right foot and Goliath's head, obviously date from the late nineteenth century (they were in fact thinner). The same patinations, evenly applied to the rest of the *David,* were laid over earlier coats. In this regard, we use another term, *post quem,* for the patination on the sword (a substitute) that we can definitely date as having been applied in 1778 thanks to the mentioned document. Thus, the surface patinations on the *David* match the materials used by the bronze-worker Corrini in 1778.

And finally, while imagining other patinations beneath this eighteenth-century coat, the original gilding on the statue tells us the original level of the surface. Hence, the restoration was based first on research for information and a critical assessment of the information found, and then on the scientific support of a whole series of analyses that are described in the report on the restorations.

Notes

1. The broader scope of issues related to the conservation of bronzes outdoors has, in recent decades, prompted the development of a specific theoretical basis for the restoration of non-archaeological bronzes regarding mainly the problem of cleaning—i.e., the elimination of alterations and deposits that have a negative impact, while maintaining those patinas, defined as "noble" (Brandi and then Marabelli) that are free of compounds that can trigger the corrosion process. Thanks to sophisticated and advanced technological tools, research has made considerable progress in the characterization and identification of materials and alteration products and in developing both cleaning methods as supplements or alternatives to traditional processes and materials that can inhibit alterations and protect the outdoor bronzes from pollutants. For the issues and conservation methods for metal objects in general, see M. Marabelli, *Conservazione e restauro dei metalli d'arte* (Rome: Accademia nazionale dei Lincei, 1995), which includes a full bibliography. The exhibition catalogues *Donatello e il restauro della Giuditta,* ed. L. Dolcini (Florence, 1988); and *Il Maestro di Leonardo. Il restauro dell'Incredulità di san Tommaso di Andrea del Verrocchio,* ed. L. Dolcini (Milan, 1992), are of significant interest regarding major restoration projects, as is *Il restauro del Nettuno, la statua di Gregorio XIII e la sistemazione di Piazza Maggiore nel Cinquecento* (Bologna, 1999) on the restoration of Giambologna's *Neptune.*

2. Pomponius Gauricus, *De Sculptura,* ed. A. Chastel and R. Klein (1504; reprint, Geneva, 1962), pp. 232–233, n. 47. The first source to offer information on this aspect of bronze sculptures, Gauricus writes that a green color could be obtained by wetting the statue thoroughly with salted vinegar, black by painting with melted pitch or lampblack obtained by burning damp straw, yellow by heating the object on a red-hot plate until the desired shade was obtained and then leaving it to cool. One could then work with chemical changes with acids or reversible treatments obtained by applying a coat of paint which, in addition to giving the metal surface a chromatic finish, leveled off any superficial deformities and protected the metal from corrosion. For additional chromatic effects, to enhance the decorative effects and "value" of the piece, silver or gold leaf could be applied with glue or in amalgam. The latter method produced a more lasting effect and was appropriate for statuary that would stand outdoors.

3. Here we refer to a study by Phoebe Dent Weil, "A Review of the History and Practice of Patination," in *Proceedings of the Seminar Corrosion and Metal Artifacts. A Dialogue between Conservators and Archeologists and Corrosions Scientists* (Gaithersburg, Maryland, 1976), pp. 77–92 and 81–84. Using sources and technical studies as her basis, the author maintains that antique bronze sculptures did not have a chromatic finish (i.e., an artificial patina) but were carefully polished and perhaps given a protective coating (bitumen and oil, according to Pliny). The coloristic effects were achieved by inlays of other metals or materials such as ivory, marble, and glass paste. Outdoor bronzes developed a natural patina due to exposure to the atmosphere.

4. For example, see the essay on the restoration of the monument to Cardinal Baldassarre Coscia by Donatello in the Baptistry in Florence, by Loretta Dolcini, published in *OPD Restauro* 3 (1998), pp. 121–122. The patinations that covered the bronze and gilding were removed.

5. We refer to the 1987 updated edition of the *Carta del Restauro* that amends and supersedes the 1972 edition. Guidelines for the restoration of bronze sculptures are contained in Attachment D.

6. On the subject of patinas and patinations in general, with some reference to metal artifacts, see G. Alessandrini, C. Beltrami, M. Cordaro, and G. Torraca, "Patine, pellicole e patinature," in *Diagnosi e progetto per la conservazione dei materiali dell'architettura* (Rome, 1998), in particular pp. 259–261.

7. See the essay by Beatrice Paolozzi Strozzi and Maria Grazia Vaccari in this catalogue, notes 49–50.

8. Letter of approval from the Ministry, n. 7577 dated 4 November 1874, in Archivio della Galleria degli Uffizi (AGU), Affari dell'anno 1882, Filza A. pos. 1, n. 37. The custom of destroying molds after reproducing sculptures meant that casts had to be made each time a copy was requested. Having acquired knowledge of the damage that making casts caused to the statues, especially if done repeatedly, the Ministry of Education was prompted to issue two circulars in 1865 prohibiting the making of casts of bronze and marble sculptures (n. 177 dated October 30, 1865, for bronzes and n. 179 dated December 2, 1865, for marble), AGU, Affari dell'anno 1865, Filza B, pos. 4 n. 56). Subsequently, under pressure from foreign governments that wanted to acquire copies of Italian Renaissance masterpieces for their museums, a law was passed (Regio Decreto n. 1727 dated December 7, 1873) that governed the issue. When Germany made a huge request for casts in 1874, specific instructions and procedures for making the casts were issued (AGU, Commissione Consultiva 1874, Filza B, pos. 4, n. 20). On this topic, see G. Gaeta Bertelà and P. Barocchi, "L'esposizione donatelliana del 1877 e la fortuna dei calchi," in *Donatello e il primo Rinascimento nei calchi della Gipsoteca* (Florence, 1985), in particular pp. LVII–LIV, and the *Appendice Documentaria*, pp. 250–280, which contains a full transcription of the documents mentioned here.

9. AGU, Galleria delle Statue 1876, Filza A, Pos. 1, n. 56.

10. Although these documents are not exhaustive on the matter of how many casts were made from the *David*, they do help create a link between the dark patinas on the surface and the treatments applied to the bronze prior to molding and then afterward to remove the materials used to protect it and detach the casts. In other words, the re-patinations served to conceal the unevenness created by the partial re-moval of the patina. The 1876 observation that "the tips of the toes on the right foot are shiny" serves as a terminus post quem for dating a specific revarnishing process.

Salvatore Siano
Maria Ludovica Nicolai
Simone Porcinai

VERROCCHIO'S DAVID: CHARACTERIZATION AND CONSERVATION TREATMENTS

1. INTRODUCTION

Before going into the specific aspects of the restoration of Andrea del Verrocchio's *David*, we believe some general considerations are appropriate. They will shed light on the reasons for this important conservation project, and on the context in which it was undertaken, making a major impact on the understanding of the masterpiece.

As is the case with many Renaissance and other artworks, over the centuries Verrocchio's *David* was subjected to a series of surface treatments that altered its original appearance.[1] There is no written justification for the repeated applications of patinations over the artist's original treatments and gilding. These gave the statue its dark and more or less uniform tones that we all knew. Nor is there any documentation concerning the materials used, other than some indirect clues obtained from reports on similar treatments applied to other sculptures. On the basis of studies of various artworks we can now affirm that between the eighteenth and nineteenth centuries many bronze and even marble statues were patinated by applying layers of dark tones to create a "bronze-like" effect. The most likely explanation for this is that they wanted to adapt the pieces to current tastes. It remains unclear how this practice is connected to the complex artisan tradition of patinating bronzes. However, because of the stratigraphic coarseness, lack of consideration for material compatibility, and poor stability, these modifications cannot be considered on a par with ancient and Renaissance surface treatments, which were much finer and more compatible. This is the basic reason why, in several situations, it was decided to remove these nineteenth-century bronzings, giving priority to conservation and artistic values over the presumed historical value of arbitrary treatments applied in the past.[2]

The analysis of the *David*'s state of conservation described below will clarify these aspects. Furthermore, it will show that even when we are faced with apparent alterations in the form and content of great masterpieces, decisions to restore and the methods employed are currently based on rigorous conservation criteria. In order to safeguard and protect the cultural heritage, they are implemented through the integration of advanced diagnostic and modern treatment and protection methodologies.

That this type of approach requires interdisciplinary discussion and cooperation is a well-known fact. However, we believe that the real integration of skills cannot be considered a given, since each specific conservation issue becomes a test of interdisciplinary interactions that in some ways is always unique and not always easy to put into practice due to the "distances" in the methods and languages involved.

The analytical characterization and restoration approach followed for Verrocchio's *David* fits into the context of the experience built up by the Florentine institutions dedicated to the protection of the cultural heritage. Over the past decades these organizations

97

have established a network of cooperation with research centers, universities, restorers, producers, foundations, and domestic and international experts that has yielded exemplary results in several major restoration projects. It is a true methodological school that is inspired by famous and not-so-famous figures. It is a "school" that confirms Florence's international lead not only because of its rich and vibrant tradition of skills, but also for the development of innovative methods and tools for the conservation of its renowned heritage.

For this project the Museo Nazionale del Bargello and the Soprintendenza per il Polo Museale Fiorentino created a team that included the Opificio delle Pietre Dure for the stratigraphic analysis, the Istituto di Fisica Applicata del Consiglio Nazionale delle Ricerche (CNR, National Research Council) of Florence for diagnostic integration and optimization of the laser cleaning, the Ente per le Tecnologie, l'Energia e l'Ambiente (ENEA) of Rome for the radiographic studies, the Istituto di Chimica e Tecnologie Inorganiche e dei Materiali Avanzati, CNR of Padua for the specific diagnostic and protective aspects, and the Soprintendenza per i Beni Archeologici of Tuscany for knowledge about early casting techniques and input from individual experts. The work was preceded and accompanied by ongoing diagnostic tests for the purpose of optimizing the cleaning and protective treatments and by in-depth studies of all of the piece's stratigraphic and technological aspects, enabling us to increase our knowledge of Renaissance techniques. The project also gathered as much information as possible to reconstruct the little known aspects of the statue's "life" and to document—from the objective standpoint of material sciences—the episodes that have come down to us through historical documents.[3] In this regard, we must state that, notwithstanding the fact that progress of the work does indeed allow us to draw a series of important conclusions, the scientific analysis, especially insofar as the technological aspects of the statue are concerned, cannot be considered complete. These will be the subject of further studies through analysis of the already available data and additional comparative diagnostic tests.

2. STATE OF CONSERVATION

As we have noted above and as reported in other essays in this catalogue, visual inspection of the statue revealed a series of coats ranging from dark brown to black in color along with earthy accumulations in the deep points (grooves, curls, etc.). Apparently, the patinations on the David were more consistent and coherent and had greater chromatic variations than those on the head of Goliath, which were less stratified, incoherent, darker, and more uniform in tone (fig. 1). The structural differences explain why it was possible to conduct an exhaustive stratigraphic study only on the David.

In both cases the greatest accumulations of material in the deeper areas diminished the relief to the extent that some details of the finishing, such as the engraving on the trim, were almost completely concealed. This totally altered the chiaroscuro effects and created an illusion of less detail. To this we must add the almost total covering of the original gilding. In fact, not only is gilding not even mentioned in the detailed nineteenth-century descriptions of the statue, but up to ten years ago it was believed that only the trim on the clothing was gilded.[4] In fact, this restoration began with a mapping of the possible gilded areas done through a careful microscopic study and cleaning tests, since visual observations alone could not shed light on the location and extent of the gilding. As we shall see below, there is much more gilding on the David than initially believed.

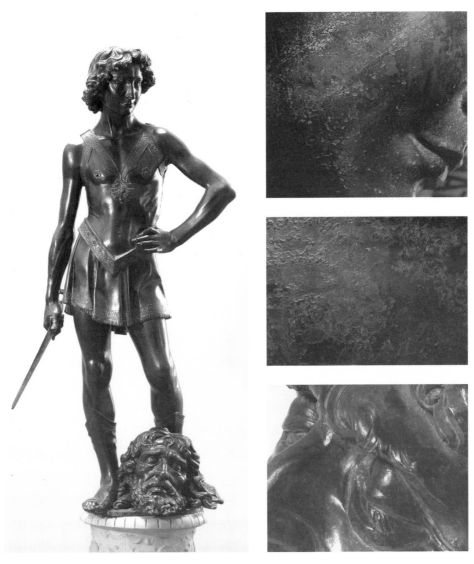

FIGURE 1. Verrocchio's *David with the Head of Goliath*, ca. 1465, bronze, National Museum of the Bargello, Florence. The details show the chromatic changes in the patinas and their varying consistencies; the head of Goliath appeared less stratified and more even.

Even though all this could apparently justify a cleaning aimed at eliminating the arbitrarily applied coatings, we must state that the cleaning would not have been possible without a careful diagnostic campaign aimed at developing optimized methods. Furthermore, it would have been unjustified without the analytical support that specifically identifies the type of materials used, their stability, and the real need for removing them, along with the level of cleaning to pursue and the type of protection that would assure its conservation over the years to come. To this we must add the unique opportunity it provided for studying specific and general aspects of art history and artistic techniques with the help of the objective data obtained from the study of the materials.

The results of the diagnostic campaign reported in the following paragraphs have allowed us to obtain information concerning the materials used in the patinations, the gilding technique, the bronze alloy, and technological details about the casting which provide useful data for a complete understanding of Verrocchio's masterpiece.

99

2.1 Patinations and Surface Corrosion

In order to identify the patinations on the *David* from the chemical-physical standpoint, we took a series of surface samples using mechanical tools. We then used optical and electron microscopes (SEM-EDX) for the stratigraphic study, infrared spectrophotometry (FT-IR) to analyze the organic and inorganic compounds, and gas chromatography for a clear identification of the binders and protective treatments.

Figure 2 shows the optical and SEM-EDX observations of a typical cross-section in which we can see a series of clearly distinguishable overlapping layers (fig. 2a). The bottom layer consists primarily of copper hydroxychloride as we can see from the back-scattered electrons SEM observation (fig. 2b) and the EDX analyses (figs. 2c–e). The subsequent layers can be attributed to various coats of earth pigment, ochres, and carbon black patinas (figs. 2a and 2f) distributed within an organic binder matrix. On the sample we examined we found from two to five distinct patinations, which can most likely

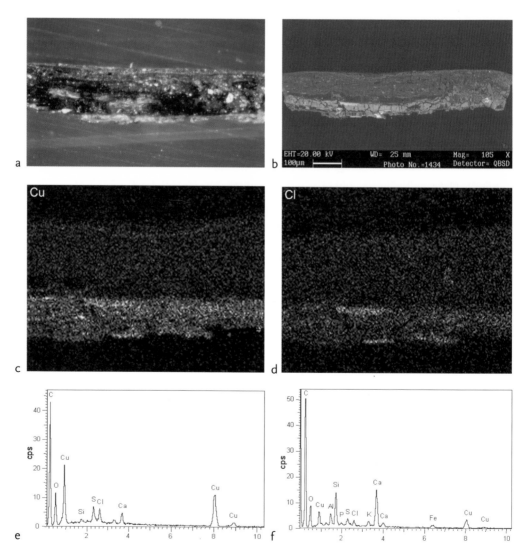

FIGURE 2. Stratigraphic section typical of the patinations on the *David*: (a) viewed under an optical microscope; (b) viewed under SEM with back-scattered electrons; (c) distribution of the copper (SEM-EDX); (d) distribution of chlorides (SEM-EDX); (e) EDX analysis in the proximity of the bronze surface; (f) EDX analysis of the patinas.

be associated with maintenance procedures subsequent to the first coat and at times limited to localized fill-ins. The layers vary as to consistency and chromatic tone. For example, we can see that the uppermost layer—i.e., the last treatment (fig. 2a)—is not as thick and presents a much finer granulometry than the underlying layers.

The FT-IR analysis revealed the following prevalent compounds: gypsum, with greater concentrations on the outermost layers, calcium oxalate, silicates, calcium nitrates, calcium carbonate, and oily substances. This last group was clearly identified by the gas chromatography. The binder was found to consist of highly polymerized linseed oil as substantiated by the presence of azelaic, palmitic, and stearic acids. The analysis revealed the presence of spermaceti along with possible traces of beeswax as a possible product deriving from polishing and protective procedures. Spermaceti is a finer wax than beeswax and is extracted from sperm whale oil. It is significant to note that spermaceti wax came into use in the middle of the eighteenth century and was marketed on a wide scale during the next century even though it was relatively expensive. It was (and still is) used in natural or synthesized form in making fine (transparent) candles and in many other applications, including the modern cosmetics industry. Given the peculiar nature of this treatment it will be interesting to compare these results with similar studies conducted on samples from other bronzes that were first displayed in the Uffizi and then moved to either the Bargello or the Museo Archeologico in Florence.

2.2 Gilding

For the study of the gilding we took three stratigraphic micro-samples from the David's hair, edge of the jerkin, and right boot leg. Careful microscopic examination of these surfaces revealed traces of gilding. Figure 3 shows the cross-section of the sample from the right boot leg observed under back-scattered SEM. It clearly reveals pure gold-leaf gilding applied with a fine glue and completely covered by thick coats. It also shows the peculiar type of degradation that affects the residual gilding. The soluble salts in the patinations penetrate beneath the gilding and under the glue, giving rise to crystallization phenomena that cause the gold leaf to separate from the base and break, weakening the adhesion and increasing the gaps in the leaf. This type of process is accelerated by the presence of numerous transverse micro-fractures that were probably caused by thermal cycles. They transport water vapor, dissolved salts, and harmful gases through the various layers of patinations and the gilding itself to reach beneath the glue.

We measured the thickness of the gold leaf directly on the micro-fragments—that is, without any stratigraphic preparations. This method gives more reliable values in view of the how thin Renaissance gold-leaf gilding is and how readily it deforms under the smallest stress.[5] We took measures on various fragments similar to those shown in Figure 4 that clearly reveal the advanced state of deterioration from the superficial standpoint. The thickness we found ranges from a minimum of

FIGURE 3. SEM back-scattered electrons image of a stratigraphic section from the right boot. From the outside toward the inside we see the visibly cracked overlapping layers: the leaf gilding (thin white layer) and the underlying glue (dark layer).

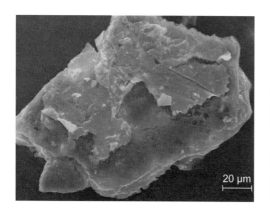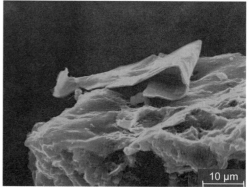

FIGURE 4. SEM image of gilded micro-fragments. Note: (a) the advanced deterioration of the residual gilding; (b) the thinness of the gold leaf (0.18 and 0.55 mm).

0.18 mm to a maximum of 0.55 mm (mean around 0.25 mm) and this is perfectly in line with the data in the literature.[6]

3. Studying the Technique

Information concerning the technological aspects of the statue was obtained from a careful visual examination and a series of analyses that included gamma ray radiography for the macroscopic study, electron-microprobe on some minuscule metal fragments to determine the chemical composition of the bronze alloy, and mapping of eddy currents to verify homogeneity and to identify technological and structural peculiarities such as plugs, fractures, runners, and corrosion.

3.1 Macroscopic Features

Visual and radiographic observations made it possible to determine that the *David* was cast with the direct lost wax method—that is, modeling the wax after applying it to a rough clay figure made on an iron support without using a plaster or clay model (fig. 5). The arms are solid, while the other parts of the body still contain the casting core, including the support and clay. In fact, there are no openings on the *David* for emptying, and one of the iron elements can still be seen protruding from the left heel. This explains the apparently excessive weight (126 kg) for a statue of this size (1.26 m). Goliath's head was also cast with the same method, as we can see from the relatively thick walls (weight: 17.4 kg).

Other very interesting peculiarities were found during the examination of the finishing on both the *David* and the head of Goliath. For example, looking at both heads we can see that the hair is very different: on the *David* it was cold worked and the facets make the curls lively and elegant (fig. 6a); on the other hand, Goliath's hair is much coarser (fig. 6b). In this case, it seems that the locks were created on the wax with wooden sticks, and the cold finishing is relatively homogeneous and less meticulous compared to the *David* and was probably done by rubbing with sharkskin.

The most evident thing, however, is the reduction of the base plate of the statue (fig. 1) by chisel. Originally, it must have been bigger and was probably fitted with a small bronze tenon that served as a connection and support for the left heel, which is now suspended with the iron rod protruding from the inside. The reduction in the size of the base made the equilibrium unstable, and, in fact, the *David* cannot stand alone. This would explain why it was necessary to make a large hole in the middle of the support, using a chisel to allow an anchoring ring to be put into place. With a horizontal shim (the seat is still clearly visibly), the ring held the statue firmly.

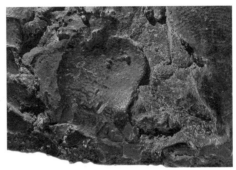

FIGURE 5. Frontal gammagraph of the *David*'s legs.
Note the two iron bars that supported the casting earth and the spiraled metal wire armature.

FIGURE 7. Imprints of the artist's fingers on the head of Goliath are evidence that he molded the wax *ad hoc* to create the "housing" for the *David*'s legs. In particular, note the pressure of the thumb in the middle and a clear fingerprint on the right side that was probably created by moving the thumb during the surface modeling.

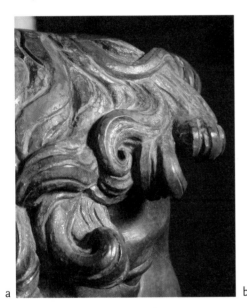
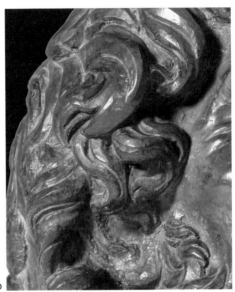

a b

FIGURE 6. Detail of the hair on both heads. The hand finishing on the *David* (a) is much more complex and sophisticated than the Goliath (b).

There is yet another important structural-qualitative element that we believe is essential for a correct interpretation of the statue. Some sources have raised doubts about the original position of Goliath's head.[7] They hypothesize that it was next to the *David* rather than between its feet since the shape of the curls would be poorly suited to the space available at the base of the figure. The visual examination, however, revealed that the housing grooves for David's feet between the locks on Goliath's head were made by the artist while he was working with the wax. The metal surface on both sides of the head bear imprints of the artist's fingers (fig. 7); prior to the casting, he did an ad hoc shaping to adapt the size and shape of Goliath's head to the space between the *David*'s feet. The missing curls on the right side, which seem to have been cleanly removed without any sign of chisels, files, or other tools, would lead us to believe that this modification was made directly on the wax.

And finally, a few notes on the sword. The steel blade that was added in 1778, according to the inventory documents, is 34 cm long. It was fastened to the inside of David's right hand with an existing steel pin that went through the tang that was fastened by plaster and lead.

FIGURE 8. Back-scattered electrons SEM image of the bronze alloy of the base. Note the typical lack of homogeneity of the alloy as cast and the presence of lead (white spots).

3.2 Micro-Structural Aspects

On the basis of our findings, we can say that there are no substantial differences between the composition of the alloy used for the *David* and the head of Goliath other than a slightly greater amount of lead in the latter. It is a quaternary bronze alloy with significant traces of antimony, arsenic, nickel, and (in the *David*'s base) iron. The analysis by electron microprobe yielded the following values for this part of the sculpture (fig. 8): 86.48% Cu, 5.81% Sn, 2.84% Pb, 0.94% Zn, 0.81% Sb, 0.53% As, 0.36% Fe—which are comparable to the chemical compositions of other Renaissance bronzes.

In order to verify the homogeneity of the alloy and investigate the distribution of the plugs and other technological peculiarities, we did an accurate mapping of the sculpture by measuring eddy currents. This revealed a main gradient from the base to the head of the *David* that is compatible with a greater accumulation of lead in the lower part. This suggests that the sculpture was cast upright and not upside down, on its head, as was often the preferred method in older times because of the need to make the solid tenons "automatically." An almost constant signal at the same height leads us to consider a distribution of the runners at various and almost parallel levels, even if the perfect surface finishing does not allow these points to be identified. The only evident patches are located inside the right thigh and on the top of the *David*'s head. These were probably necessary to conceal the end of the iron rod of the internal support.

4. OPTIMIZATION OF THE CLEANING PROCEDURES

What we learned from the characterization of the statue's state of conservation made it clear that we had to remove the patinations that covered Verrocchio's original surface finishing of patina and gilding. Their highly porous structure favored the infiltration of water and atmospheric pollutants along with the soluble salts they contain, such as sulfates and chlorides. These compounds kept the corrosion processes active beneath the patinations, thereby furthering the deterioration of the bronze substrate and residual gilding. Therefore, the cleaning was inspired not merely by a justified desire to restore the *David*'s physical appearance to the original, insofar as possible, but also—and primarily—the conservation need to protect this masterpiece from deterioration that was greatly accelerated by arbitrary past interventions using materials whose chemical and physical properties were totally incompatible with conservation, other than with aesthetics.

4.1 Cleaning the Bronze Surfaces

As we have stated, the stratification on the *David* was very thick and polymerized to the extent that mechanical cleaning appeared difficult and risky to the integrity of the metal surface. This led us to experiment with methods that would structurally weaken the patinations to facilitate the mechanical finishing. After a preliminary selection of chemicals and possible methods of application, we concentrated on poultices of sodium bicarbonate and Contrad® in a moderately alkaline water solution. The mechanism of action of the first substance, sodium bicarbonate, is based on the saponification effect it induces on

FIGURE 9. Comparative cleaning tests, done mechanically after applying poultices of sodium bicarbonate (A1 and A2) and Contrad® (B1, B2) in moderately alkaline aqueous solutions. A1: pH 8; A2: pH 10; B1: pH 8; B2: pH 9. C shows a laser cleaning test.

greasy substances, while the latter is a more complex product that can be effective in various situations. We tested two pH levels for each solution: 8 and 10 for the sodium bicarbonate, and 8 and 9 for the Contrad®. As the support we used Japanese paper, which adapts most readily to the shapes.

We conducted cleaning tests on a typical area, on the inner surface of the left calf. We estimated the optimum application period that would soften the patinas enough to permit their easy mechanical removal on the basis of visual control and tenacity tests at fifteen-minute intervals. In this way we calculated a mean application period of about one hour. The stratification was removed with scalpels, using similar and controlled movements in the various areas. When removal was completed, we refinished the surfaces using natural bristle brushes mounted in a handle powered by a small, variable-speed motor, a tool commonly used in metal restoration and other precision tasks.

The most satisfactory results were obtained on the area pretreated with a pH 10 sodium bicarbonate solution (site A2, fig. 9). The comparative assessment was made primarily on the basis of the level of cleaning achieved, as deduced from the surface texture and chromatics as they appeared under macro- and microscopic observation as well as a comparative measurement of residual soluble salts using ion chromatography and conductivity measurements. The effects of the pH 8 sodium bicarbonate solutions were bland. It did not permit complete removal of the stratified materials using controlled mechanical movements, and this yielded a dark appearance that was similar in tonal variations to the original state. On the other hand, the level of cleaning achieved with Contrad® pretreatment was too deep, as revealed by the exposure of oxides, which beneath any possible patina represent the interface with the substratum or the metal itself. Although we do not preclude a finer control of this product, we must say that in this particular situation the bicarbonate-based solution was clearly more controllable.

4.2 Cleaning the Gilded Surfaces

Obviously, the above cleaning method could not be used on the gilded portions of the *David*, which careful microscopic examination revealed to be the hair, the eyes, the hilt of the sword, all the decorations on the garments, boots, and trim. In fact, any organic solvent would have attacked the glue beneath the gold leaf and even if it had a neutral chemical effect, manual finishing of surfaces with traces of gold leaf would have been impossible under these conditions. The same applies to treatments to solubilize the corrosion products of copper, which could have caused severe damage especially on the bronze-glue interface.

Therefore, we had to use a method that would permit gradual removal of the stratification and protect the gold leaf without altering its already precarious adhesion. Without excluding other options, which still had to be tested, we decided to test the Nd:YAG (1064 nm) laser method with an optimized pulse duration of 50 ms (EOS 1000 El.En. S.p.A.). We believe that this approach has enormous potential for tackling the cleaning of complex gilding such as on this statue. However, we must point out that this opin-

ion is based on personal experience accrued over the years through in-depth laboratory tests and major restoration projects that distinguish the IFAC-CNR and Opifico delle Pietre Dure as leaders in the development of specific laser cleaning methods and technologies.[8] Today these are considered innovative, not only with respect to conventional methods, but also in the context of the state of the art of laser cleaning.[9]

Laser cleaning is based on pulsed heating of the incrustation associated with radiation. This leads to a rapid removal of a certain micro-volume of material. Under optimum conditions it permits the desired level of cleaning to be achieved without significant collateral damage. There are various conditions that favor selectivity and control. In this case we achieved them by selecting laser parameters that would keep the pressure and temperature gradients transferred to the gilding sufficiently low, taking into account the considerable selectivity contribution from the high reflectance of the gold leaf at the wavelength we used. As in other cases, we moistened the surfaces during irradiation in order to limit the thermal peaks; this increased our operating margins and facilitated removal, since it is significantly mediated by the pulsed vaporization of water.

Irradiation of the stratifications of a gilded area selected on the hair and decorations of the skirt with a relatively low energy density (1.5–2 J/cm²) permitted gradual removal and exposure of the residual gold leaf (fig. 10). In the gaps, the laser removal stops at the residual glue or surface oxidation of the bronze, and in this latter case it restores the typical tonality of the cuprite. This type of result can be considered optimal in these circumstances and it could only be achieved with difficulty if at all using other methods.

For thoroughness, we also tested the laser in ungilded areas (site C, fig. 8), but as we can see in this case—as for the gaps in the gilding—we reached the cuprite in the substratum without any possibility of stopping earlier. We must add that this result and especially the appraisal of the level of cleaning achieved cannot be considered as generalized and therefore does not exclude the possibility of using lasers on other bronze surfaces, as has already been proved on archaeological pieces.[10]

5. THE INTERVENTION

There are many practical issues when we try to extend a specific (even if carefully optimized) methodology to an entire artwork, since no analysis can provide exhaustive information on all the material variations, the distribution of the stratifications, and their tenacity. In

metaphorical terms we could say that restoring a masterpiece is always something of a leap into the dark due to the irreversibility of the effects of each procedure, the danger of achieving scientifically or aesthetically unacceptable results, and the emotional tension that all these factors produce.

In the case of Andrea del Verrocchio's *David*, we needed a special organization, guided by both intuition and the versatility of the manual approach that has matured through extensive experience in the conservation of bronze artworks. Alongside the problem of reproducing the opti-

FIGURE 10. First laser cleaning test on the *David*'s hair.

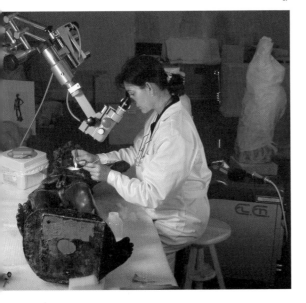 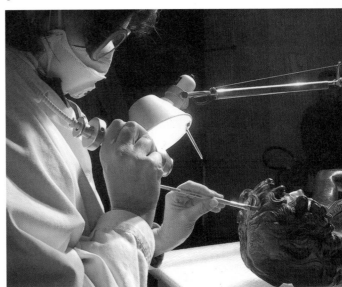

a b

FIGURE 11. Two phases of the restoration: (a) mechanical cleaning of the bronze surfaces under a microscope and (b) cleaning the gilded areas with laser irradiation.

mum results achieved in the cleaning tests, we had to take special precautions on areas such as the chest, which had been visibly scratched in the past. Here using a scalpel could have proved disastrous as the metal was easy to nick and the damage would have been clearly evident. To this we must add the fact that, notwithstanding an accurate initial mapping of the gilding, we could not exclude the possibility of other gilded areas—as we did indeed discover.

It is for these reasons that, after applying the poultices and repeatedly monitoring their effects on predetermined areas, all the manual cleaning was done under a microscope (fig. 11a). Along with scalpels we used a set of specifically developed instruments in order to remove the patinations from the complex contours of the surfaces completely and without risk. Therefore, in areas with thick layers of patination, such as the deep points and the grooves of the chiseling, chasing, etc. we used Plexiglas sticks with appropriately ground tips (fig. 12) to get into the small spaces.

The laser cleaning of the gilded areas (fig. 11b) was conducted under continuous microscope monitoring of the surfaces, given the difficulty of distinguishing the material variations, reliefs, and other surface features with the naked eye. Furthermore, we were not fully aware of all the gilded areas. For example, during the process we discovered gilding on the pupils, the edges of the irises, and the corners of the eyes. Also, in addition to the gilding on the trim, there is a complex decoration on the boots.

We must also point out that Verrocchio's *David* is only the third artwork on which laser has been extensively used to clean the gilding. The other two are the *Porta del Paradiso (Gates of Paradise)* by Lorenzo Ghiberti and the *I Santi Quattro Coronati (Four Crowned Saints)* by Nanni di Banco.[11] In some ways, this latter group had some similarities with the *David* and was, in fact, used as a reference in our choice of laser and energy densities.

FIGURE 12. Instruments used for the mechanical finishing of the cleaning process.

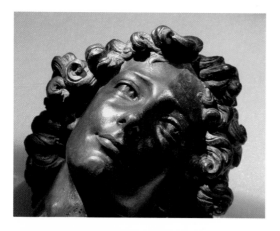

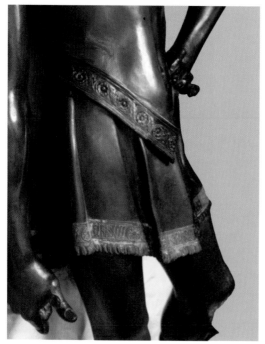

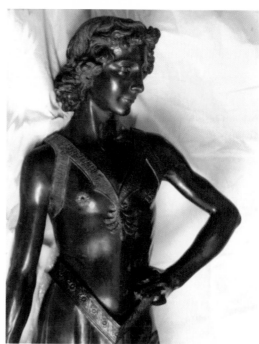

FIGURE 13. The *David*'s face during cleaning.

FIGURE 14. A cleaned area on the trim of the garment. Note the recovery of traces of gilding and the fine burin finishing.

FIGURE 15. The right side of the statue, cleaned except for the braiding on which only the area shown in figure 14 had been cleaned.

FIGURE 16. A front view during cleaning.

6. Conclusion

The outcome of work is clearly visible in Figures 13–16, which show details of the statue after the treatments and compare them with adjacent areas that still remained to be cleaned. It is not our task to assess the results from an interpretative standpoint. But we believe that, as a contribution to the discussion of the rereading of Verrocchio's masterpiece and the reconstruction of its history, it is useful to note that we cannot reach a scientific certainty that the patina of the bronze surface as revealed by the restorations has any chromatic or material relationships with Verrocchio's original intentions. Certainly the chromatic homogeneity, the fineness which veils the oxidized bronze surface, and the continuity with the substrate harmonize well with what we define as patina from the material sciences standpoint. This consideration is also based on the fact that what we see now cannot be immediately associated with the removed patinations or processes of mineralization of the bronze.

As to the gilding, it is interesting to note how, even though much of it has been lost, the overall effect when viewed from a certain distance probably renders the original impact the statue must have aroused. The gilding was probably damaged by the mechanical effects of cleaning and periodic surface treatments, especially perhaps one that must have been an in-depth cleaning between the eighteenth and nineteenth centuries aimed at making the first patina adhere better. It is, however, reasonable to assume that the definitive chromatic homogenization produced by what we today consider an arbitrary patination was done in consideration of the advanced deterioration of the gilding rather than from a mere, and deliberate, desire to alter the appearance of Andrea del Verrocchio's masterpiece.

Technical difficulties and decisions related to the protective treatments of surfaces will be addressed in subsequent publications.

Notes

1. L. Dolcini, *La scultura del Verrocchio: itinerario fiorentino* (Florence: Le Lettere, 1992). Also see Beatrice Paolozzi Strozzi and Maria Grazia Vaccari's essay (p. 13) in this catalogue.

2. A. Giusti et al., *Documentary and Analytical Analogies in the Study of Patinas of the "Quattro Santi Coronati" by Nanni di Banco*, in *Proceedings of the Ninth International Congress on Deterioration and Conservation of Stone*, ed. V. Fassina (Amsterdam: Elsevier Science, 2000), pp. 671–678; S. Siano et al., *Caratterizzazione stratigrafica e pulitura della Minerva da Arezzo: studio preliminare*, in *Proceedings of the Third International Congress on Science and Technology for the Safeguard of Cultural Heritage in the Mediterranean Basin*, ed. A. Guarino (Rome: CNR, 2002); and A. Giusti et al., "Indagini storiche e diagnostiche per il restauro dei Quattro Santi Coronati di Nanni di Banco, gruppo marmoreo della facciata di Orsanmichele a Firenze," *OPD Restauro* 13 (2001), pp. 143–150.

3. D. Karl, *Il David del Verrocchio, Museo Nazionale del Bargello* (Florence: S.P.E.S., 1987), pp. 2–11. Also see Beatrice Paolozzi Strozzi and Maria Grazia Vaccari's essay (p. 13) in this catalogue.

4. Karl, *Il David del Verrocchio*; AGU, Galleria delle statue, Filza A, Posiz.1, n.56; and P. Adorno, *Il Verrocchio* (Florence, Casa Editrice EDAM, 1991).

5. V. Merzenich, "Dorature e policromie delle parti architettoniche nelle tavole d'altare toscane fra Trecento e Quattrocento," *Kermes* 26 (1996), pp. 51–71.

6. V. Merzenich, "Dorature e policromie"; and S. Siano et al., "The Santi Quattro Coronati by Nanni di Banco: Cleaning of the Gilded Decorations," *Journal of Cultural Heritage* 4 (2003), pp. 123s–128s.

7. L. Dolcini, *La scultura del Verrocchio*.

8. S. Siano et al., "The Santi Quattro Coronati"; S. Siano and R. Salimbeni, "The Gates of Paradise: Physical Optimisation of the Laser Cleaning Approach," *Studies in Conservation* 46 (2001), pp. 269–281; S. Siano et al., "Laser Cleaning Methodology for the Preservation of the Porta del Paradiso by Lorenzo Ghiberti," *Journal of Cultural Heritage* 4 (2003), pp. 140s–146s; and M. Matteini et al., "Laser and Chemical Cleaning for the Preservation of the Porta del Paradiso by L. Ghiberti," *Journal of Cultural Heritage* 4 (2003), pp. 147s–151s.

9. V. Verge-Belmin, ed., "Proceedings of the International Conference LACONA IV," *Journal of Cultural Heritage* (Paris: Elsevier Science) 4, supp. 1 (2003).

10. S. Siano et al., "Caratterizzazione stratigrafica e pulitura della Minerva da Arezzo"; and R. Pini et al., "Test of Laser Cleaning on Archaeological Metal Artefacts," *Journal of Cultural Heritage* 1 (2000), pp. S129s–S137.

11. For the *Gates of Paradise*, see S. Siano and R. Salimbeni, "The Gates of Paradise"; S. Siano et al., "Laser Cleaning Methodology"; and M. Matteini et al., "Laser and Chemical Cleaning." For the *Four Crowned Saints*, see S. Siano et al., "The Santi Quattro Coronati."

SELECTED BIBLIOGRAPHY

Bertelà, Giovanna Gaeta, and Marco Spallanzani, eds. *Libro d'inventario dei beni di Lorenzo il Magnifico.* Florence: Associazione Amici del Bargello, 1992.

Bule, Steven, Alan Phipps Darr, and Fiorella Gioffredi Superbi, eds. *Verrocchio and Late Quattrocento Italian Sculpture.* Florence: Le Lettere, 1992.

Butterfield, Andrew. "New Evidence for the Iconography of David in Quattrocento Florence." *I Tatti Studies, Essays in the Renaissance* 6 (1995): 115–133.

Butterfield, Andrew. *The Sculptures of Andrea del Verrocchio.* New Haven: Yale University Press, 1997.

Caglioti, Francesco. *Donatello e I Medici: Storia del David e della Giuditta.* Florence: Leo S. Olschki Editore, 2000.

Ettlinger, Leopold D. *Antonio and Piero Pollaiuolo.* Oxford: Phaidon, 1978.

Garzelli, Annarosa. *Miniatura fiorentina del Rinascimento, 1440–1525, Un primo censimento.* Florence: Giunta regionale Toscana & La Nuova Italia Editrice, 1985.

Hegarty, Melinda. "Laurentian Patronage in the Palazzo Vecchio: The Frescoes of the Sala dei Gigli." *Art Bulletin* 78 (1996): 264–285.

Hind, Arthur M. *Early Italian Engraving: A Critical Catalogue with Complete Reproduction of All the Prints Described.* 1938. Reprint, Nendeln, Lichtenstein: Kraus, 1970.

McHam, Sarah Blake. "Donatello's Bronze David and Judith as Metaphors of Medici Rule in Florence." *Art Bulletin* 83 (2001): 32–47.

Merisalo, Outi, ed. *Le Collezioni Medicee nel 1495.* Florence: Associazione Amici del Bargello/ Studio per Edizioni Scelte, 1999.

Randolph, Adrian W. B. *Engaging Symbols: Gender, Politics, and Public Art in Fifteenth-Century Florence.* New Haven: Yale University Press, 2002.

Rubinstein, Nicolai. *The Palazzo Vecchio 1298–1532: Government, Architecture, and Imagery in the Civic Palace of the Florentine Republic.* Oxford: Clarendon Press, 1995.

Seymour, Charles. *Michelangelo's David: A Search for Identity.* Pittsburgh: University of Pittsburgh Press, 1967.

Vasari, Giorgio. *Le Vite dei più eccellenti pittori scultori ed architettori.* Edited by Gaetano Milanesi. Florence: G. C. Sansoni, Editore, 1906.

———. *Lives.* Edited by Paola Barocchi. Florence: Sansoni, 1966.

This book printed in English and Italian editions totalling 8,000 books. The text is set in FF ScalaSans and Adobe Jenson. The paper stock is 150 gr. Gardapat Matte. Printed in Prato by Giunti Industrie Grafiche.